Restoration and Retouching with Photoshop® Elements 2

Restoration and Retouching with Photoshop® Elements 2

Laurie Ulrich

Wiley Publishing, Inc.

Restoration and Retouching with Photoshop® Elements 2

Published by
Wiley Publishing, Inc.
909 Third Avenue
New York, NY 10022
www.wiley.com

Copyright © 2003 by Wiley Publishing, Inc., Indianapolis, Indiana

Library of Congress Control Number: 2002114771

ISBN: 0-7645-2474-7

Manufactured in the United States of America

10 9 8 7 6 5 4 3 2 1

1K/RU/QS/QT/IN

Published by Wiley Publishing, Inc., Indianapolis, Indiana
Published simultaneously in Canada

WILEY is a trademark of Wiley Publishing, Inc.

Foreword

My first camera was far from digital. Still, that Polaroid Instant device gave me near-immediate visual gratification. I never imagined that one day I would have an unlimited supply of "film" at my fingertips, and that I could fix the substandard snapshots seconds after shooting them. Photography used to be interesting only for professionals and hobbyists, but now even my mother is catching the shutter bug. Not a week passes when I don't receive an optimized image from her through e-mail. Oh yes, the software is just as important as the hardware.

When I was training to be a teacher in college, I couldn't afford to purchase Adobe Photoshop. By the time my career was underway, I had been working with an alternative image editor for years. Old habits do, indeed, die hard. The Adobe Photoshop Elements 1.0 CD-ROM came bundled with various peripherals I had purchased, but like most seasoned geeks, I paid no attention to the disc. "I don't want to install or use a demo of the real deal." How wrong I was. When someone showed me the Quick Fix tool in person, my jaw dropped.

I soon came to realize that Photoshop Elements had pretty much the same functionality as the full-blown Photoshop product. At least, as far as how I'd use it — because I'm what you'd call a regular guy. As Laurie Ulrich illustrates in *Restoration and Retouching with Photoshop Elements 2*, this particular Adobe product is quite powerful — but it's also accessible. Home users, Web developers, and professional photo editors alike have seen the power of the package — some going as far as to abandon Photoshop for certain routines Photoshop Elements can clearly do better, faster, and with less hassle.

Whether you're thinking of picking up Photoshop Elements or if you already own it, these tips will fortify your decision. In writing *The Complete Reference: Photoshop 7*, Laurie established herself not only as a Photoshop expert, but as an evangelist as well. Her passion is what separates *Restoration and Retouching with Photoshop Elements 2* from the others. Although, Laurie's understanding of Photoshop Elements' intended audience is equally as important as her understanding of the software itself, which is what makes this book an essential part of anybody's toolset.

There's a great selection of photo software for both the Macintosh and Windows platforms, but as far as what the average person needs, Photoshop Elements is perfect. You'll become addicted to the editing process with the touch-up of your first "bad" photo. Salvaging prints from the brink of invisibility will give you an adrenalin rush the likes of which you've never had. Well, maybe not, but the tips you learn from Laurie will last a lifetime. What's more, the information in the following pages will transcend the book's namesake.

I love this stuff. Seriously, I've been playing with technology since I was in the fifth grade, and I'm still learning how to maximize my time in front of the monitor. This is your sandbox, my friend. You can open an image, edit it to your heart's desire, and save it to a different folder when you're finished. This way, the fear of damaging the original beyond reparation will not exist. And if you just so happen to make a mistake in the middle of the session, simply call upon your ally: Undo. But don't do it all in one day.

Reading this book from cover to cover in one sitting will pump you up and prime you for working

with photos. But don't leave it sitting on the bookshelf. *Restoration and Retouching with Photoshop Elements 2* is just as important a tool as the camera itself. You can reabsorb and master the processes by mimicking them with your own images. From giving your mother-in-law a nose job to resurrecting pictures that were previously damaged beyond recognition, this book will increase your photo-optimizing skills. And what's more, you'll have fun doing it.

Chris Pirillo
Host, *Call for Help*
TechTV

Preface

Through a very reasonable price, Adobe Photoshop Elements has put much of the power of the industry standard in computerized photo editing — Adobe Photoshop — into the hands of growing businesses, non-profit organizations, and home users. As a graphic artist, computer trainer, and author, I find this exciting — the tools that were primarily in the domain of professional photographers and "serious" graphic and Web designers are now something that just about anyone can afford and use. This means that I can share more of what I know about restoring photos, creating original artwork, and designing images for the Web with more people.

I wrote this book to share what I know about restoring and retouching photographs with the people who are now, thanks to Photoshop Elements' appearance on the market, in possession of the right tools for the job. Also, as more people are using digital cameras to capture new photos and scanners to preserve their old photos, the need for accessible yet powerful software to make the most and best of these images has never been greater. Photoshop Elements rises to the occasion and gives you all the tools you need to fix just about anything that's gone wrong with your photos — from technical glitches that occurred when the photo was taken and/or developed, to abuse and neglect that's caused actual damage in the form of rips, scratches, stains, and missing content.

Restoration and Retouching with Photoshop Elements 2 is designed to make you comfortable with Photoshop Elements — starting with a tour of the interface and taking you through all of the different types of restoration and retouching tasks you may need to perform and the tools you need to complete them. The book's final chapter provides a discussion of printing, saving, and display options, and the book ends with two appendixes that point you toward online sources for Photoshop Elements-related information and tips for preserving your original images, especially endangered vintage photos. Throughout the book, you'll find practical ideas and suggestions taken from my own experience in preserving photos of all kinds for clients, friends, and family. You'll also see photos that are representative of the kind of images you're probably working with — family photos, vacation shots, professional portraits, and antique images, many of which are in sad shape. This should help you apply what you read to your real-life restoration projects — rather than my using slick images that only a professional photographer would take or use, I used my own family images throughout the book.

Another of my main goals in writing this book was to take the apprehension and pessimism out of the restoration and retouching process. The phrases "it can't be done" and "it's beyond help" should be removed from readers' lexicon (with regard to photos, anyway), as you'll find out how to approach the restoration process logically, avoiding redundant effort, and eliminating time-consuming or otherwise daunting tasks when they're not worth the time or when there's a faster, better way to perform them.

This book has been written to help and appeal to a variety of people with a variety of restoration and retouching needs:

- If you have photos that you would love to display or reproduce and give as gifts, yet the photos are in such bad shape you have them hidden in a drawer, this book is for you.
- This book is also for you if you need to use photos on the Web and want to make them

clearer, cleaner, and reduce them to the essentials so that they load quickly and impart information efficiently.

- If you're researching your family tree and are finding photos along the way, this book can help you preserve your images and display them in ways that help tell the story of your family and its history.

- You'll enjoy this book if you're a professional or experienced amateur photographer and would like to use Photoshop Elements to enhance your images — both those captured digitally or scanned from original prints. The lower price makes Photoshop Elements available to fledgling photographers and people who might otherwise have taken the photo and left the retouching to someone else in an attempt to save time.

- If you'd like to create a backup of your most cherished images, eliminating the threat of loss due to fire, flood, or misplacement, you'll like this book. Even if there's nothing wrong with your original, when you scan it into Photoshop Elements, you're able to resize it, edit it, add a frame to it, or apply artistic special effects. You'll be able to do so much more with your photos than you may have imagined, in addition to making sure that the original isn't the only useful copy of the image.

- If you've been taking your photos to the local printer to have color copies made, you'll find great tips for printing your photos with a low-cost inkjet printer, making it possible to create as many prints as you want, in as many sizes as you need. The printer pays for itself in no time, and you save yourself a lot of time and effort.

I hope you find the information and inspiration you need, and that if you have any questions you'll send me an e-mail message. I'm happy to hear from you, and as questions roll in, I'll build a Frequently-Asked Questions page on my Web site to house them. You can reach me via e-mail at laurie@ planetlaurie.com.

Acknowledgments

I must thank three people right off the bat: Tom Heine for recognizing the value of my original idea for this book and helping to find it a home at Wiley Publishing; Katharine Dvorak for her editorial expertise, guidance, and encouragement; and Robert Fuller, for his insightful technical edits, based on his many years of experience with Photoshop and more recently, Photoshop Elements. Given that Robert is also my "significant other," I was grateful that he was able to remain objective throughout the editorial process — most technical editors don't have to work in the same room with the author they're editing, much less live with her!

In addition, I want to express my appreciation for the efforts of copy editor, Jerelind Charles, and Project Coordinator, Nancee Reeves, who helped pull all of the text and artwork for this book together. It takes a team to create a book like this, and I thank everyone for their hard work and creativity.

Finally, I must thank my agent, Margot Maley-Hutchison. I don't know what I'd do with out her wisdom, practicality, and sense of humor.

Contents at a Glance

Foreword v

Preface vii

Acknowledgments ix

Chapter 1 A Tour of Photoshop Elements' Restoring and Retouching Tools 3

Chapter 2 Scanning Your Original Photographs 35

Chapter 3 Improving Photo Color and Contrast 47

Chapter 4 Too Dark or Too Light: Correcting Exposure 67

Chapter 5 Moving and Removing Unwanted Content 89

Chapter 6 Repairing Scratches, Tears, and Spots 103

Chapter 7 Removing Dust, Mold, and Unwanted Textures 121

Chapter 8 Performing Plastic Surgery with Photoshop Elements 143

Chapter 9 Mastering Special Effects and Filters 163

Chapter 10 Printing and Displaying Your Restored Images 183

Appendix A Preserving Your Originals 201

Appendix B Online Resources 205

Appendix C Before and After Images 209

Glossary 215

Index 223

About the Author 239

Colophon 240

Contents

Foreword v

Preface vii

Acknowledgments ix

Chapter 1
A Tour of Photoshop Elements' Restoring and
Retouching Tools 3

Understanding Photoshop Elements' Workspace
 and Tools 3
 Working with the Toolbox 6
 Using the Options Bars 7
 Using Tool Presets 9
 Creating Custom Brush and Fill Presets 9
 Using Selection Tools 10
 Making Marquee Selections 11
 Selecting Free-form Shapes 13
 Selecting by Color and Light Levels 14
 Adding to, Subtracting from, and Intersecting
 Selections 14
 Identifying Restorative Tools 16
 Sharpening and Blurring 17
 Adding Light and Dark 18
 Blending 19
 Cloning 20
 Erasing 21
 Removing Red Eye 22
Working with Palettes and Controls 22
 Displaying the Palettes 26
 Using the Palette Well 27

Setting Relevant Preferences
 and Color Settings 27
 Setting General Preferences 28
 Customizing File Management Tools 29
 Choosing Display and Cursor Settings 29
 Selecting the Appearance of Transparency 30
 Working with Rulers and Units of Measure 30
 Customizing and Using the Grid 31
Getting Help, Taking Hints, and Following
 Recipes 31
 Working with Hints 32
 Following How To Instructions and Recipes 32
The Big Picture 33

Chapter 2
Scanning Your Original Photographs 35

Working with Scanning Devices and
 Software 35
Installing a Scanner 36
Scanning Color Images 37
 Importing Printed Photos into Photoshop
 Elements 38
 Previewing the Image to be Scanned 38
 Setting Up the Scan 39
 Performing the Scan 40
 Keys to Successful Color Scanning 40
 Scanning in Black-and-White 41

Scanning Old or Damaged Photos 42
Tips for Web-bound Photos 44

The Big Picture 45

Chapter 3
Improving Photo Color and Contrast 47

Improving Photo Color and Contrast 47

Adjusting Image Brightness and Contrast 48
Making Automatic Contrast Adjustments 49
Adjusting Highlights, Grays, and Shadows 50
Performing Automatic Level Adjustments 50

Correcting Colors 51
Controlling Hue and Saturation 51
Removing a Color Cast 54
Adjusting Color with Variations 55

Controlling Image Content and Appearance
with Layers 56

Selecting and Using Paintbrush Blending
Modes 60

The Big Picture 65

Chapter 4
Too Dark or Too Light: Correcting Exposure 67

Adjusting Backlighting and Fill Flash to Correct
Exposure 68
Creating Better Backlighting 68
Using the Fill Flash 69

Creating and Repositioning Light Sources 70
Using the Lighting Effects Filter 70
Choosing a Lighting Style 70
Establishing the Type of Light Needed 71
Customizing the Lighting Properties 72
Creating 3D Texture Effects with Lighting 73
Creating a Flash of Light with the Lens
Flare Filter 73

Controlling Lights and Darks 74
Adding More Light with the Dodge Tool 75
Creating Shadows with the Burn Tool 76

Adjusting the Amount of Color in
Your Photos 77
Using the Sponge Tool to Add and Remove
Color 78
Adjusting Hue and Saturation 80
Removing and Replacing Color 81

Using Quick Fix to Control Lighting and
Saturation 82

Working with Color Variations to Make
Sweeping Changes 84

Eliminating Red Eye 85
Using the Red Eye Brush 85
Getting Rid of Red Eye Manually 86

The Big Picture 87

Chapter 5
Moving and Removing Unwanted Content 89

Rearranging Image Content 89
Selecting the Content to be Moved 90
Moving the New Layer's Content 91
Making Moved Content Feel at Home 92
Covering Up and Blending In 93
Resizing Your Rearrangement 95
Shedding the Right Light 96

Removing Undesirable Content 97
Selecting and Deleting the Unwanted Content 97
Filling In the Void 97
Cloning to Fill the Void 97
Creating a New Layer to Fill the Void 98
Creating a Layer with Content from
Another Image 99
Retouching the Filler Content 100

To Merge or Not to Merge 100

The Big Picture 101

Chapter 6
Repairing Scratches, Tears, and Spots 103

Reconstructing Torn Images 103
 Rebuilding Missing Content 104
 Using Copy and Paste 105
 Creating and Positioning New Layers 106
 Making Repairs Blend In 106
 Adjusting Light Levels 107
 Softening the Edges 107
 Merging the Patch Layers 108
Fixing Minor Rips, Tears, and Scratches 109
 Using the Clone Stamp to Fix Rips and Tears 109
 Painting Out Scratches 111
 Smudging Blemishes Away 112
 Using and Controlling the Smudge Tool 112
 Smearing with the Finger Painting
 Option 113
Getting Rid of Spots and Stains 114
 Washing out Stains with the Sponge Tool 114
 Selecting and Recoloring Stained Content 115
 When All Else Fails: Spot and Stain
 Camouflage 116
Understanding the Special Needs of
 Vintage Photos 117
The Big Picture 119

Chapter 7
**Removing Dust, Mold, and Unwanted
Textures 121**

Removing the Signs of Dust, Mold,
 and Mildew 122
 Using the Dust and Scratches Filter 122
 Using the Median Filter to Soften Light
 and Dark Spots 126
 Blending Out Individual Marks 127
 Painting Dots on Unwanted Spots 128
 Doing a Quick Smudge 129

Cleaning and Cloning Backgrounds and
 Large Areas 129
Dealing with Noise and Textures from
 Digital Captures 130
 Using the Noise Filters 131
 Working with the Add Noise Filter 132
 Despeckle-ing an Image 134
 Using the Median Filter 136
 Reducing the Impact of Moiré 136
 Using the Blur Filters 137
 Blurring Manually 139
 Using the Unsharp Mask Filter to Add
 Clarity 139
The Big Picture 141

Chapter 8
**Performing Plastic Surgery
with Photoshop Elements 143**

Removing Blemishes and Wrinkles 143
 Smoothing Out Freckles and Scars 144
 Turning Back the Clock with a
 Photographic Facelift 147
 Improving a Smile with Whiter Teeth 148
Re-contouring Facial Structure 148
 Enlarging the Eyes 149
 Fixing a Nose 151
 Raising Cheekbones 152
 Changing the Jaw Line 153
Repairing the Signs of a Bad Hair Day 154
 Lengthening and Shortening Hair 155
Applying Digital Cosmetics 156
 Creating Eye Make-up 157
 Thickening Eye Lashes 157
 Plucking and Reshaping Eyebrows 158
 Adding Color to Lips and Cheeks 159
 Creating Subtle Changes in Skin Tone 159
 Applying Color and Shine to Lips 160
The Big Picture 161

Chapter 9
Mastering Special Effects and Filters 163

Applying Special Effects 163
 Displaying Image Options 164
 Applying Filters and Effects 166
Distorting Image Content 168
Applying Artistic Filters 170
 The Artistic Filters 170
 Brush Stroke and Sketch Filters 171
 Choosing a Brush Stroke Filter 172
 Working with Sketch Filters 172
Working with Realistic and Imaginative
 Textures and Styles 174
 The Pixelate Filters 174
 The Stylize Filters 175
 The Texture Filters 178
Applying Layer Styles 179
 Applying Layer Styles 180
 Removing Layer Styles 181
The Big Picture 181

Chapter 10
Printing and Displaying Your Restored Images 183

Putting Finishing Touches on Black-and-White
 Photos 183
 Colorizing a Black–and–White Photo 184
 Converting Grayscale to RGB 184
 Selecting Content to Colorize 184
 Using Color Variations to Turn Gray
 to Color 185
 Converting a Vintage Black-and-White Photo
 to Sepia Tone 186
 Creating Duotone Images 188

Saving Photos for Use on the Web 189
 Choosing the Right File Format 189
 Establishing File Options 190
Printing Your Photos 190
 Should You Use a Laser Printer? 191
 A Common Choice: The Inkjet 191
 Working with Dye Sublimation Printers 191
 Selecting the Right Paper for Your
 Printed Photos 191
Display Options for Your Photos 192
 Creating a Collage 192
 Combining Content from Several Photos
 into a Single Image 192
 Positioning and Blending the Collage
 Elements 194
 Inserting a Background Image 194
 Adding a Textured Mat to Frame the Image 196
 Using Frame Effects 196
 Creating a Frame from Scratch 197
The Big Picture 199

Appendix A
Preserving Your Originals 201

Storing Vintage Photos 201
Keeping New Images in Mint Condition 202
Creating Electronic Archives 203

Appendix B
Online Resources 205

The National Association of Photoshop
 Professionals 205
The Photos Used in This Book 206

Appendix C
Before and After Images 209

A Damaged and Faded Group Photo 209
Writing, Marking, and a Tear 210
The Green Cat in the Bowl 212

Glossary 215
Index 223
About the Author 239
Colophon 240

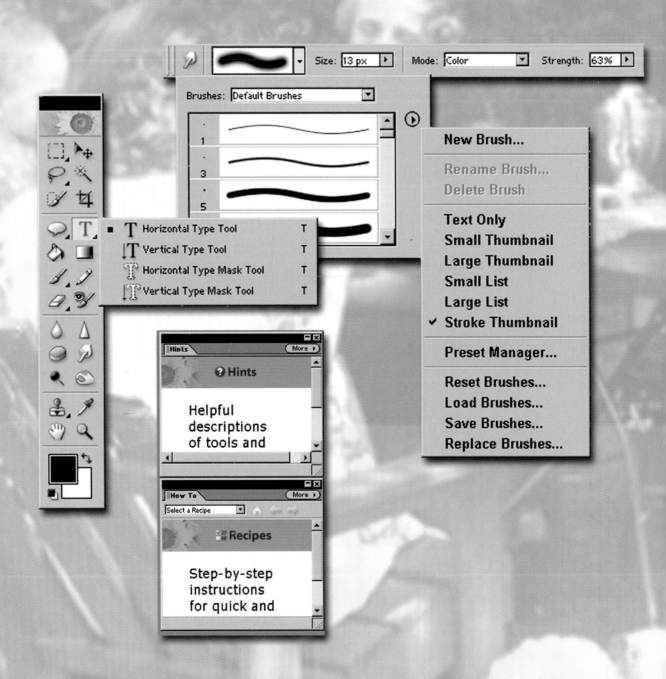

A Tour of Photoshop Elements' Restoring and Retouching Tools

What good are computers? They can only give you answers.

PABLO PICASSO

Picasso was right. Usually the questions in our lives are more interesting than the answers. But when it comes to your digital photographs, you want and need answers — to questions about restoring old photos, repairing damaged prints, creating original artwork to compliment your digital images, just to name a few. Adobe Photoshop Elements provides answers to these questions in the form of its very powerful set of tools, palettes, and options. In this chapter, you discover how to display and customize these tools, palettes, and options; identify those that pertain to restoration and retouching, and the other jobs you have to do; and how to get the help you need when you find that you have more questions than answers.

Understanding Photoshop Elements' Workspace and Tools

The Photoshop Elements' workspace is both structured and free-form. Its default configuration (1.1)

can be manipulated, expanded, and enhanced to meet your needs for different tasks and different types of images, but leaves the key features on-screen at easy reach for your most commonly-performed commands and activities.

● 1.1

3

The workspace is made up of six sections:

- The **toolbox** (1.2) contains 24 buttons and a set of color controls and offers selection, painting, cloning, retouching, fill, zoom, and navigation tools. Buttons with a triangle in the lower-right corner contain alternate tools, such as a variety of erasers or free-form selection tools. To see the alternate tools, click and hold the button down for a second (you can also right-click if you are a PC user). The other buttons appear in a small fly-out toolbar (1.3).
- The **options bar** (1.4) varies, depending on which toolbox tool is selected at the time. Options come in the form of drop-down lists

and check boxes, each controlling how the selected tool works. You can move the options bar down into the open area of the workspace if you drag it by its handle, located at the far-left end of the bar.

- The **menu bar** (1.5) doesn't hold too many surprises in terms of functionality — the commands that require further interaction from you are followed by an ellipsis (...). Select these tools and a dialog box with further options open. Lack of an ellipsis indicates that the command causes something to happen automatically — important to keep in mind if you're not sure what that will be. You can "undo" anything you've done, however, by choosing Edit → Undo, or using the

● 1.2

● 1.3

Undo History palette, which I discuss later in this chapter. Note also that keyboard shortcuts appear in the menus as well.

[NOTE]

The Edit → Undo keyboard shortcut is listed as Alt + Ctrl + Z (Option + Command + Z for Mac users), but the old standby, Ctrl + Z (Command + Z for Mac users) works, too.

- The **shortcuts bar** (1.6) offers tools for common file-management and related tasks — opening files, saving them, importing, printing — and also provides access to two very handy features: Quick Fix and Color Variations, which

are discussed in more detail in Chapter 3. As the name implies, the shortcuts bar simply exists to put the tools for things you do often right at your fingertips.

- The **palette well** (1.7) houses eight tabs, each representing a different palette. You can display the palettes by clicking the tabs, and then as desired, drag the palettes down onto the workspace. Just drag the palette by its tab and release (1.8). After being freed from the palette well, the palette has its own title bar and a More button, which provides commands pertaining to the palette's function and the portions of the image the palette controls.

● 1.4

● 1.5

● 1.6

● 1.7

● 1.8

• The **palettes** (1.9) appear in two places in the default workspace configuration. Eight live on the palette well, and two (Hints and How To) live in the open workspace area. Why have these two been freed from the palette well? Because they offer help for whatever tool becomes active as you work, and they need to remain open, displaying that help, without your doing more than scrolling to read text that doesn't fit to display within the palette's default dimensions. You can bring down the eight palettes that live in the palette well into the workspace, and you can resize as needed.

These six sections work together to provide and support all the tools you need to perform virtually any restoration or retouching task in Photoshop Elements. There are manual, brush, and pointer-based tools for making selections, applying color and effects by hand, or filling shapes. There are automatic tools that adjust color and lighting qualities for you, based on the content of your image. There are also dialog boxes and other interactive tools that enable you to make adjustments by eye, achieving the results you had in mind, using what's at hand.

[T I P]

Photoshop Elements also offers a full set of preferences that enable you to customize your environment, tools, and display settings. You find out more about the Photoshop Elements Preferences later in this chapter.

● 1.9

Working with the Toolbox

Activating toolbox buttons is a simple matter of clicking on them. After you do so, the tool becomes active and its optional settings appear — you guessed it — on the options bar. You can find the name of any tool by hovering over the tool with your mouse for a few seconds. At that point a tool tip appears, identifying the name of the tool and its keyboard shortcut (1.10).

You can move the toolbox around on the workspace, dragging it out of the way if it's obscuring part of the image window, or moving it in close if you are working between two or more tools frequently. The keyboard shortcuts (shown when you point to a tool with your mouse and listed in Table 1.1) help you to select tools and switch between related tools quickly. This makes tools that are typically used in tandem easier to navigate. For example, you can switch between the Brush and Eyedropper tools to change colors easily after you begin painting — all by pressing *I* to activate the Eyedropper, and then after sampling a color (selecting a color with your mouse), pressing *B* to activate the Brush. You can then apply the sampled color. When you're working in close on a photo that needs retouching, not having to stop and grab the mouse to change tools can be a huge help.

Not all of these shortcuts are based on an obvious pneumonic device — B for Brush is easy to remember, but Q for Sponge? Probably not. The more you use them, however, the more you are able to recall them when you need them. The key pairs — the Eyedropper and Brush, or Hand and Zoom, are easy to remember because you use them together.

[T I P]

Click the sunflower graphic at the top of the toolbox to go directly to Adobe online (www.adobe.com) — assuming you're connected to the Internet at the time.

As stated earlier, several of the toolbox buttons are home to more than one tool. When you see a small triangle in the lower right-hand corner of a button,

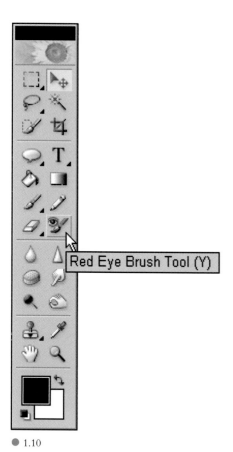

● 1.10

that's your indication that you can access additional buttons from this tool. To display the alternates, either click and hold your mouse down on the button for a second, or if you are a Windows user, you can right-click the button. The alternate tools appear in a small menu, and you can choose the one you want to use, at which point, until you close Photoshop Elements and reopen it later, the newly-selected tool is the one seen on that particular button's face.

Using the Options Bars

Each tool in the toolbox has its own set of options — settings that enable you to control how the tool works. Each of the settings has a default built in, and for many of your images, the defaults work just fine, as these settings are established with an average image in mind. You will need to make adjustments from time to time, however, and doing so is really quite simple (1.11).

Another aspect of the options bars that makes them easy to deal with is the amount of repetition. Every brush-based tool — the Brush, Smudge, Dodge, Burn, Sharpen, and Blur tools — all require you to establish a brush size, and you can choose from the same set of brush style and shape options when any of these tools are active (1.12). Tools that change the content of your image — sharpening or blurring, erasing, smearing — have a Strength setting so that you can choose how dramatic an effect the tool will have. This consistency between related or similarly-behaving tools helps you concentrate on the tools and spend less time figuring out how to customize them.

● 1.11

● 1.12

TABLE 1.1 KEYBOARD SHORTCUTS

SHORTCUT	TOOL ACTIVATED
M	Rectangular and Elliptical Marquee tools
V	Move tool
L	Lasso tool
W	Magic Wand tool
A	Selection Brush
C	Crop tool
U	Custom Shape tool
T	Horizontal or Vertical Type tool
K	Paint Bucket
G	Gradient fill tool
B	Brush
N	Pencil
E	Erase
Y	Red Eye Brush
R	Blur tool
P	Sharpen tool
Q	Sponge tool
F	Smudge tool
O	Dodge tool
J	Burn tool
S	Clone Stamp tool
I	Eyedropper tool
H	Hand tool
Z	Zoom tool
X	Switch the Current Foreground and Background Colors
D	Return to the Default Foreground and Background Colors

[T I P]

The Hand tool does not have any options. When the Hand tool is selected, the options bar displays view option buttons instead – you can choose Actual Pixels, Fit On Screen, or Print Size.

Using Tool Presets

Photoshop Elements offers presets — pre-existing groups of tool settings — that you can apply to any tool to make quick, global changes to the way the tool works. After you apply the tool preset, say a textured brush of a certain size, you can further tweak the way the tool works by adjusting the brush size, shape, and choosing a color and mode for the brush.

To view the presets for the Brush tool, click the Brush Presets drop-down list and scroll through it. You can click the Brushes drop-down list within the presets list (1.13) and choose from a new group of presets.

Creating Custom Brush and Fill Presets

You can also save new brush presets by making adjustments to the size, shape, style, and opacity settings for an existing preset and saving it with a new name.

To do this, follow these steps:

1. Select a brush preset to serve as the foundation for your new brush.
2. Click the More Options button to access tools for changing the brush shape, spacing, jitter, and other stroke attributes (1.14).
3. Adjust, as needed, the size of the brush and set the Opacity to make sure that the brush, when used, applies the appropriate amount and density of paint.
4. Choose a Mode for the brush if Normal (the default) is not appropriate.
5. Click the Brush Presets drop-down list again and click the options menu button.
6. Choose New Brush from the menu.

● 1.13

● 1.14

7. **In the Brush Name dialog box that appears, enter a name for your new brush.**

Try to choose a descriptive name that indicates the effect that the brush will have, or if it imitates a particular texture or is good for a specific task or situation, make that clear in the name you enter (1.15).

Other presets include gradient fills and patterns, which you won't find as much use for when restoring photos as you would in creating or editing other types of images, such as original artwork that will be used on the Web or in print. Should you have need of a pattern or gradient fill, you can access the existing presets for Pattern fills by clicking the Paint Bucket tool, choosing Pattern from the Fill drop-down list, and then clicking on the then-available Pattern list (1.16). To access the existing presets for Gradient fills, click the Gradient tool and then on the Gradient drop-down list (1.17).

● 1.15

● 1.16

Creating a new pattern or gradient preset is very similar to creating brush presets — choose an existing pattern or gradient, make changes to its settings (Mode, Opacity), and then click the options menu button in the Pattern or Gradient drop-down list. Choose New Pattern or New Gradient, name your preset, and it will always be there to apply to future fills.

[N O T E]

You can make brushes out of shapes by selecting a portion of your image and choosing Define Brush from the Edit menu. Give the brush a name, and you have a completely custom brush that joins the current set of presets.

Using Selection Tools

You can apply most Photoshop Elements tools to an entire layer in an image or to a selected area within a layer. In order to apply a tool to the desired amount of your image, you have to make the selection before invoking and using the tool. Photoshop Elements offers three main types of selection tools and a total of seven individual tools:

- Rectangular Marquee
- Elliptical Marquee
- Lasso
- Polygonal Lasso
- Magnetic Lasso
- Magic Wand
- Selection Brush

How do you know which selection tool to use? There's no hard and fast rule. Let the situation be your guide. If you need to select a big area, the Marquee tools might be good, or you may prefer the free-form capabilities of the Lasso tools. If you want to restrict your selections to only pixels of a certain color, the Magic Wand is your best bet. The most effective way to learn how to use the selection tools is to use them, and through that use, you'll find which situations warrant which tool, and how to customize them for any selection job you run into.

[T I P]

Need to select a very small area? Zoom in first! One of the most-forgotten and underused tools is the Zoom tool, and people often torture themselves needlessly trying to select and/or edit a small area of their image without zooming in. You can zoom in with the Zoom tool (found in the toolbox), the Navigator palette (see its tab on the palette well), or the Zoom status box in the lower-left corner of the Photoshop Elements workspace.

Making Marquee Selections

The Marquee selection tools enable you to select rectangular or elliptical-shaped areas by clicking and dragging your mouse (1.18). You can constrain the shape to a perfect square or circle by holding the Shift key as you drag — be sure to release the mouse before the key, though, or the shape snaps to the dimensions it would have been without using the Shift key at all.

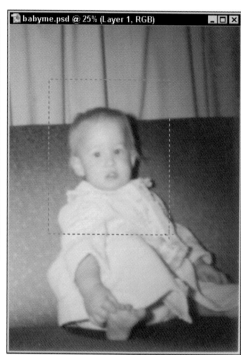

● 1.17

● 1.18

After you've drawn your selection, you can move it if you point to the dashed border and watch for your mouse pointer to change to an arrowhead with a box next to it (1.19). When your mouse displays this particular pointer, you can move the selection without moving the content within the selection.

● 1.19

Selecting Free-form Shapes

The Lasso tools and the Selection Brush give you complete freedom to select any shape of any size, anywhere in your image. Bound only by the accuracy of your mouse-moving skills, you can draw around an object to select it, along an edge, between two objects, or anywhere you want to select (1.20).

The Lasso tool has two variations that give you more control without losing the ability to make free-form selections — the Polygonal Lasso, which allows you to select free-form, yet straight-sided, shapes with any number of sides (1.21) and the Magnetic

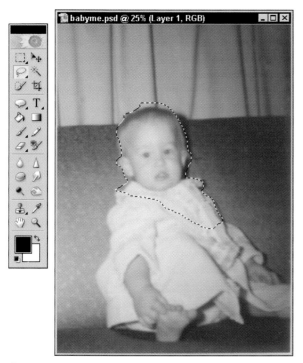

● 1.20

● 1.21

Lasso, which follows edges within your image to help you isolate specific objects (1.22).

The Selection Brush lets you select by painting brush strokes, anywhere on your image. You can set the size of the brush, which determines the width of the selected stroke area (1.23). By dragging and crossing over existing portions of the selection-in-progress, free-form areas can be selected with the ease of painting — something some people prefer to use the Lasso tool, which requires a greater degree of eye-hand control with your mouse or other pointing device.

Selecting by Color and Light Levels

The Magic Wand gets its name from the way it works — you click with the mouse on a single pixel or group thereof, and abracadabra! All the pixels of the same color are selected (1.24). You can augment your selection by using the Shift key and continuing to click around on the image, gathering more and more pixels with each click, and you can free the tool

to select non-contiguous pixels by removing the checkmark next to the Contiguous option on the options bar (1.25).

After the pixels are selected — with the Magic Wand or any other selection tool — you can delete them, paint over them, move them, cut them, or copy them to another spot in the same photo or to another photo entirely.

[T I P]

Want your color-based selection to span all of your layers? Turn on the Use All Layers option, found only with the Magic Wand tool.

Adding to, Subtracting from, and Intersecting Selections

Whichever selection tool you use — the Marquee tools, the Lasso tools, the Selection Brush, or the Magic Wand — you can manipulate your selection

● 1.22

● 1.23

through the use of four buttons found on the options bars for each of the selection tools (1.26). From left to right, the buttons are

- **New Selection.** This is the default mode, and if you leave this on, each click of the mouse (without the Shift key, which always allows you to add to an existing selection) starts a brand new selection.
- **Add to Selection.** Use this selection option to augment a selection. You can switch to a different selection tool, thus combining, say, a square and a

free-form amoeba shape, or just keep selecting with the same tool (1.27).

- **Subtract from Selection.** You can create interesting shapes with this selection option in effect, carving out from the middle of a selection, creating a frame effect (by selecting a smaller square within a larger one), or by shaving off rectangular or free-form bits of an existing selection to

● 1.26

● 1.24

● 1.25

● 1.27

create a brand-new shape (1.28). This selection option is also useful if you made a mistake while using the Lasso, Selection Brush, or Magic Wand tools. You can select the area that was inadvertently included in the first selection, and it is removed from the overall selection.

- **Intersect with Selection.** This selection option turns the portion of two overlapping selections into the selection. You can create semi-circle selections, pie-wedge selections, and a wide variety of free-form shapes by intersecting any combination of selections made with any combination of selection tools (1.29).

Identifying Restorative Tools

Photoshop Elements is a spin-off of Adobe Photoshop, which was designed for retouching photos. Therefore, most, if not all of the tools have some retouching or restorative function. Photoshop Elements is expanded to include tools for more creative original artwork and to support designing Web pages and graphics bound for the Internet, but the core set of photo retouching tools remain, which are listed in Table 1.2.

These tools are part of the original set of tools you find in Photoshop. Add to that the Red Eye Brush and the Quick Fix command, and Photoshop

● 1.28

● 1.29

Elements has a few tricks up its own sleeve. Of course, the Brush and Pencil tools are always used in any restoration or retouching project. Their role is not simply to paint or draw color onto an image, as their blending Mode settings allow them to do much more, including increasing or decreasing the amount of color and light and adjusting the opacity of existing content.

Sharpening and Blurring

The Sharpen and Blur tools add and remove focus, respectively. They do this by heightening the diversity between adjacent cells (Sharpen) and reducing diversity (Blur). If you have a photo that was slightly out of focus to begin with, or one that has faded over time resulting in a loss of detail, these tools can bring back the focus by adding the details back (1.30), or by taking them away from non-essential content (1.31), leaving only what's important to capture the viewer's attention.

To use the Sharpen and Blur tools, you need to set your brush size and the Mode and Strength. There's also an option called Use All Layers (1.32), which enables you to make your blurring or sharpening affect the entire image, not just the layer active at the time. The options bars for both tools are nearly identical — the button image on the far left (identifying the active tool) is all that's different.

[C R O S S - R E F E R E N C E]

In Chapter 3, you can find out all about the various brush blending Mode options that you have at your disposal when using a brush-based tool, such as the Sharpen and Blur tools, or, of course, the Brush and Pencil tools. The blending Mode you choose for any tool that manipulates individual pixels in an image can be set to adjust color, contrast, lighting, shades, hues — any quality you might want to change.

● 1.30

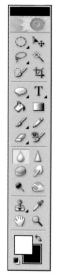

● 1.31

● 1.32

TABLE 1.2	RETOUCHING TOOLS	
Sharpen		
Blur		
Smudge		
Dodge		
Burn		
Clone Stamp		
Eraser		

After you set your options for the degree of sharpening or blurring that you want to occur (Strength) and how big a brush you're going to use to apply the effect, you're ready to start changing the focus in your image. You may need to use both tools in an image, sometimes using them both in the same area. You can use the Blur tool for artistic effect (1.33), blurring content to a point where it's nearly unrecognizable, if that's what you want to do. (This can really make one central element stand out.) Usually, however, the Sharpen tool is used to subtly bring out details (1.34), as overuse of the Blur tool can still be interesting, but overuse of the Sharpen tool can have disastrous results.

[N O T E]

Photoshop Elements also includes Blur and Sharpen filters, which apply a uniform degree of blurriness or sharpness to the image or a selection within it. Chapters 8 and 10 discuss and demonstrate filters.

Adding Light and Dark

The Dodge and Burn tools are another complementary pair of tools. The Dodge tool adds light, and the Burn tool, as its name implies, adds darkness. These, like the Sharpen and Blur tools, are brush-based — you apply them with your mouse after selecting the size and style of the brush to use and adjusting the degree of dodging or burning desired (1.35).

To use the tools, adjust the Range, choosing between Highlights, Midtones, and Shadows as the target areas to lighten or darken and choose the amount of light or dark that you want to add by adjusting the Exposure setting. After these settings (and the Brush size and style) are established, you're ready to drag your mouse around on the image to apply the effects. If you want to control the area affected, make a selection first (1.36).

● 1.33

[T I P]

The terms *dodge* and *burn* are not specific to Photoshop or Photoshop Elements – rather, they're traditional photography terms relating to how photos are exposed during the development process. By "dodging" or "burning," the photographer can control the amount of light and shadow produced in the final printed image, which directly affect the amount of detail and clarity achieved in the image.

Blending

The Smudge tool's keyboard shortcut is the letter F — and you can easily remember this by remembering what the Smudge tool does and by looking at its button face. The Smudge tool is a finger-painting tool, enabling you to achieve the same effect with your mouse that you'd get if you were blending colors in a pastel or chalk drawing with your fingertips. The "paint" that makes up your photo's content can be blended subtly or smeared dramatically, and you can literally turn on the Smudge tool's Finger Painting option (1.37) if you want to add the current Foreground color to your smudges.

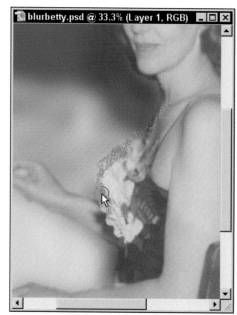

● 1.34

● 1.35

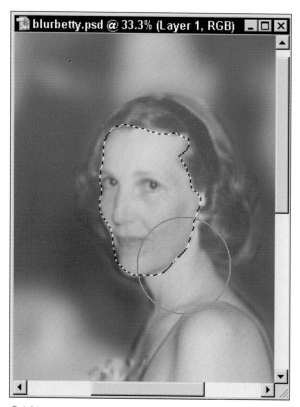

● 1.36

● 1.37

Obviously, the Smudge tool is a great choice if you want to soften an edge or blend two areas together. It's also great for smoothing out wrinkles, raising cheekbones, or wiping away small blemishes (1.38). The size of the brush you choose determines your results — if you pick a big brush, your smudge will alter shapes and contours in the image (1.39), and if you choose a small brush, you can make subtle changes and use the tool as more of a makeup or cosmetic effects tool.

Another setting you can adjust when using the Smudge tool is Strength. This determines the pressure with which your "fingertip" presses on the image, and how much of the content is smudged with each stroke of your mouse. A low percentage gives you subtle results, and a high percentage gives you more dramatic effects. Feel free to experiment until you find the right setting for your specific needs in each photo.

Cloning

Clones are exact duplicates of an original, presumably created because the original is so valuable that we wish we had more than one. Photoshop Elements' Clone Stamp tool enables you to clone an area within your image and paint that cloned content over another area — covering up unwanted content or damage, or augmenting a photo with more of something good (1.40).

The tool's options include brush Size, Mode, Opacity, and an option called Aligned (1.41). This last option enables you to control where the cloned content comes from — an original spot in the image and nowhere else, or from spots at a fixed distance from

● 1.38

● 1.39

the brush as you continue to paint over the unwanted or damaged content. If Aligned is on, that fixed distance is maintained, and the cloning process is repeated as you move around, painting. If you leave it off (the default), your original cloned content is applied over and over again.

Unlike the other tools in Photoshop Elements' toolbox, the Clone Stamp requires the use of a key on your keyboard to make it work. When you *sample* (click on to select) the area to be cloned, you must press the Alt key (Option on a Mac) to tell Photoshop Elements "I want to clone this spot here." With the Alt/Option key pressed, the next spot you click on will be cloned. Then you release the key so that you can begin applying the cloned content, clicking to apply it once or dragging to apply it in strokes. You can click and drag as many times as you want, based on a single sampled spot.

Erasing

An obvious choice for any retouching or restoring tools list, the Eraser comes in three flavors — the standard Eraser, the Background Eraser, and the Magic Eraser. Between these three tools, you can easily get rid of any content in your image, restricting your erasure to a selected area, a single layer, or using it simultaneously on all layers. You can erase everything in the mouse's path (the standard Eraser), all of the similarly-colored pixels on an entire layer (the Magic Eraser), or only the background pixels, determined by your sampling spot with your mouse (the Background Eraser). Erasing can be performed to get rid of a stain, rip, tear, or other unwanted content, or it can pave the way for content that's on an underlying layer to be visible through a layer above it (1.42).

[T I P]

While it might seem like a logical thing to do, don't use the Eraser to get rid of something you've added to the image, such as a line or shape you drew or painted on to replace missing content or a fill you applied to a framing area around the image. When there's something that you added that you want to get rid of, use the Undo History palette or the Edit → Undo command. If the element you added is no longer "undo-able," try hiding or removing the layer it's on — provided you placed the new content on its own layer, which is the best approach when you're adding content to a photo.

● 1.40

● 1.41

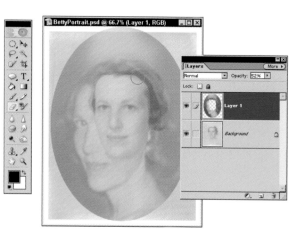

● 1.42

Removing Red Eye

One Photoshop Elements tool you won't find in Photoshop is the Red Eye Brush. The Red Eye Brush removes that demonic glow that appears when your camera's flash bounces off the subject's retina. It's very common in pictures of dogs and cats, whose pupils are much larger than a human's (1.43). It can happen to people, too, especially if they were very close to the camera when the picture was taken, or if there wasn't adequate lighting in the room. Red-eye rarely, if ever, appears in photos taken outdoors, as there is enough ambient light to eliminate any flash-caused problems.

The Red Eye Brush works by replacing the current glow in the subject's pupil with a default or user-defined color. The tool's options bar (1.44) enables you to choose the brush Size (which should be the approximate size of the offending pupil or glowing

● 1.43

area within it), the Current and Replacement colors for the red eye area, a Sampling method (First Click or Current Color), and a Tolerance setting, which enables you to determine how effective the replacement will be. The Tolerance setting is sort of a threshold control — a high Tolerance means that more pixels in the area you click with the Red Eye Brush will be replaced with the Replacement color, and a low Tolerance means fewer pixels will be replaced.

[CROSS-REFERENCE]

Chapter 4 covers a complete discussion and demonstration of the Red Eye Brush.

Working with Palettes and Controls

Palettes are small boxes that contain information and settings that you can use to control how tools work, which parts of your image are affected by commands and tools, and which parts of your image are visible. A total of eight such palettes are found in the Photoshop Elements' palette well, plus two more palettes that offer help and guidance that are open on the workspace by default.

The palettes in the palette well appear in order:

- **Filters.** This set of special visual effects tools may or may not come in handy when you're retouching a photo. If you want to create an interesting, yet not terribly realistic effect, such

● 1.44

as the look of your photo being viewed through rippling water or under glass, you can find a filter to give you that effect. If you want your photo to look like a drawing or painting (which can be a clever way to salvage a photo with so many problems you don't feel up to restoring it), you can choose from a variety of artistic filters representing several different artists' mediums (1.45).

- **Effects.** Very similar to the Filters palette, the Effects palette offers a list of special effects that can be applied to layers or type. The Effects have illustrative names, such as Brushed Aluminum, Cold Lava, and Lizard Skin, and are generally applied without your having to use a dialog box to control the results. If you view the Effects as a list (click the List View button at the bottom of the palette), you can see which of the Effects is for Type and which ones are for Layers (1.46).

● 1.45

● 1.46

- **Layer Styles.** With more than a dozen styles to choose from (1.47), you can achieve just about any look for your individual layers and their content. You can choose from drop shadows, beveled effects, plastic or chrome coatings, diverse patterns, and natural textures.
- **Swatches.** The Swatches palette (1.48) works a lot like the rack of paint chips at the hardware store, except that the swatch sets can be changed, and you have seven different sets, in addition to the default set. By displaying a set of swatches, you give yourself the ability to choose a new Foreground color (click once on a swatch with the mouse) or Background color (press the Ctrl key and click on a swatch), and to view the names of individual colors before choosing them. Three different sets of swatches help you pick colors that are appropriate for use on the Web, and several sets cover you if you're going to be printing your image through a PC or a Mac.

● 1.47

[T I P]

On a Mac, you can set the Background color by pressing the Command key as you click your mouse on a swatch.

- **Undo History.** This palette displays a list of the steps that have been performed on the image because it was opened in the current editing session. You can undo a series of steps, in reverse chronological order, by clicking on the last step that you want to remain in force — at that point, everything done after that will be undone. You can undo your undo, by clicking on steps that you've undone, bringing back all the steps between the oldest and most recent steps you've clicked. When steps have been undone, they dim and their descriptive text becomes italicized. When you click on a step to say "Take things back to this state," that step becomes highlighted in blue (1.49).

[T I P]

Want to go back to the very beginning? Click the Open state, which is the first one in the palette. You can also get rid of all the subsequent steps so that they cannot be redone by accident. To do so, click the More button or right-click on any step listed in the palette and choose Clear Undo History.

- **Navigator.** Use this palette to adjust your magnification (Zoom) and choose which part of the image is visible within the image window. The latter functionality only applies if the image is larger than the current size of the image window — if there are no scroll bars, which indicates that the entire image is visible within the window, then you cannot pan. If there are scroll bars, you can pan, and you can use the Navigator palette's thumbnail of the image (drag the red box) to choose which part of the image appears within the frame of the image window. To adjust the Zoom, drag the slider (1.50) to the

right to zoom in or to the left to zoom out. You can also click the Zoom In and Zoom Out buttons on either side of the slider.

[T I P]

You can also type a zoom percentage into the small text box in the lower-left corner of the palette to zoom to a particular size.

● 1.48

● 1.49

- **Info.** Need to know what levels of Red, Green, or Blue are in a particular pixel in your image? Click on that pixel with the Eyedropper tool, and the RGB levels appear in the Info palette (1.51). Need to draw a Marquee rectangle that's exactly 1.25" x 2.75"? Watch the W (width) and H (height) measurements as you drag, releasing the mouse when the right dimensions are achieved. In general, you can use the Info palette to get statistics on any tool that draws or selects

● 1.50

● 1.51

content or that applies color. The X (horizontal position) and Y (vertical position) coordinates tell you where on the image your mouse is as you point, select, paint, blur, smudge, sharpen, or do anything where your mouse moves over the image.

- **Layers.** A scanned photo or image taken with a digital camera and imported into Photoshop has a single layer called *Background*. When you add content, you hopefully place it on a new layer, which is named *Layer 1* by default. When you want to adjust the color and lighting in your image, you can create an adjustment layer, which is named for the effect you choose to apply via that layer (such as Brightness and Contrast). When you bring in content from another image, or if you copy content from one location to another in the same image, a layer is automatically created. When you use the Type tool to add text to your image, a Type layer is created. All of these actions create layers in an image, and it is through the Layers palette that you select, hide, display, duplicate, rename, and delete these layers (1.52).

[N O T E]

Throughout the rest of the chapters in this book, you find several ways to utilize the Layers palette to your advantage, as it's one of your most powerful allies in the retouching process if you use it properly. When you add anything to the image, put that new content on its own layer – this enables you to hide your additions individually, choosing whether or not to keep them or to print them in certain versions of your image. You can also link two or more layers so that their content is moved in tandem, and you can drag layers from one image to another, instantly sharing content.

Displaying the Palettes

To open any of the palettes in the palette well, simply click the palette's tab (1.53). You can then drag the palette onto the workspace if you want to, or you can leave it attached to the palette well, which means it closes when you're not using it. If you drag it onto the workspace, it remains open until you close it. To close it, click the Close (X) button in the upper-right corner of the palette.

● 1.52

Using the Palette Well

You can set any palette that's been dragged onto the workspace so that it will return to the palette well after you close it. This makes it easy to use a palette and keep it open and close by while you need it, but then get rid of it in one click when you no longer require its features. To send your palette back to the palette well, click the More button and choose Close Palette to Palette Well (1.54). Then, click the Close (X) button in the upper-right corner of the palette — the palette goes back to the well, with only its tab showing as it awaits the next time you need it.

● 1.53

● 1.54

[TIP]

You can change the order of the palette tabs in the palette well by right-clicking them (or by Control + clicking if you're on a Mac) and choosing from the rearrangement commands: Move to the Left, Move to the Right, Move to the End, and Move to the Beginning. This makes it possible to put them in an order that makes sense to you, based on use perhaps, or alphabetical order.

Setting Relevant Preferences and Color Settings

Photoshop Elements provides a comprehensive set of tools for customizing how the application works in general, and how individual images appear. You can also customize how you access tools, how you interact with them, and how you save your files. Everything from how your transparent background layer looks to whether or not certain keyboard shortcuts work is customizable through the Edit → Preferences submenu (1.55).

● 1.55

[T I P]

As soon as you choose one of the Preferences submenu items, the dialog box for the selected group of preference settings appears. Within it, there are Prev (previous) and Next buttons that you can use to access the rest of the Preferences dialog boxes — no need to close one and go through the whole Menu → Submenu step sequence to open another Preferences dialog box.

Setting General Preferences

The General Preferences dialog box (1.56) enables you to choose how the basic elements of the application work. You can choose which Color Picker you want to see — Photoshop Elements' own, called "Adobe" (1.57), or a Windows version (1.58). Note that if you're on a Mac, "Mac" appears in the drop-down list instead of "Windows." Why would you want a choice? Because you may be used to working with the color-selection tool provided by your operating system, and may therefore find it easier or faster to work with. It's probably wiser to work with Adobe's Color Picker, however, as there are more tools and color palettes available inside it for selecting and tweaking colors.

Through the General preferences dialog box, you can also choose which keys take you backward a step and forward a step. The default setting is Ctrl/Command + Z (Undo) and Ctrl/Command + Y

(Redo), but you can choose variations on these two that include the Shift and Alt/Option keys if you've already assigned those shortcuts to something else. Your Print shortcuts can also be set, and you may want to change from the defaults (Ctrl/Command + P = Print with Preview, and Ctrl/Command + Alt/Option + P = Print) so that the simpler shortcut (Ctrl/Command + P) gives you the simpler Print dialog box and gets the job done without making you look at a Preview first. If you find that most of your print jobs benefit from having seen the Preview first, then by all means, leave the default in place.

● 1.57

● 1.56

● 1.58

[T I P]

Mac users should replace Control (Ctrl) with Command and Alt with Option in any of the shortcuts discussed in this book.

One other important preference set through this box — one that may be of particular interest to people retouching photos — is the Save Palette Locations option. On by default, this option means that Photoshop Elements saves information about how and where your palettes were displayed when you exit the program. By saving this information, you make sure that the next time you open Photoshop Elements, the palettes are in the same places and at the same sizes that you left them. If you've painstakingly arranged them to facilitate your photo restoration project, this can be a serious convenience and timesaver, helping to keep all your tools where you need them and to keep the workspace set up for your specific needs.

Customizing File Management Tools

When you open the File menu, one of the commands is Open Recent. This command spawns a submenu of the most recently-used files, and lists the last 10 files by default. You can use the Saving Files preferences dialog box (1.59) to reset this number of files to as few as 0 or as many as 30.

In addition, you can choose whether or not you'll be prompted to include layer information when saving files in the TIF format, and how broadly compatible your PSD (Photoshop) files will be with other applications. You can also choose whether or not to save image previews (useful if you want to use the Print with Preview command) and whether or not to use lowercase letters for the extension on file names.

You may not ever tinker with these settings, as they're not terribly important to the restoration or retouching process — with the exception of the TIFF layers option. Leaving that one turned on is a good idea as you may need to edit the TIFF file later and will want any layers and their content to be preserved.

Choosing Display and Cursor Settings

The Display & Cursors preferences dialog box (1.60) enables you to choose how your mouse or other pointing device looks while certain tools are in use.

Your Painting Cursor preference choices are

- **Standard**, which makes the pointer look like the tool that's in use, such as a paint Brush, a Pencil, or a finger used to Smudge the image
- **Precise**, which makes all cursors look like a crosshair
- **Brush size**, which displays a circle that is the same pixel width as the size brush you selected

● 1.59

● 1.60

I tend to work in Brush Size, but sometimes Precise is good if you want to see the center of your brush, which is represented by the center of the crosshair. This is a good choice if you're sampling individual pixels or doing very, very fine editing, down to the pixel level. Standard is a good choice if you want to be able to tell by looking at your mouse which tool you're using. Many of the images in this book were captured with Standard cursors in use, for just that reason — so that you can tell when I was painting versus erasing versus smudging.

Your Display preference is whether or not you want to employ a practice called *pixel doubling*. This simply speeds up the rate at which images display, causing Photoshop Elements to reduce the resolution of the image display by half. This doesn't affect the file itself, just how it is composed as it's opened or reopened on-screen.

Selecting the Appearance of Transparency

If your Background layer is transparent, you may want to be reminded of that by having it appear as a checkerboard pattern behind your other layers. This can be handy if you erase content on a layer above the Background, so that you know you've erased to a transparent state. The Transparency preferences dialog box (1.61) enables you to choose how that checkerboard is configured — the color of the grid and the size of the blocks.

[T I P]

The default setting for a transparent background is a light gray grid set to Medium size.

Working with Rulers and Units of Measure

If your images are bound for the Web, you may want to measure them in pixels, which will help you to design them with your page dimensions and the spots preserved for individual images in mind. On the other hand, if your images are to appear in print, you may be more comfortable seeing them measured in inches — as your paper and any frames or display medium is measured in inches, too. Of course, if you're in Europe, metric measurements are preferable.

Regardless of your measurement preferences, the Units & Rulers preferences dialog box (1.62) gives you the ability to choose the default measurement for both images and type and to choose the default resolution for new, blank images — both the screen resolution and the print resolution.

[T I P]

You can also set the default Column Width, which is used by some layout programs to specify the display of an image across columns. The Image Size and Canvas Size commands also refer to this setting.

● 1.61

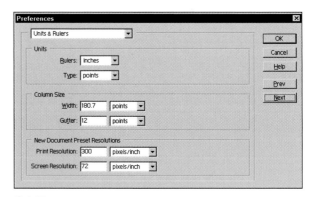

● 1.62

Customizing and Using the Grid

For the purpose of moving and resizing image components on individual layers (which they must be, if you want to move them independently), Photoshop Elements provides a grid, and by default, your content snaps to that grid, making it easier to move things and have them line up relative to each other or to the edges of the image. In the Grid preferences dialog box (1.63), you can set the color, style, frequency, and number of subdivisions in the grid. Of course, in order to see the grid after you tinkered with its settings, you must choose View → Grid, which displays the grid across your image (1.64). Don't worry, the grid doesn't print — it just helps you position things, and can be turned off if you no longer want to see it — just choose View → Grid again to toggle it off.

Getting Help, Taking Hints, and Following Recipes

Photoshop Elements was designed to provide Photoshop's power in a somewhat more digestible form for small businesses, home users, and the growing number of people who are called upon to edit and restore photos, yet don't have strong backgrounds in photography or digital imaging. For this reason, unlike Photoshop, Photoshop Elements offers a variety of on-screen help and instructional features:

- Hints
- How To
- Recipes

You also have access to Photoshop Elements' Help files, which are accessed through (of all places) the Help menu. These files are similar to any other application you may have used, and they appear within a

● 1.64

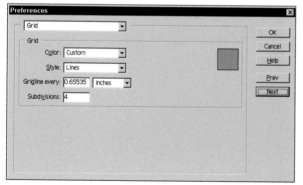

● 1.63

browser window (1.65), and you can Search them by keyword, comb through an Index, or view a topic-based Contents format to find the help you need.

Working with Hints

Open on the workspace, rather than appearing as a tab in the palette well, the Hints tab offers context-sensitive help for whatever you're working on at the time. If you click on a particular tool, hints for how to use it appear in the palette (1.66).

As you scroll through the content that appears in the Hints palette, you find hyperlinks (blue, underlined text) that if clicked, take you to other Hints information. This is sort of a *see also* system, such as you'd find in an encyclopedia to help you find information related to the information currently being viewed.

[T I P]

If you don't find the Hints help to be helpful enough, you can access the actual full-fledged Help files by choosing Search from the More button's menu in the palette. The Help browser window opens in Search mode, awaiting your keywords.

● 1.65

Following How To Instructions and Recipes

Unlike the Hints palette, which responds to your actions in the toolbox, the How To palette requires input from you in the form of a selection from the Select a Recipe drop-down list (1.67). Upon displaying the list, you can choose from a series of activities — everything from Designing Web Graphics to Retouch Photos. When you make a choice, the instructions for performing tasks related to the Recipe you chose are displayed in the palette in the form of a series of hyperlinks (1.68). To access a particular Recipe, click the link that describes the task you want to perform or the area of Photoshop Elements you want to explore.

● 1.66

[TIP]

The How To palette has Home, Back, and Forward buttons at the top, enabling you to go back to a generic view that displays no particular recipe or to move backward and forward through the recipes you viewed in the current session.

The Big Picture

In this chapter, you took a tour of the Photoshop Elements workspace, tools, menu bars, and palettes, seeing where things are, how they work, and specifically, which tools and features play a big role in your restoration and retouching efforts. All of these tools are covered in detail elsewhere in the book, where they're discussed in relation to a specific restoration or retouching task. In the next chapter, you read about scanning — everything from installing a scanner and its software to scanning images for use in print or online, and how to make sure that you start with the best possible image.

● 1.67

● 1.68

Scanning Your Original Photographs

Come quickly. You mustn't miss the dawn. It will never be just like this again.

GEORGIA O'KEEFFE

While no two sunrises are the same, one that is captured on film can be viewed over and over again, enabling you to experience its uniqueness whenever you look at the picture. Of course, looking at a picture of a sunrise is not the same as viewing it "live" — hearing the birds start their day and smelling the dew still left on the grass — but a picture does save the sunrise for a time when memories may fail us, and when others want to share in our experience. Your photos of anything — people, places, sunrises, sunsets — were preserved first in your mind, and then preserved by taking the picture with your camera and having your film developed and printed.

To make sure that this tangible evidence is preserved forever, you can lock your negatives in a vault somewhere, or place your printed original in a frame, hung somewhere away from the sun's damaging rays. In addition, thanks to the scanner becoming an affordable fixture in any home or business setting, you can also preserve your photos by scanning them and saving them in an electronic format. This process makes it possible to print many copies of the original, in any size you want, on a variety of papers. It also enables you to tinker with the original, removing signs of wear and tear, improving color quality,

changing the lighting in some or all of the photo, or creating a new vision through the application of special effects. In this chapter, you discover more about the scanning process, and how to make sure that you preserve as much of the detail from your printed photograph as possible, making for beautiful reproductions.

Working with Scanning Devices and Software

Scanners, available for under $200 as of this writing, make it possible to take any printed photo, drawing, letter, report, or even a solid object, such as a hand or plate, and turn it into electronic data. In the case of photos, drawings, or scanned objects, the data becomes a graphic file, something you can open and edit through an application, such as Adobe Photoshop Elements. Reports and letters, if typewritten, can be scanned and then sent through a process called *optical character recognition* (OCR, for short) that converts the image of the text to actual editable text. You can't open the files created through the OCR process in Photoshop Elements, and you don't want to do that anyway — you want to open

35

them in a word processing application, where a full set of text editing and formatting tools await you.

So if text goes to a word processor and images go to Photoshop Elements, what else is there to know?

- You can scan only a portion of an image, creating a new image by preserving only the area that interests you or that will fit within the intended display device.
- You can scan in color or in black-and-white, regardless of the nature of the original.
- You can scan your images at a high resolution, which creates a very large file but preserves as much detail as possible, or you can scan at a low resolution to create a smaller file with less fine detail.

That's just the tip of the iceberg, of course, and the techniques for scanning different types of images, and images intended for a variety of uses, is covered as you read on.

Installing a Scanner

If you don't already have a scanner attached to your computer, you won't be able to use Photoshop Elements to scan just yet — you have to get a scanner, attach it to your computer, and then install the software that came with your scanner. If the scanner is plugged directly into one of the ports on the back of your computer, you may be able to set it up simply by shutting down the system and restarting it, at which point the operating system (Windows, being a "plug-and-play" operating system) sees that a new device is attached and will set up your system and software to work with that device.

[N O T E]

The installation procedures in this section pertain solely to Windows users. Apple users do not have as many steps to set up a scanner, assuming they're using compatible equipment and operating systems. You can obtain support for your Mac and any peripherals (such as scanners) at this address within the Apple Web site at www.info.apple.com.

If Photoshop Elements is on your computer before you add a scanner, the scanner setup process should let Photoshop Elements know that there is a scanner available, and the Import submenu (found in the File menu) gains a new entry — listing your scanner and its software (if you installed the scanner's software) by name (2.1).

[T I P]

If you can't seem to make Photoshop Elements see your new scanner (and you know it's plugged in properly and you installed its accompanying software), you might try reinstalling Photoshop Elements. Uninstall it first, which cleans out any reference to the software within your system and then reinstall. When the installation occurs, the computer "tells" Photoshop Elements about the scanner, and the software is set up to make use of it.

If there is software that came with your scanner, you should install it, especially if you'll be doing any OCR work with text documents. Further, Photoshop Elements needs to open an application to facilitate the scan after you choose scanning from the File → Import submenu. The installation process should be quite simple, and only because each different scanner's software varies slightly do I not enumerate the steps

in detail. Suffice to say, to install your scanner software, insert the CD-ROM into your CD-ROM drive. An autorun program should start, through which you choose to install the software, OK the folder into which the software wants to install itself, and then let the installation program take over. You may be asked to enter your name and a serial number (found on the CD case) for registration purposes, but other than that, it should be a quick and painless process.

[T I P]

Registering your scanner software is a good idea so that you are eligible for any free or low-cost upgrades in the future. The same is true of Photoshop

Elements – if you haven't registered it yet, do so now – registering lets Adobe know you're there, and they can send you alerts for software upgrades, bug fixes, and discounts on software and training. To register your copy of Photoshop Elements, go to www.adobe.com.

Scanning Color Images

After your scanner and its software are installed, you're ready to go. All you need is a photo placed face-side down on the scanner's plate (the large pane of glass), preferably placed with its top against the edge of the plate so that you know the image isn't crooked. The rest of the process varies slightly with different scanning software packages, but remains simple:

1. Choose File → Import → From Scanner (or choose your scanner software by name from the submenu).

[N O T E]

The exact wording of this submenu command may vary and may mention the name of your scanning software.

2. Preview the plate.
3. Select the area to be scanned by using a simple marquee selection tool and your mouse.
4. Choose the type of scan you're going to do – black-and-white or color – and set the quality of the scan.
5. Scan the photo or the selected area within it.
6. Save the image with a new name (replacing the temporary name that the software may have applied).

Pretty straightforward, right? These steps, of course, omit detailed reference to the scan setup process — you find out more about that as situations and their

● 2.1

scanning solutions are discussed throughout this chapter.

Importing Printed Photos into Photoshop Elements

The importing process begins by choosing File → Import. Then, choose the submenu command that corresponds with your scanner. If you have a digital camera, you'll see it listed in this Import submenu, too. Choose the scanner software by name and watch as the scanning software opens on-screen (2.2). For demonstration purposes, the software that came with my Visioneer PaperPort scanner is used, so unless you have the same scanner, your dialog boxes and software views vary.

[T I P]

If you open your scanning software and see an image already in place in the preview area, don't panic – it's just left over from the last time you used the software. When you do a preview scan this time, your image replaces the "ghost" of scans past.

Previewing the Image to be Scanned

After the scanning software is open, you can preview the area to be scanned. This takes a few minutes, as the scanner performs a visual check of the entire plate (the large pane of glass that you place your image on). This is also known as the scanning *bed*. After the preview is complete, the software window should display the image that is placed on the plate (2.3).

[T I P]

When you place your image on the plate, use one or two of the side guides (the frame around the plate, normally calibrated like a ruler) to position the image. By placing the edge of the image flush against the guides, you know your image is straight on the plate. This requires, of course, that your printed image is cut straight. If it isn't, don't worry – you can rotate the canvas in small increments later, after capturing the image and seeing it open as a new file in Photoshop Elements.

Next, you want to focus on the part of the image to be scanned. If you want to scan the entire image,

● 2.2

● 2.3

resize the scanning selection box (2.4) so that it encompasses the entire image, with a tiny bit of the surrounding area. Now you're ready to set up the scan for the image at hand.

[T I P]

If you're scanning a vintage photo that's in a paper mat frame, including the frame in the scan is good – it helps date the image, as the mat usually includes the name of the photography studio that created the image, along with a year, and possibly an address for the studio – telling you and anyone who views the scanned image how old the image is and where it was taken. This can be valuable information if you're compiling family photos and perhaps creating visuals to go along with a family tree.

Setting Up the Scan

After previewing the image and deciding which portion of it to scan, you're ready to tell your scanning software what kind of scan you're doing — color, black-and-white, or grayscale. Your scanning software

may also offer quality options for quick, low-quality scans, or slower, higher-quality scans (2.5). I always choose the best quality scan, despite the time it takes, so that the scanning process gathers the most detail and color information. Remember, you can always reduce resolution later, after editing and manipulating the image.

If your scanning software offers options or advanced settings you can employ to customize the scan, use them — the default settings may be fine, but you may want to increase the scanning resolution or take advantage of some preventative tools to brighten, lighten, darken, or improve the color of the image (2.6).

● 2.5

● 2.4

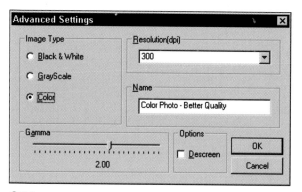

● 2.6

Performing the Scan

After your settings are in place, click the Scan button. The scanner makes one pass over (or actually, under) the plate, and gathers all the information about your image based on the scan type and quality settings you selected. When the scan is complete, the scanned portion of the image appears in a new file window within the Photoshop Elements workspace (2.7). If you have nothing else to scan for now, you can close the scanning software.

[T I P]

Don't be impatient with your scan and cancel out of it if you think it's taking too long. It's rarely a bad thing to scan at a high resolution – even though it produces a large file (several megabytes in some cases) and takes a long time to do the scan itself. You end up with an image that has lots of detail, which gives you more to work with when you're editing the image. If the image is destined for the Web, you can use the Save for Web command (in the File menu) along with the Image Size command (in the Image menu) to reduce the file size after you do all your restoration and retouching.

● 2.7

Keys to Successful Color Scanning

Scanning color images requires, of course, a color scanner. A color scanner can also be used to scan black-and-white images, but the ability to interpret and store color information about the image being scanned is essential. You needn't spend a great deal of money on a scanner — many for under $200 produce high-quality scans that you can use for print and Web work.

When scanning a color image, you're going to end up with a color image that has many of the same problems the original had. If your original was overexposed or too dark, blurry, faded, torn, oddly colored, or presenting any other problems, those problems will follow the image from printed original to scanned electronic version. Fortunately you can mitigate some of the problems by following some of these tips:

- Don't be afraid to use the scanning software's tools for adjusting brightness and contrast (2.8). While you can scan the image as is and make those adjustments later, if you see that making the adjustment through the scanning software makes the preview look better, you're potentially saving yourself some editing time later. If the results are undesirable, you can always rescan without making any adjustments.
- Scan at the highest possible resolution. Yes, this results in very large files, but it also results in images with a great deal of information in them — lots of pixels for you to work with as you repair damage, adjust colors, and correct bad lighting.
- If your scanning software provides it, use a "better quality" or "high quality" setting. This defaults to a higher resolution, and you can increase that manually, as needed.

- Scan directly into Photoshop Elements. If you start your scanning software separately and then have to save the file to another application (such as Microsoft Photo Editor, which may have come with your Microsoft Office software), you'll have to save it and then open it in Photoshop Elements. Avoid any loss of quality or detail that can result, and just use the Photoshop Elements Import command to start your scanning software.

Scanning in Black-and-White

Black-and-white photos aren't really black-and-white — they're actually made up of many shades of gray, and convert to Grayscale mode after scanned into Photoshop Elements (2.9). You can scan in black-and-white mode through your scanning software, or if grayscale is an option, choose that.

If both grayscale and black-and-white scanning modes are available, black-and-white is exactly that — everything will either be pure black or pure

white, and all shades of gray are ignored (2.10). In some applications (PaperPort's software, for instance), this low-quality scan mode is called "Faxing, Filing, or Copying," meaning that the scan quality is just good enough for those purposes.

● 2.9

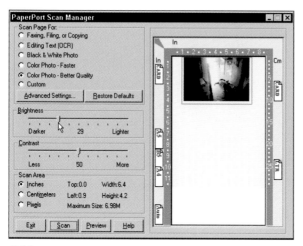

● 2.8

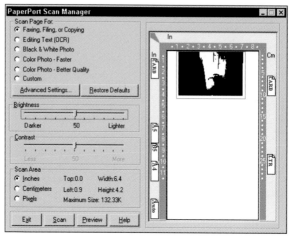

● 2.10

When I scan black-and-white photos, I typically scan them by using a color mode, usually "best" or "high" quality. This has several results:

- The color information enables you to make more interesting use of the Photoshop Elements' tools for lightening, darkening, and saturating the image.
- The grays are warmer, and the image has more visual depth and clarity. For example, take a look at these two versions of the same image, the first was scanned in grayscale (2.11), the other in color (2.12).

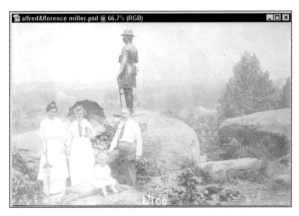
● 2.11

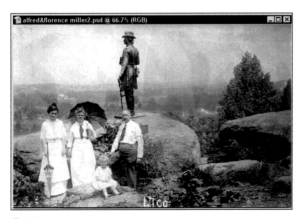
● 2.12

- The image is automatically set to RGB (Red, Green, and Blue) mode in Photoshop Elements, which paves the road for their use on the Web.
- If you want to colorize the image later, by applying a single-color screen or actually giving the image the "Ted Turner treatment," the image is already in RGB mode, which makes available many of the Photoshop Elements' image adjustment commands and tools that would be dimmed if the image were in grayscale.

[N O T E]

One tool that behaves unpleasantly if you don't use it carefully is the Burn tool. If the image is in RGB mode (by virtue of you scanning it in color, even though it's black-and-white), overuse of the Burn tool causes a brown, singed tone to appear on the burned portions of the image. If you scan in black-and-white or grayscale mode, the Burn tool simply darkens the image, applying darker grays.

[T I P]

Want to scan a drawing or a handwritten note or letter? Scan it as you would a photo — in color if there is any color in the image, or if you want to get the deepest and most varied shades of gray in a black-and-white drawing. If the drawing is very simple and cartoon-like with very little shading or solid color fills, you can use the black-and-white mode for scanning, which gives you crisp blacks and whites.

Scanning Old or Damaged Photos

The scanning process picks up everything — scratches, tears, scuffs, spots, and stains — just as well as it picks up the actual desired image content. What it also may do is pick up the three-dimensional aspect of a rip or tear, or where there's something stuck to

the surface of the image, such as you find when photos get wet and stick to each other. Deep scratches and tears also survive the scan, and the edges of the tear or scratch stand out in all their three-dimensional glory (2.13).

Of course, you can get rid of these blights through Photoshop Elements' various retouching and restorative tools, but if you can eliminate some of them prior to the scan, you save yourself some time. Some tips for scanning old or damaged images include the following:

- If the edges of your photo are torn, tattered, or missing altogether, scan an area that includes some space all the way around the image (2.14).

This technique gives you some "elbow-room" to work with around the perimeter of the actual image and also gives you some edge content from areas that are still intact to use as filler for missing content along damaged edges.

- If there are raised scratches or tears in the image, try to press the raised edges down by rubbing over them with the back of a plastic spoon or something similarly rounded and smooth. This eliminates some of the 3D effects.

- If something's stuck to the surface of your photo, try to gently lift it off, if possible. However, if it's not going to come away without taking your photo's coating with it, don't lift it, just leave it alone and you can get rid of it later with Photoshop Element's Clone Stamp (to replace

● 2.13

● 2.14

the damaged area with something from elsewhere in the image) or simply paint it out with a Brush or Pencil tool.

[CROSS-REFERENCE]

Find out about using the Clone Stamp tool in Chapter 6, where you also find out more about repairing scratched and torn images.

• If someone taped a torn image in the past, that tape may have turned yellow by now, or if it was clear, matte-finish tape, the matte finish may be covering up details that lie on the image beneath it. Try to get rid of the tape if you can, but don't force it or you could damage the photo even more. You can always replace the tape-covered content, or counteract the effects of old, yellowed tape with various color adjustment tools.

[TIP]

Many old photos may be *sepia tone*. These are images with an overall beige tinge (also known as *sepia*, from which the photo coloring style derives its name). You want to scan these in color mode, despite the fact that they are not full color images. By so doing, you can make use of color adjustment tools that can fix uneven tones over the surface of the image, or change the cast of the sepia, which may have started to be more yellow over time. Read all about dealing with sepia tone images in Chapter 10.

Tips for Web-bound Photos

If the photo you're scanning will spend its days as an image on the Web, you should use Photoshop Elements' Save for Web tool, found in the File menu. This command opens a dialog box that provides options for reducing file size (to speed up the loading process when someone visits your Web page) while maintaining as much clarity and detail as possible (2.15).

Despite the need for small file sizes when you're working with Web graphics, you want to scan the images at a high resolution. As stated previously, the higher the resolution of the scan, the more of the original image content you capture with the scan, and the more detail and color information you have to work with as you retouch and restore the image.

● 2.15

After making all the required edits, you can reduce the image resolution (Image → Resize → Image Size) to 72 pixels per inch (ppi) (2.16), although you can leave this step for the Save For Web dialog box, which reduces the resolution to 72 ppi automatically when any of the Web-safe formats are selected for the image.

The next step is to issue the File → Save for Web command, which performs the final optimization steps — converting the image to a Web-safe format, and enabling you to choose how the image loads, what level of quality you want to maintain, and showing you an estimate for the load-time based on your current settings.

[T I P]

When you save your photo for the Web, save it in JPG format. The JPG format supports millions of colors (rather than the 256 colors that the GIF format supports), and is universally supported by browsers of just about any vintage.

● 2.16

The Big Picture

In this chapter, you discovered how to scan images and how the way you scan them can affect the quality of the image and the amount of restoration and retouching that can later be performed on the photo. In the next chapter, you read about adjusting and improving your photo's color and contrast.

Improving Photo Color and Contrast

Art produces ugly things, which frequently become beautiful with time. Fashion, on the other hand, produces beautiful things, which always become ugly with time.

<div align="right">JEAN COCTEAU</div>

While not all of your photos may be art or fashion in the accepted definition of the words, your photos are probably quite precious to you, even if they're faded, discolored, and generally looking the worse for the wear. If you have a drawer filled with them, many showing the signs of age or exhibiting less-than dazzling photographic technique, you're not alone. Adobe Photoshop Elements makes it possible, however, to take those faded, oddly-colored, or poorly lighted photos and turn them into images you'll be proud of — if not into works of art.

Improving Photo Color and Contrast

When you're dealing with photographs, some of the most common problems you encounter involve faded or odd colors and inappropriate contrast. Whether the photo was visually-challenged from the start — due to problems with the camera, the photographer, or the way the photo was developed — or because the photo has aged, resulting in fading or yellowing, Photoshop Elements provides the tools you need to fix the problem.

In this chapter, you discover how to brighten and deepen faded colors with the Brightness/Contrast tool, and how to add new color where there was none, or where the colors that were there are long gone with the Color tool. You learn to manipulate the color levels manually and through automatic tools and layers, as well as how to customize your painting and drawing tools so that they not only apply color, but also apply light and shadow where needed. Like many other Photoshop Elements tools, the Brightness/Contrast and Color tools have both manual and automatic versions — you can adjust the color, brightness, and contrast levels yourself, or you can let Photoshop Elements make the changes for you.

[NOTE]

To make the most effective use of the color, brightness, and contrast adjustment tools, you may need to use Photoshop Elements' selection tools (the Marquee, Lasso, or perhaps the Magic Wand) to specify the area you want to adjust. You find everything you need to know about making selections in Chapter 1.

Adjusting Image Brightness and Contrast

Not to be confused with adjusting the lights and darks in an image, the Brightness/Contrast dialog box (3.1) enables you to adjust the tones, or shades, of your image. You can intensify the tones by increasing brightness and contrast levels (3.2), or soften the tones by decreasing these levels (3.3). You can adjust the brightness and leave the contrast alone, or vice versa. You can also increase one and decrease the other. Your options are limited only by the length of the adjustment sliders and the entry limits for the text boxes for Brightness and Contrast — you can enter −100 to +100, with 0 being the middle.

Making a selection prior to adjusting the Brightness/Contrast controls ensures that you only apply the changes to the areas that need it. For example, if you have a group photo and only those people (or portions thereof) in the sunshine seem washed out (3.4), you should select them before adjusting the brightness and/or contrast so that the parts of the image in the shade don't become lost when you decrease the contrast for the sun-washed portions.

If you apply brightness and/or contrast changes without making a selection first, the changes will apply to the entire active layer. If the image is one you just scanned in through Photoshop Elements' File → Import command, the entire photo becomes the Background, which is the only layer. If the image is one on which you've already worked, you may or may not have added layers to it, and if you did, you need to make the desired layer active before you make any changes to the image quality. If you don't select a layer, you may see no change, especially if the inadvertently selected layer is beneath other content.

● 3.1

● 3.2

Obviously, if the brightness and/or contrast problem is relatively uniform across the entire photo, you can apply the changes to a layer rather than a selection, or you can make multiple selections and adjust each of them individually.

[TIP]

To select an individual layer, click the desired layer in the Layers palette. The layer will turn blue in the palette to indicate that it is selected.

[NOTE]

Assuming you left the Preview option on in the Brightness/Contrast dialog box, as you drag the sliders for Brightness and Contrast, you see the changes in your image window, but those changes aren't literally put into effect until you click OK. If you don't like the results of your tinkering, click Cancel to close the dialog box without making any changes to the image.

Making Automatic Contrast Adjustments

The Auto Contrast command, found in the Enhance menu, makes automatic changes to your image (or to a selected portion thereof), adjusting the contrast based on general standards for color and tone. When you issue this command, Photoshop Elements views the pixels within your image individually and in groups, and decides for you which pixels to darken or lighten to achieve the best overall contrast change.

When using this command, you can select some of the image first, or leave a layer selected with no selection made — either way, the command works on its own, with no intervention required from you. If you don't like the results, you can use the aforementioned Brightness/Contrast dialog box to tweak some or all of the Auto Contrast effects, or you can use Edit → Undo to remove the changes completely. Another good way to go back in time to before a particular change was made to a photo you're editing is to use the Undo History palette — click on any state in the Undo History and everything done since that point

● 3.3

● 3.4

in time is undone (3.5). You may find this handy if you don't realize you don't like your Auto Contrast results until much later in the session, when you may have exhausted the allocated 20 levels of Undo. Of course, you can use the Undo History palette to undo any action you've taken, from resizing an image to changing colors, to drawing on the image with the Paintbrush. Bear in mind that the Undo History palette only keeps track of the last 20 changes you've done — this limit exists to save memory — so you may end up using the File, Revert command to start over at the last point when your image was saved.

[T I P]

The rather long and not-likely-to-be-remembered keyboard shortcut for Auto Contrast is Alt + Shift + Ctrl + L. If you're a Mac user, your keyboard shortcut is slightly different – press Option + Shift + Command + L.

[T I P]

Keep the Undo History palette handy by dragging it down from the docking well, turning it into a free-floating palette. To drag it off the well, grab it by its tab and move it to wherever it will be close at hand without being in the way.

Adjusting Highlights, Grays, and Shadows

Also in the Enhance menu, found in the Adjust Brightness/Contrast submenu, is the Levels command. The Levels dialog box (3.6) gives you the ability to establish the Black Point, Gray Point, and White Point of your active image, and to adjust the levels of one or more of the color channels relative to those points. By establishing these points, you provide Photoshop Elements with the color and light extremes — the darkest pixel (black), the lightest pixel (white), and a pixel that's in the middle of those two, a gray pixel. This works even if you're not using a black and white image, and you are picking the darkest and lightest colors, and a color or shade in between them.

After establishing these extremes and their middle ground, you make the level adjustments by dragging the Input and Output Levels sliders. The Preview setting is on by default, so that you can see the results of your tinkering. You can take a photo that's too dim or too bright and improve it (3.7), adjusting one or more of the Input and/or Output levels.

Performing Automatic Level Adjustments

Also accessible from inside the Levels dialog box (click the Auto button) or by choosing Auto Levels from the Enhancements menu, is an automatic levels

● 3.5

● 3.6

adjustment tool. Through the Auto Levels command, Photoshop Elements provides automatic overall adjustment to your image. Of course, you can make a selection before issuing the Auto Levels command, or apply the adjustment to the entire active layer.

While the Auto Levels command is easy to use and the results appear quickly, you may find the results too harsh. If you allow Photoshop Elements to determine your black, gray, and white points, you could end up with very bright white/light colors, and too much contrast between colors (3.8). If you don't like the results of the Auto Levels command, simply click Edit → Undo (or click the Undo button), press Ctrl/Command + Z, or go back in time through the History palette.

Correcting Colors

A photograph with washed out colors or colors that are too red, too yellow, or too anything can be very frustrating to work with, especially if the photo represents the only tangible evidence of a past event or gathering, or depicts special people or places. You can bring faded photos back to life and restore the correct colors with an assortment of Photoshop Elements tools — from features that remove an unwanted color cast over the entire photo to tools that add color where there wasn't any to begin with.

[T I P]

Just like Ted Turner colorized many treasured old movies in an attempt to make them more interesting to view, you can colorize black-and-white photos, turning white, black, and shades of gray into any number of colors. If your photo was taken before color's availability, you can go back in time and add colors to bring out flowers, fabrics, skin tones, even a blue sky.

Controlling Hue and Saturation

You find Photoshop Elements' Hue and Saturation command in the Enhance menu, in the Color

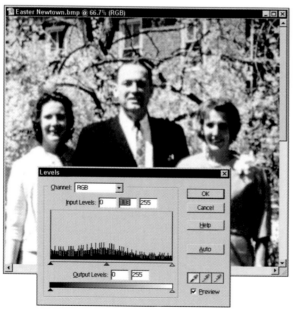

● 3.7

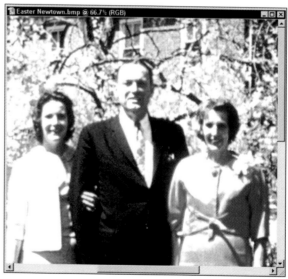

● 3.8

submenu. This is the obvious place for it, because *hue* is really a synonym for color, and the *saturation* level of a given color or hue indicates its purity. The Hue/Saturation dialog box (3.9) is in itself a great tool for understanding hue and saturation, as well as a great tool for adjusting these qualities within a photo or portion thereof.

[T I P]

Is the Hue and Saturation command dimmed in the Color submenu? If your image is black-and-white, it may be in Grayscale mode. If you want to add or adjust color in a black and white image, change its mode to RGB by choosing Edit → Mode → RGB. This adds color information to the image, which the various Enhance menu tools can work with.

When you open the Hue/Saturation dialog box, you notice a set of color bars, which are also known as color *ramps*. These bars represent the color wheel, and the order in which colors appear on the wheel. The top bar shows the color before you make any adjustment and the lower bar shows how adjustments

you make with the Hue, Saturation, and/or Lightness sliders affect the hues in your selection.

To make adjustments to these three levels, follow these steps:

1. **First, choose which of the colors in your selection you want to adjust by making a selection from the Edit drop-down list (3.10).**
 Master enables you to adjust all of the colors simultaneously, and the individual colors (Reds, Yellows, Greens, Cyans, Blues, and Magentas) enable you to control those hues one at a time.

2. **Drag the Hue slider to the right to move clockwise on the color wheel.**
 Doing this results in a positive number in the Hue level text box. You can enter a level into the box directly, too.

3. **Drag the Saturation slider to shift the color closer to the center of the color wheel or farther away from it.**
 Dragging it to the left decreases saturation, and dragging it to the right increases it, with −100 and +100 being your respective limits. If you reduce the saturation to −100, the color completely washes out to a dull gray (3.11). If you

● 3.9

● 3.10

increase the saturation to +100, the color becomes very vivid (3.12).

The Lightness slider enables you to control the amount of white or black you add to the color. If you drag this slider all the way to the right (+100), the color becomes pure white. Conversely, dragging the slider all the way to the left (−100) turns the color to pure black. The more likely adjustments are not so extreme, however, and you can drag slightly in one direction or the other to lighten or darken the color slightly.

Other adjustments you can make within the Hue/Saturation dialog box include the following:

• Use the **Eyedropper**, **Add to Sample**, and **Subtract from Sample** eyedropper tools to pick a color from somewhere on the workspace. This gives you more control over how the adjustments you make apply to your image, because you're controlling which pixels are "considered" by the software as your other adjustments are made through the dialog box.

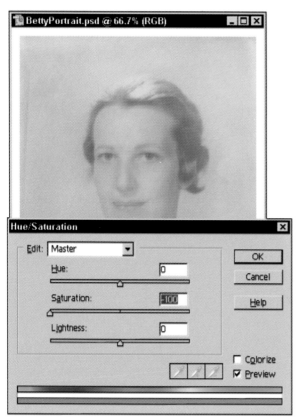

● 3.11

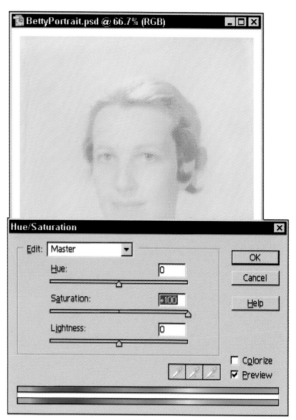

● 3.12

The Add to and Subtract from variants of the Eyedropper tool enable you to change (expand or reduce) the color bars' range (3.13).

- To create a duotone image (an image made up of two colors — black and one other), turn on

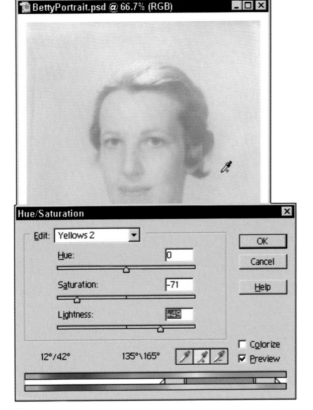

● 3.13

● 3.14

the **Colorize** option to apply the current Foreground color, which you chose through the toolbox, to the entire layer or selection therein. Choosing to create a duotone image is an aesthetic choice, such as the desire to mimic a sepia-tone print, which can be quite effective when dealing with vintage photos.

[N O T E]

When the Edit drop-down list is set to Master, the eyedropper tools are not available because you're adjusting all the colors at once. Turning on the Colorize option also disables the eyedropper tools, because if you're applying the Foreground color, you don't need to sample colors within the image or elsewhere on the workspace.

Removing a Color Cast

If your color image has an unpleasant cast — perhaps a yellow or red tinge — you can adjust it with the Color Cast command. You can also use this command to adjust the tones in a black-and-white image that you've converted to RGB mode. To use the command, follow these steps:

1. Open the image from which you want to remove an undesirable color cast.

2. As needed, activate the layer with the content you want to adjust.

3. Choose Enhance → Color → Color Cast. The Color Cast Correction dialog box opens (3.14), providing instructions.

4. As directed, use the Eyedropper tool (already activated within the dialog box) to click on the gray, and then white, and then black points in the image.

As you click around in the image, the color cast changes. You can stop when you like the effects, even if you haven't clicked to set all three points. If you click and don't like the result (3.15), click the Reset button to start over — perhaps all you need to do is click on a different spot for the white, gray, and/or black point.

As with all color and contrast adjustment tools, leave the Preview option on in the dialog box. Otherwise, you won't see your changes applied to your photo and can't really tell if you're getting the results you want. Don't worry whether the changes you see in the Preview box will have any effect on your image. Any effects you see previewed won't take permanent effect until and unless you click OK to apply them, and even then they're not permanent — you can always undo!

Adjusting Color with Variations

The Color Variations dialog box (3.16) is a very effective, if imprecise, tool in Photoshop Elements. Opened by choosing Enhance → Adjust Color →

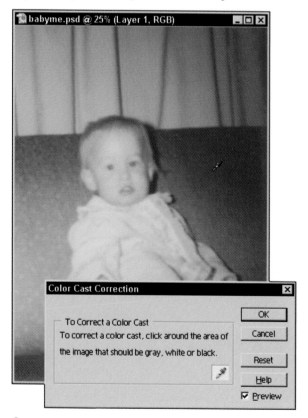

● 3.15

Color Variations, you can pick from several alternative versions of your photo, which Photoshop Elements represents with a series of thumbnails. The thumbnails enable you to see the results of adding More Green, More Yellow, More Cyan, and so on, or making the picture Lighter or Darker. Of course, the Variations command isn't the tool you want to use to adjust specific areas of an image — it's more of a generalist's tool for adjusting the color and brightness of an entire photo without any real precision.

Through the Color Variations dialog box, you can choose which aspect of the photo you adjust — Shadows, Midtones (the default), Highlights, or Saturation. You can also drag the Amount slider to set the degree of change applied by your adjustments. Dragging it to the left applies subtle changes, while dragging to the right applies the changes more dynamically. You can preview your results by watching the top two thumbnails — the Before and After. The Current Pick thumbnail shows the effects of choosing one of the other Variations thumbnails, and the Original appears next to it to enable you to make a side-by-side comparison. A duplicate Current Pick thumbnail also appears in the middle of the More... thumbnails, enabling you to see the results of your selection up against more extreme results. For example, if you click the More Red thumbnail, Photoshop Elements adds

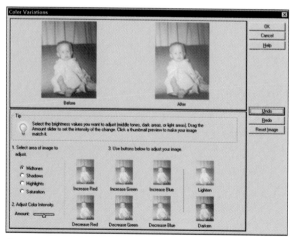

● 3.16

more red to your image than is displayed in the Current Pick thumbnail.

If you choose Saturation from the four options in the lower-left corner of the Color Variations dialog box, the More... thumbnails disappear in favor of Less Saturation and More Saturation thumbnails (3.17). If you want to adjust the saturation and then tinker with colors, choose the Saturation option first, and then click the appropriate Less or More thumbnail. Then you can go back to any of the remaining three options (Shadows, Midtones, or Highlights) ad use the More... color thumbnails to adjust the tonal variations for the more or less-saturated image.

[T I P]

You can turn on the Show Clipping option if you want to see a neon preview of the portions of the photo that the Variation thumbnail clips (removes) when you select it. If your changes result in a pure white or black image, Photoshop Elements clips a portion of the image.

[W A R N I N G]

The Color Variations feature does not work for images in Indexed Color mode, which is one of your color mode choices found in the Image menu's Mode sub-menu. The color mode you choose for any image dictates the color components used to make up the image. And in the case of Indexed Color, the color information stored in an indexed color image is not sufficient to make use of the Color Variations feature.

Controlling Image Content and Appearance with Layers

Another way to make adjustments to your image quality — improving or changing its color, contrast, or brightness — is to create an adjustment layer. You can apply an adjustment layer to the entire image, or to a section thereof, by creating a new layer that adjusts one

or more of your image's attributes. Created from right within the Layers palette, adjustment layers make it easy to fix the facets that are wrong with your image. When you click the Create New Fill or Adjustment Layer button at the foot of the palette, you're presented with a menu of choices, each representing a different role for the adjustment layer (3.18).

Your choices in this menu include other options as well. You can create a Fill layer that applies a Solid Color, a Gradient, or a Pattern. These options obscure the image content, assuming that the Fill layer is on top of the main image layer (typically the Background). Below these first three choices, however, are the adjustment layer options, including Levels, (see the Levels dialog box discussion earlier in this chapter), Brightness/Contrast, Hue/Saturation, Gradient Map, Invert, Threshold, and Posterize.

You can also find most of these commands in the Image and Enhance menus, and through those menus, you can apply them directly to the existing layers in your image. By applying them through an adjustment layer, however, you leave the main image intact, and apply an adjustment overlay. This means you can go back to the original image by hiding or deleting the adjustment layer(s) at any time. It also makes it possible to apply an overlaying adjustment layer that only

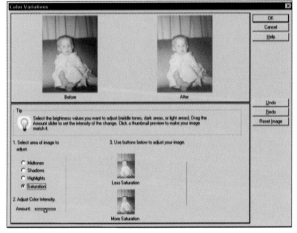

● 3.17

affects part of the image, so that the rest of the original image shows through the adjustment layer.

To create an adjustment layer, follow these steps:

1. **If you want to restrict the effects of the adjustment layer to a particular region of the image, make a selection or simply click on the layer you want to adjust, activating it in the Layers palette.**

 If you only click on a layer and don't make a selection, your adjustments will apply to the entire active layer.

2. **Next, click the Create New Fill or Adjustment Layer button and choose the type of adjustment that the layer should make.**

 All but one of the choices (Invert) results in a dialog box, which you can use to adjust how to make the adjustment.

3. **As soon as you click the OK button in the resulting dialog box, the effects take place on the new adjustment layer (3.19).**

 Photoshop Elements names the layer the same as the adjustment command you chose when you created the adjustment layer.

After you create the adjustment layer, you can readjust its effects by double-clicking the left-most thumbnail or by choosing Layer → Layer Content Options. Using either method, the same dialog box you used to create the adjustment layer in the first place reopens, and you can adjust the sliders and other tools in the dialog box, changing the effect of the adjustment layer.

[T I P]

You can make the adjustment layer more or less opaque by dragging the Opacity slider on the Layers palette while the adjustment layer is active. Reducing the opacity decreases the effects of the adjustment, which may be a good thing if the layer is applying too much color, contrast, or brightness.

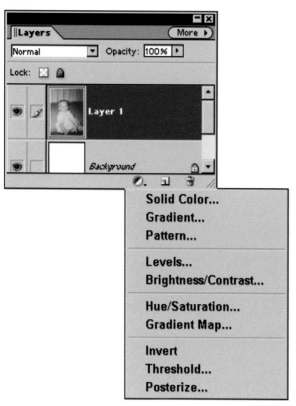

● 3.18

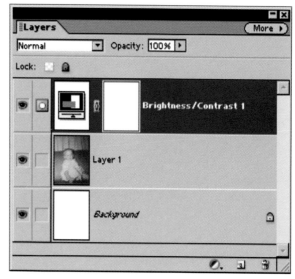

● 3.19

If you're not sure which type of adjustment layer to create, consider what the problem with your image is as it stands now. Is it too dark? Then you probably want to use the Brightness/Contrast command to create a layer that adjusts the lighting in the image. If there's an unwanted color cast or faded or distorted color over the entire image or a portion thereof, you may want to use the Hue/Saturation command or the Levels command. Because you can easily hide or delete the adjustment layer if you don't like its effect on the image, you can also easily experiment with adjustment layer types, and even stack them for a combined effect. You can adjust the brightness with

one layer and then adjust the hue with a second layer — whatever combination of problems your image has, you can create any combination of adjustment layers to solve them. To assist you in making logical choices, here's what each of the adjustment layer commands enable you to do to the image:

- **Levels.** This command opens the Levels dialog box, through which you can set values for the highlights, midtones, and/or shadows in your image. This dialog box (3.20) enables you to use three sampling eye droppers to set the lightest, darkest, and midrange pixels in your image, and you use these samples to fine-tune the levels in your image.
- **Brightness/Contrast.** This command opens a dialog box (3.21) that enables you to bring in more light (increasing Brightness) and more diversity between lights and darks (increasing Contrast). You can also reduce these levels if your image is too bright or overexposed, which would have caused the higher-than-desired contrast. (This command is discussed in greater detail in Chapter 4.)
- **Hue/Saturation.** This command adjusts color, which color dominates the image, how much color is applied, and how much light is included in the color (3.22).

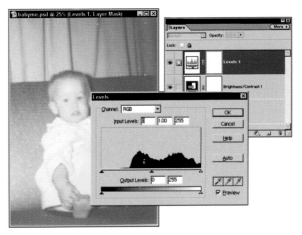

● 3.20

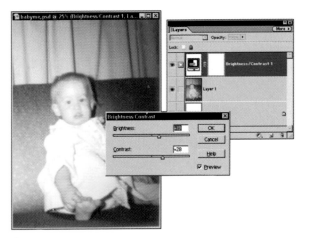

● 3.21

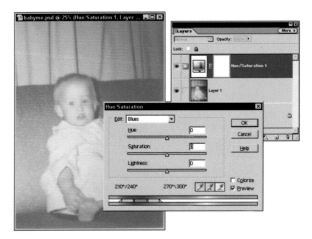

● 3.22

- **Gradient Map.** If you want to choose a gradient style and adjust how it's applied, choose this command. Rather than filling the layer with a gradient, it applies the gradient to the active layer's content (3.23). Don't confuse this command with the Gradient command that creates a Fill layer.
- **Invert.** No dialog box appears when you choose this command. Instead, the command reverses the lights and darks and swaps the existing colors for their color-wheel opposites. Essentially, the command creates a photo negative (3.24) on all or a selected portion of the image.

- **Threshold.** Use this command to focus on the brightest and darkest spots in the image — extreme highlights and shadows. You can drag the dialog box sliders to the far right, turning the image (or a selection therein) totally black, and then ease the slider back to the left, stopping when some white appears. This indicates the highlights (3.25). The reverse process (starting on the far left), which turns the image white, establishes shadows (3.26).
- **Posterize.** This command enables you to determine the tonal complexity of an image. You can set the number of levels to 2 for a very flat color

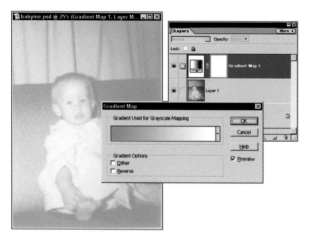

● 3.23

● 3.25

● 3.24

● 3.26

effect, reducing the number of tones in the image to just two (3.27). A greater number of levels — 10 or more — creates more subtle tonal effects, as you include more tones in the layer (3.28).

● 3.27

● 3.28

Selecting and Using Paintbrush Blending Modes

Just as an adjustment layer can change your image by adding a color or light-adjusting overlay, Photoshop Elements' painting and drawing tools also enable you to control the amount and quality of light and color. Instead of adding a removable layer, however, the work you do with these tools becomes part of an existing layer.

Whenever you use the Brush, Pencil, Clone Stamp, Dodge, Burn, Sponge, Smudge, Blur, Sharpen, or Eraser tool, the options bar offers a Brush setting that you can use to change the size and shape of your brush, and a Mode setting to choose how Photoshop Elements adds or takes away color or light. The Mode option lists up to 24 different blending options, each affecting the image in a slightly different way.

● 3.29

Some images, depending on the color model (RGB, CMYK, Grayscale, or Indexed Color, for example), have shorter lists, or display dimmed blending modes when you click the drop-down list. When using the Brush tool, however, all of blending options are available (3.29).

Most of the Mode names clarify what the individual modes do, but you may find some of the names rather cryptic. For example, Darken is obvious, but Difference may not be. You might guess that when you paint with a Brush set to Soft Light that you add a gentle brightness, but you might be surprised at the results of the Vivid Light blending mode. Following is a list of all of the blending modes available for the Brush tool.

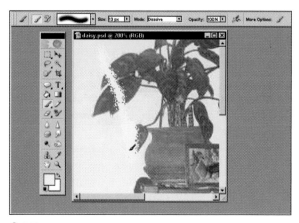

● 3.30

- **Normal.** This mode paints each painted pixel to make it the *result color* (the color you chose for the Foreground color on the Color Picker).
- **Dissolve.** This works the same as Normal mode, except that Photoshop Elements applies the paint to look as though the color dissolves on the painted surface (3.30). This works only in areas that are not 100% opaque, dithering semi-opaque pixels.
- **Behind.** This mode paints the transparent areas of a layer only and is obviously only applicable on layers with Lock Transparency turned off. This mode gives you the look of paint applied to the back of a clear surface, such as glass or a sheet of plastic.
- **Clear.** The Clear mode makes each pixel you paint transparent, or clear, thus earning its name (3.31). You can use Clear mode on tools other

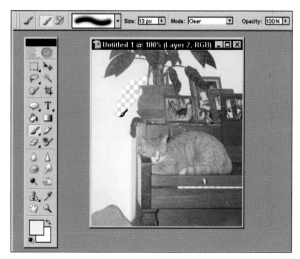

● 3.31

than the Brush, such as the Paint Bucket tool, the Pencil, the Fill command, and the Stroke command. Like Behind mode, you must turn off Lock Transparency to use this mode.

- **Darken.** This mode refers to the color information in each channel and selects the darker color when comparing the base and blending color. Photoshop Elements replaces pixels that are lighter than the blend color and leaves the pixels darker than the blend color as they are. You use Darken when you want to apply a light color and darken a base color that's already darker than the color with which you're painting.

- **Multiply.** Use this mode to create a darker color by multiplying the base color by the blend color, based on the color information in each channel. When you use Multiply mode and paint with colors other than white, you create increasingly darker colors as you paint over and over in the same spots, much like applying layers of translucent color and overlapping the same or different colors. The more you paint or draw in the same spot, the darker your colors become.

● 3.32

- **Color Burn.** This mode darkens the active layer (wherever you paint on it) by increasing the contrast between base and blend colors. You can use this blending mode to get a stark, high contrast effect, and by simultaneously adjusting the Opacity of the brush, you can create more subtle or dramatic effects. Obviously, lower Opacity levels yield the more subtle result (3.32).

- **Linear Burn.** This mode works much like Color Burn, but it uses the color information in each channel to reduce the brightness levels of the base color.

- **Lighten.** If your base color is lighter than your blend color, Photoshop Elements chooses the base color as the result color, and vice versa — if the blend color is lighter, that becomes the result. If you have pixels in the painted area that are darker than the blend color, they change to the result color, and pixels that are lighter than the blend color don't change at all. You can use this mode to achieve an eraser-like effect that wipes out darker colors in favor of a lighter one. If you paint with a color that's already in the image, that color remains unaffected by the new paint, but anything darker is replaced with white, and transparent areas are filled with the painting color.

- **Screen.** Unlike Multiply, which creates darker colors where painting overlaps, the effect of Screen mode is a lighter color. Screening with black doesn't change the color, and screening with white gives you white. For a good visual analogy, imagine aiming dueling overhead projectors (with color slides on them) at the same spot on the wall. Unlike overlapping slides on the same projector, which produce darker colors where they overlap, the two projected images appear lighter at their common target.

- **Color Dodge.** For an extreme brightening effect, use the Color Dodge mode. This mode takes the color information in each channel and then brightens the base color (and thus the result color) by decreasing the contrast (3.33). If you paint with white or very light colors, you increase the effect.
- **Linear Dodge.** The results of this mode are very similar to Color Dodge, but instead of reducing contrast to achieve added brightness, the brightness level is directly increased.
- **Overlay.** This mode works like Multiply or Screen in that overlapping colors maintain highlights and shadows. The base color mixes with the blend color to give you a result color that has the same light or dark quality of the base color.
- **Soft Light.** Imagine shining a soft, white light on something. The light source increases the shadows and highlights, but the effects are subtle. Changes to color in this mode are based on the blend color, and the lightness or darkness of that color determines the lightening effect. If the

blend color is lighter than 50% gray, this mode produces an effect similar to the Dodge tool. If the blend color is darker than 50% gray, the Burn tool's effect is mimicked.

- **Hard Light.** Having the opposite effect of the Soft Light mode, Hard Light creates a harsh, bare-bulb lighting effect on your image (3.34). You use the blend color as in the case of Soft Light, but the effects are much harder and not subtle in the least.
- **Vivid Light.** This mode lightens (dodge) or darkens (burn) as you paint by adjusting the contrast in relation to the blend color. When the blend color is lighter than 50% gray, the Vivid Light mode lightens the image by reducing contrast. Conversely, if the blend color is darker than 50% gray, a darkening effect increases the contrast.
- **Linear Light.** The same way Vivid Light bases contrast adjustments on the blend color, Linear Light mode adjusts brightness based on the blend color. A blend color that's lighter than 50% gray

● 3.33

● 3.34

results in a lighter effect with an increased brightness level. If the blend color is darker than 50% gray, brightness decreases, resulting in a darker effect.

- **Pin Light.** In Pin Light mode, if your blend color is lighter than 50% gray, Photoshop Elements replaces any pixels darker than your blend color with the result color. Pixels lighter than the blend color in the path of your paintbrush remain unchanged. On the other hand, if your blend color is darker than 50% gray, Photoshop Elements replaces any pixels lighter than your blend color, and if you have pixels darker than the blend color in the path of your paintbrush, those don't change, either.

- **Difference.** Use this blending mode to invert lower layers based on the levels of brightness in the layer on which you're painting. This mode takes the color information in each channel and takes the blend color from the base color or the base color from the blend color. It all depends whether or not the base is brighter than the blending color, or vice versa. The results can be quite dramatic, and appear in a sort of color-negative effect.

- **Exclusion.** This mode has virtually the same effect as Difference mode, with lower contrast levels.

- **Hue.** Working with the HSL color model (Hue, Saturation, and Luminosity), this blending mode gives you a result color that has the luminosity and saturation of the base color and the hue of the blend color.

- **Saturation.** Again using the HSL mode, this mode gives you a result color with the luminosity and hue of the base color and the saturation of the blend color.

- **Color.** Yet another combination of the HSL color model's components, this blending mode gives you a result color with the luminance of the base color and the hue and saturation of the blend color. This mode works well when you change the tint of a color image or when you add color to a monochrome image.

- **Luminosity.** This mode gives you a result color with the hue and saturation of the base color and the luminosity of the blend color. If you also adjust the Opacity, you can control the intensity of the effect. A lower Opacity results in a more subtle effect (3.35).

Of course, you can apply color with more than one blending mode. You can layer the color by painting in one mode first, and then using a second mode to go over some or all of the previously painted area. The Mode option is also on the option bar when you use the Paint Bucket, so that you can choose how solid color and pattern fills apply, as well.

The Big Picture

In this chapter, you read how to improve the color quality of your image and to adjust contrast so that both color and black-and-white photos look better. In the next chapter, you discover how to adjust light levels and to fix light-related problems, such as red-eye and a lack of proper backlighting.

● 3.35

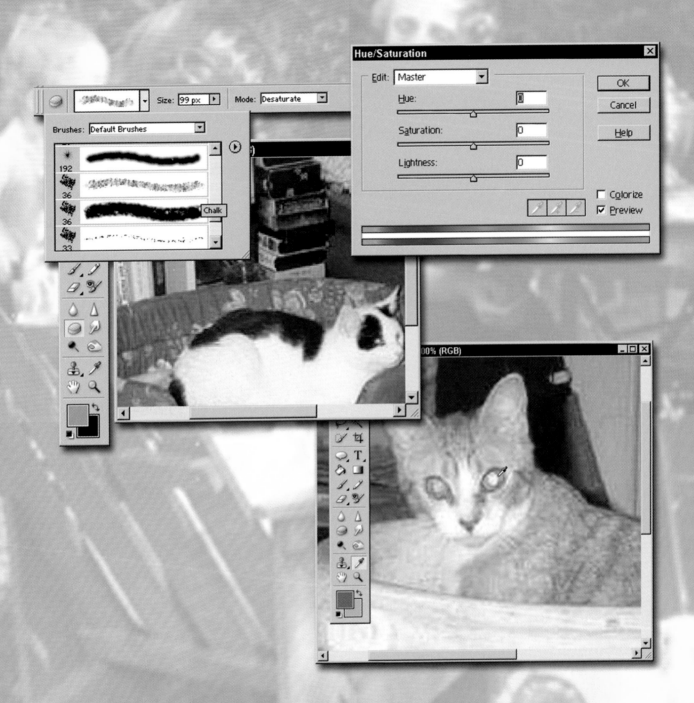

Too Dark or Too Light: Correcting Exposure

You have the sky overhead giving one light; then the reflected light from whatever reflects; then the direct light of the sun; so that in the blending and suffusing of these several luminations, there is no such thing as a line to be seen anywhere.

WINSLOW HOMER

The amount of light in a photo is one of the most important elements in that photo. First, photos can't be taken without light — it's the light that the camera lets in for a split second that creates the photo in the first place. Second, the amount of light present in a photo determines the amount of color you see and the detail you capture. If a photo has too much light — from an overactive flash, too much sunlight, improper development techniques — details and colors can get washed out. If there's a specific point of light — say a flash bouncing off something shiny or reflecting off bright or white objects in the photo, the results can be distracting at best. Too much light can also cause unpleasant shadows, and those shadows can be destructive, too.

Photos without enough light in them can also be a problem, in that details within the image can be lost in dark corners. Bright colors can be made dull by the absence of an appropriate amount of light, resulting in a very boring image. We've all taken pictures with an automatic flash camera and seen what happens when

the flash doesn't go off. If there isn't enough natural or man-made light in the area to compensate, the image can be blurry, grainy, and very little detail will make it into the photo. The same thing can happen to outdoor photos taken on a cloudy day or too close to sunset.

No matter what went wrong with your photo's light levels, you can adjust them through Adobe Photoshop Elements, utilizing the toolbox and a variety of dialog boxes and light-adjusting settings. You can add light where there isn't enough, change the apparent direction from which the light was coming when the picture was taken, and you can get rid of unwanted light. It's almost like going back to when the picture was taken and adjusting the camera and the lighting in the room or the amount of sunshine available, and making sure the photo was properly exposed from the beginning. Of course, if your photo or parts of your photo are completely dark and have no light in them, you will have to invent the content hidden in the shadows — you can't create light that wasn't there.

● 4.1

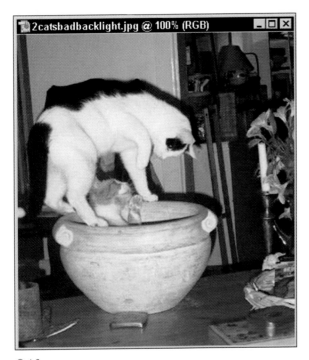

● 4.2

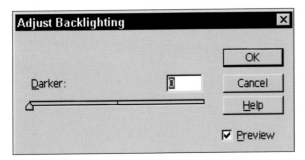

● 4.3

Adjusting Backlighting and Fill Flash to Correct Exposure

The source of or amount of light in your photographs is something you may not have been able to control when you were taking the photos, but thanks to Photoshop Elements, you can control it later, simulating the effects of a brighter flash or a light source behind the objects in your images. Of course, you can use a variety of tools to brighten the highlights, midtones, and shadows in any photo (and I discuss each of them later in this chapter), but to actually simulate the effects of a brighter flashbulb or a light source behind the photo's subject, you need to use the Adjust Backlighting and Fill Flash commands, found in the Enhance → Adjust Lighting submenu (4.1).

Creating Better Backlighting

If you're a serious photographer or have ever worked with one, you're probably familiar with the term *backlighting*. The term isn't that enigmatic, actually, because it simply means "light coming from behind the subject." That lighting can be directly behind the subject or somewhat to one side or the other, but it is decidedly behind the person, place, or thing in your photo, and is normally man-made or at least man-manipulated — someone puts a light behind someone by moving a lamp or opening a window blind to let the sun in. But what if you are unable to adjust the lighting? You can't move the sun if you're outside, and in many indoor settings, it's not possible to move or change the lighting.

When a good source of backlighting is absent in your photo and you've got funky shadows as a result (4.2), choose Enhance → Adjust Lighting → Adjust Backlighting. The Adjust Backlighting dialog box appears, enabling you to choose a backlighting level from 0 to +100 (4.3). Setting the backlighting level

to the extreme end results in a very dark background and very little light in the foreground, found only on the items closest to the camera. The results are almost like a photo taken by candlelight (4.4).

[TIP]

If nothing you do in the Adjust Backlighting dialog box seems to improve your photo, chances are that the backlighting was OK to begin with. If you know that's not the case, consider copying objects in the foreground to their own layers and then adjust the backlighting on the layer behind them.

Using the Fill Flash

The Enhance → Adjusting Lighting → Fill Flash command opens the Adjust Fill Flash dialog box that provides two sliders: one for adding light all over (Lighter) and one for adding or removing color (Saturation) (4.5). You can control the area affected by these tools by making a selection within in the image before opening the Fill Flash dialog box, in which case only the items within the selection (on the active layer) appear to have been affected by a bigger, brighter flash.

Obviously, if you add too much light, everything in the image — color, detail — will wash out. You can compensate somewhat by increasing saturation, but applying the Fill Flash in small amounts is best for the most natural, subtle effects.

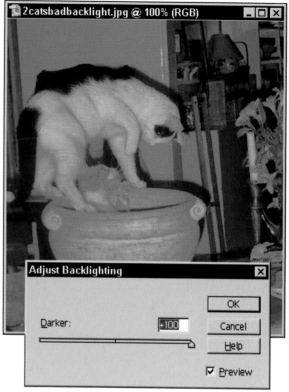

● 4.4

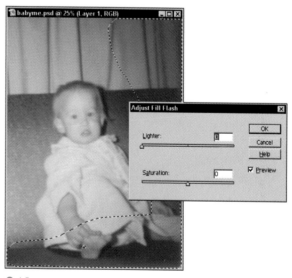

● 4.5

Creating and Repositioning Light Sources

If your photo is not well lighted or if the light is coming from the wrong direction, you aren't stuck with the situation. Thanks to Photoshop Elements, you can do something about it, and the solutions are pretty easy. Through the use of two different filters, Lighting Effects and Lens Flare, you can create the appearance of a distinct light source in your image, making it look as though the sun were shining on a cloudy day, or that there were lamps nearby, illuminating your indoor subjects. You can apply these filters from multiple directions simply by repeating their application as many times as you need sources of light in your image. You can also use other lighting and color-adjustment features to augment or adjust the overall effects these filters have on your photos.

[T I P]

Rarely is a single adjustment "all you need." It's often a combination of restorative steps that create the look you're seeking.

Using the Lighting Effects Filter

Found in the Filter menu's Render submenu (Filter → Render → Lighting Effects), this lighting tool has some sophisticated options that you can use to create the exact type of lighting your photo currently lacks. The Lighting Effects dialog box (4.6) is broken into four sections:

- Style
- Light type
- Properties
- Texture Channel

By using the options in each of these sections, you can create anything from the harsh, focused glare of a flashlight to an overall spotlight. Each of the Style options has its own default settings, and you can use them to create a completely custom lighting effect.

Choosing a Lighting Style

The Style section of the Lighting Effects dialog box offers a drop-down list of 17 different types of light — everything from 2 o'clock spotlight to Triple spotlight, and lots of options in between. You can

4.6

4.7

[T I P]

See the little light bulb under the image preview in the
Lighting Effects dialog box? You can drag it onto the
image in the preview window as many times as you'd
like, each time creating an additional light source with
its own set of control dots and nodes. To select an
individual light source, be it part of the originally
selected Style and Light type or one that you've added,
just click its center dot.

Creating 3D Texture Effects with Lighting

Use the Texture Channel to choose which color
channel (Red, Green, or Blue for RGB and other
color mode images) will be affected by the light.
When None is selected, the options in this section
are dimmed. When Red, Green, or Blue is selected,
you can turn the "White is High" option on and off,
which controls how much white is added to the
image, and you can drag the Height slider to control
the highlights and shadows created by the light. Like
most of the options in the Lighting Effects dialog
box, tinkering with the sliders and watching the
Preview window for the results is probably the best
way to find the right settings for each individual
photo you're retouching.

[T I P]

If you want to use a particular set of Style, Type, and
Properties settings again in the future, click the Save
button in the Style section of the dialog box. You can
then name and save a new effect, and you find it in
the list of styles next time you go to use the filter. You
can delete the styles you create (choose your style from
the drop-down list and click the Delete button), but
you can't delete the styles that were installed with the
software.

Creating a Flash of Light with the Lens Flare Filter

While it might be considered a defect in some pic-
tures to be able to see a spot created by the flash
reflecting off the camera's lens, it can also be an inter-
esting effect — adding a single spot of light to a
indoor shot taken in low light (4.13) or to a night-
time outdoor shot. You might want to add a lens flare
simply to balance out another naturally occurring
flash of light or to draw the viewer's eye to a partic-
ular portion of a larger or busy image. Another way
to use this feature is to use it in conjunction with the
Lighting Effects filter. You can add a flare to accent
the focused lighting of a spotlight or to add more
"atmosphere" to a dimly lit nighttime indoor or out-
door photo.

● 4.13

To use the Lens Flare filter, start by choosing Filter → Render → Lens Flare. The Lens Flare dialog box (4.14) enables you to choose the intensity and size of the flare (drag the Brightness slider) and to choose the type of lens flare you want to apply. Your Lens Type choices are 50–300 mm Zoom, 35 mm Prime, and 105 mm Prime.

As you click on each of the Lens Type options, the resulting flare appears in the Preview window. When you find one you like, adjust the Brightness, and as needed, reposition the flare by dragging the crosshair (4.15) to a new spot on the photo. When positioning the flare, consider the light source (real or added via the Lighting Effects filter) and place the flare above and to the left of the pool of light shed by the light source, as this is the most natural location for a flare to occur on its own.

[T I P]

A *prime* lens is a lens with a fixed focal length, which means the distance from the camera's lens to the point where light rays are brought into focus cannot be changed.

Controlling Lights and Darks

Not to be confused with adding an artificial light source or masking the existence of a naturally occurring light source, the Dodge and Burn tools enable you to add light and dark, respectively, to specific areas of your image. This can help bring out details lost to a lack of adequate lighting (4.16) or to too much light (4.17) and can be applied to very specific

● 4.14

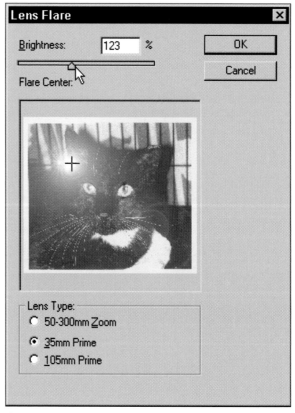

● 4.15

areas of your image. The Dodge and Burn tools are brush-based, meaning you can choose the size of the brush that applies the light or dark. You can also adjust the intensity of the tools to control the amount of light or dark applied to the image.

Adding More Light with the Dodge Tool

The Dodge tool enables you to paint light onto an image by clicking on and/or dragging the tool across your image. As you expose an area to the Dodge tool, the amount of light in the affected pixels increases, creating the lightening effect. You can use the tool's options bar (4.18) to control the size of your brush, the range of pixels that will be affected (Midtones, Highlights, or Shadows), and the intensity of the effect (using the Exposure setting).

When deciding the range of pixels to lighten, consider the problem you're trying to solve in the specific photo. For example, if you have a face in bright sun, but shadows are eclipsing the facial features, you want to use the Shadows setting (4.19). Conversely, if you have a photo that's mostly in shadow and you only want to perk up the areas that should be lighter — edges of objects, surfaces exposed to the natural light source in the image — you can use the Highlights setting. If the image is just too dark overall and you simply want to lighten it up generally, the Midtones setting is your best bet.

● 4.17

● 4.18

● 4.16

●4.19

● 4.20

● 4.21

● 4.22

When applying the Dodge tool, you can make repeated passes over an area to increase the effect, but be careful not to leave obvious brush strokes in your wake. If you want to lighten a general area, use a very large brush and click rather than drag to lighten it. Using a brush style that has a diffused edge or that's textured (4.20) can also eliminate the possibility of an obvious path that the Dodge tool has taken.

If you want to Dodge a very small area, such as a face, the shadow under someone's chin, the small details on a table top, or minute ornamentation on a building, you should use a brush that's approximately the same size as the spot you're going to lighten (4.21). Finding a brush size that's the same diameter as a face, for example, enables you to apply uniform light, without also lightening the person's hair or the background visible on either side of the person's head.

[T I P]

The term *dodge* is a photographic term – it's not specific to Photoshop Elements, and it's not some software buzzword. Its official definition is "Holding back the image-forming light from a part of the image projected on an enlarger easel during part of the basic exposure time to make that area of the print lighter." Thanks go to www.kodak.com for that definition, and I encourage you to check out the Kodak Web site if you have any other terminology or conceptual questions regarding traditional photography.

Creating Shadows with the Burn Tool

The Burn tool is the Dodge tool's counterpart. Instead of adding more light (white) to pixels, it adds darkness (black) to the pixels over which you drag your mouse. The Burn tool's options bar is virtually identical to the Dodge tool's (4.22), and your customization of the

tool is limited to the brush Style, Size, Range, and Exposure settings that you put in place.

Also similar to the Dodge tool are the criteria you use in choosing the Range to burn. If your image is too light and you want to add depth to facial features, petals on a flower, leaves on a tree, or small architectural details, the Highlights setting enables you to remove harsh brightness from the peaks on surfaces — cheekbones, noses, leaf edges, rough edges on a stone wall, for example. If you're looking to just darken an area (or an entire image) that looks too light in general, use Midtones. Midtones is the default for both the Dodge and Burn tools because it does the most generalized job — it doesn't deepen shadows or highlights more than anything else, it just adds overall darkness (4.23).

[T I P]

Be careful when using the Burn tool on a color image, especially if the image is a black-and-white photo you scanned in as a color image (per my suggestion in Chapter 2). As you pass over an area repeatedly, the burning process can actually create the look of singed paper – a slightly brownish tone – making the image look as though flame or high heat was applied. Assuming that is not the effect you're shooting for, try to avoid going over the same spot more than one or two times with the Burn tool and use the Exposure setting to apply the very least amount of darkness that you need to get the look you want.

Adjusting the Amount of Color in Your Photos

Photoshop Elements provides three principal tools for controlling the amount of color present in your images:

- You can use the Sponge tool to add or remove color with your mouse, clicking or dragging over areas that are either faded and in need of color, or too bright and in need of some toning down.
- You can use the sliders in the Hue and Saturation dialog box to adjust the levels of individual colors in your image.
- You can use the Remove Color and Replace Color commands, both found in the Enhance ➔ Adjust Color submenu.

With the variety of tools available, there shouldn't be any color dilemma you can't deal with. You can restore faded photos to their original glory and tone down images that are too bright or that have too much of one color or another. You can also achieve artistic effects by selectively adding and removing color to make a statement or to draw attention to particular areas of the image.

● 4.23

Using the Sponge Tool to Add and Remove Color

The Sponge tool is really two tools in one. Like the Dodge and Burn tools, which add and remove light respectively, the Sponge tool in its two modes (Saturate and Desaturate) adds and removes color. Its options bar offers a choice between these two modes, and also offers settings for controlling the amount of your image affected and the intensity of the effect (4.24).

When might you use the Sponge tool? The uses for adding color (Saturate mode) are obvious — to increase the color depth in faded photos or to amplify colors for effect. The Desaturate mode, which removes color, might seem less useful, and you may not be able to think of a situation that calls for it. Imagine, however, that you want to make one part

● 4.24

● 4.25

of a picture stand out. You could blur everything else, and/or sharpen the item that needs to be the center of attention. If those effects aren't appropriate, you're left with using color to control the visual focus of your viewers. If the object that should be the primary focus is already properly colored, then your best choice is to remove some or all of the color in the surrounding objects (4.25).

[T I P]

To control your desaturation and apply it only to the areas you want to relieve of their color, select the area to be left fully colored, and then choose Select → Inverse. This selects everything but the spot you want to leave with all of its color, and then you can drag over the entire image as you scrub out the appropriate amount of color, without fear of removing color from the wrong places.

To use the Sponge tool in either mode, simply click on the tool and adjust the brush style and size. When choosing a style from the brush presets drop-down list, choose one that gives you the level of uniformity you're looking for. For example, if you want to add or remove color in a solid path, choose one of the crisp-edged, un-textured brushes. If you'd like to leave a textured color in your path, choose one of the brushes, such as Chalk or Dry Brush, and you achieve a more mottled effect (4.26). The size of your brush enhances the effects of the preset you choose, because the larger the brush, the more dramatic the textured effect of the brush will be. If you're using a solid brush preset, choose a size that enables you to add or remove color in the fewest amount of strokes or clicks. Finding the right size might take some experimentation by using the tool and then "Undo-ing" your effects until you find the right size and preset for the look you're going for.

The Flow setting on the Sponge tool's options bar enables you to control how much saturating or desaturating occurs on a single click or stroke with the mouse. The default is 50%, and this is a reasonable setting for a relatively subtle effect. If you want a more dramatic loss or addition of color, increase the setting to as much as 100%. If you want seriously subtle effects, reduce it to somewhere in the neighborhood of 20%, in which case you may not even be able to tell at first glance that any saturation or desaturation occurred. This is good if you're trying to make one item stand out by subtly reducing the amount of color in things around it.

You can always click or drag over a section of the image more than once, but in so doing, you risk the saturation or desaturation effects not being uniform over the portion of the image you're editing. At all costs, avoid the appearance of strokes, because they'll make your effects look unnatural (4.27).

[N O T E]

The Sponge tool can only work with the color that's there. If your image is in Grayscale mode, for example, the Sponge tool won't do anything in either Saturate or Desaturate mode. If your image is in color, your saturation strokes will only intensify the existing colors, and desaturating will remove color from the existing colors, eventually stripping the desaturated areas back to shades of gray.

[T I P]

If you want to bring color back to an area that's been desaturated, use the Undo History palette to bring back color by undoing your use of the Sponge in Desaturate mode. Your first instinct might be to use the Sponge tool in Saturate mode to bring the colors back, but you can't. If you removed the color, Saturate mode won't bring it back because there won't be any color to work with.

● 4.26

● 4.27

Adjusting Hue and Saturation

If you prefer using a dialog box to working with the mouse, you can adjust the amount of color in your photos with the Hue/Saturation dialog box (4.28). To access this dialog box, choose Enhance → Adjust Color → Hue/Saturation. You can make a selection in your image first, which limits the effects of the Hue/Saturation dialog box adjustments to a specific area within your image, and of course, as with all adjustments, selecting a particular layer also restricts the effects.

After you're in the dialog box, you can use the Edit drop-down list to choose which color channel to

adjust. If you leave it set at the default Master, all channels will be adjusted at once. Your options are Reds, Yellows, Greens, Cyans, Blues, and Magentas (4.29). You can choose more than one channel by selecting one and making adjustments, and then going back to the list to choose another and then another, as needed.

The Hue/Saturation dialog box also offers two color spectrums, showing the colors in the color wheel, in the order they appear on that wheel. Note that the starting and ending colors on the bars are the same. You can drag the triangles and vertical bars to control the range of colors that your adjustments affect (4.30), and then use the Hue, Saturation, and Lightness sliders to make your adjustments.

To further control the range of colors that are affected within your image, you can use the three eyedropper buttons in the dialog box. Use the first eyedropper (on the left) to select a single pixel and to focus the adjustments on that color. Note that when you click on a pixel with this tool, the triangles and vertical bars move in the color spectrum, enclosing the portion of the spectrum that is the same color as the one you clicked. You can add more pixels to the range by using the middle eyedropper (the one with the plus sign) to click on other spots in the image. The eyedropper with the minus sign is used to remove a color from the range that you adjust.

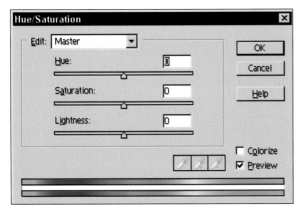

● 4.28

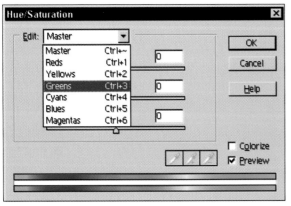

● 4.29

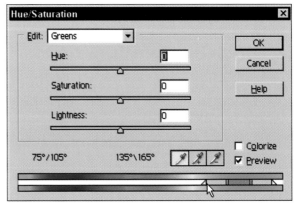

● 4.30

[T I P]

You can use the Hue/Saturation dialog box to create a duotone from a black-and-white (grayscale) image. A *duotone image* is one that's made up of two colors — one of them being black. To choose the other color, set your Foreground color to the color you want to use and then click the Colorize check box in the Hue/Saturation dialog box. You can then use the sliders for Hue, Saturation, and Lightness to adjust the intensity of the duotone effect.

Removing and Replacing Color

Want to turn a color photo into a black-and-white photo quickly? You have your choice of two methods:

- Use the Enhance → Adjust Color → Remove Color command.
- Choose Image → Mode → Grayscale and click the OK button to discard all color information.

The Remove Color command does not convert your image to Grayscale, despite it reducing it to shades of gray; therefore, you can still apply color to the image and use color adjustment tools to adjust or add colors. If you employ the Image → Mode → Grayscale command and OK the discarding of all color information, you will have to convert back to RGB (or any of the other color modes) in order to make use of any color-related commands and tools.

If you simply want to replace one color with another, you can use the Enhance → Adjust Color → Replace Color command to open the Replace Color dialog box (4.31). The Replace Color dialog box gives you tools for creating a mask over certain colors and then replacing them. For example, if you have a photo where all of the grass looks more blue than green, you can select all the blue and then use the mask to confine your efforts to only the blue pixels, and use hue, saturation, and other color-adjustment tools to turn the masked area green. When the dialog box first opens, the Mask view of the image is nearly all black, which means that most, if not all, of the image is masked. Your job is now to unmask the areas you want to recolor.

The Replace Color dialog box offers the following tools to make your masking/unmasking process easier and more controlled:

- Use the eyedropper tools to select areas that are not protected by the mask. The eyedroppers with the plus and minus signs add to and subtract from the exposed areas, respectively.
- Adjust the Fuzziness slider to increase or decrease the amount of similarly colored pixels that are sampled when you click them with the eyedroppers.

● 4.31

As you click in the image, the preview (set to Mask by default) changes. Areas that turn black are masked, those that are white are not masked, and areas that are gray have a semitransparent mask, and are only partially masked. The higher your Fuzziness setting, the more gray and white you end up with (4.32).

After your mask is set, use the Hue, Saturation, and Lightness sliders to replace the colors that are not masked. The results are visible in the image window, and when and if you're happy with them, click the OK button to close the dialog box and accept your color replacement.

● 4.32

Using Quick Fix to Control Lighting and Saturation

Quick Fix is a very aptly named tool, because it fixes a lot of problems quickly. Found at the top of the Enhance menu, it offers many of the same adjustment features that you find in other commands in the Enhance menu. You may find that it replaces your use of those tools in many situations, if only because it offers a Before and After view of the open image, and it gives you tips for using each of the tools and each tools' settings (4.33).

The first step in using the Quick Fix dialog box is to select an Adjustment Category. You have four choices:

- **Brightness.** This category enables you to use Auto Contrast, Auto Levels, Brightness/Contrast, Fill Flash, and Adjust Backlighting commands, all from within the same dialog box.
- **Color Correction.** Choose this category if you want to use the Auto Color or Hue/Saturation commands and tools.

● 4.33

- **Focus.** If you pick this category, you can choose between Auto Focus and Blur functions, which sharpen and soften your image, respectively.
- **Rotate.** Choose from five different rotation options: 90° Right, 90° Left, Rotate 180°, Flip Horizontal, and Flip Vertical. These options affect the entire image, regardless of what layer or portion of the image is selected prior to opening the Quick Fix dialog box.

After choosing a category, you can pick one of the Adjustments, and for each one, use the resulting Apply section settings. If the adjustment you choose to make is an Auto or other no-dialog-box-needed sort of adjustment, you'll just see an Apply button (4.34). If the adjustment requires some feedback from you — sliders, namely — those will appear in the Apply section, and the use of the sliders is what applies the changes to the image (4.35).

Of course, the changes only apply to the After version of the image. They won't apply to your image until you click OK. As you're tinkering with different

adjustments, you can use the Undo, Redo, and Reset Image buttons in the dialog box. These take the After version back one step, forward an undone step, or back to the original, pre-adjusted status, respectively.

[T I P]

Even though you have an *after* version of your image in the dialog box, the image window also reflects your adjustments. Don't worry, though — the adjustments won't be permanent until you click OK. This image window view of the adjustments is helpful, especially if you need to zoom in on the image to see whether the adjustments are having the effect you're looking for. The Before and After versions of the image always show the whole image, and no zoom is possible within the dialog box. By zooming in on the image in the image window (and moving the dialog box aside so you can see both the window and the dialog box), you can see the results of your changes up close, and know they're right before you click OK and commit to them.

● 4.34

● 4.35

Working with Color Variations to Make Sweeping Changes

Photoshop Elements' Enhance menu offers two very similar tools — one, which already discussed, is called Quick Fix, because it provides just that. You find the other, called Color Variations, in the Enhance → Adjust Color submenu, and its name is also very appropriate. Like the Quick Fix dialog box, the Color Variations dialog box (4.36), also contains Before and After views of your image. You can choose from a list of adjustments (section 1), and a series of thumbnails depict your image with a particular type of adjustment (Increase and Decrease options for Red, Green, and Blue, and Lighten and Darken alternatives, too).

The first three options in section 1 (Midtones, which is the default, Shadows, and Highlights) use the same set of eight thumbnails. If you switch to Saturation, however, the thumbnails change, and you're only offered two: Less Saturation and More Saturation (4.37).

Regardless of which section 1 option you choose, section 2 offers the same Adjust Color Intensity slider. If you're adding green or making the image lighter or less saturated, the slider controls how much of an effect the change you selected will make.

As you work in the dialog box, you can use the Undo, Redo, and Reset Image buttons — they work here just as they do in the Quick Fix dialog box. Undo undoes the last change you made, and Redo redoes the last thing you undid. If you want to go back to the original appearance of the image, prior to any adjustments, click the Reset Image button.

[TIP]

You can see your changes in the image window as well, although they won't take effect officially until you click OK in the dialog box. If you want to see your changes in a larger view of the image (or a zoomed in version), drag the dialog box aside so you can see the image window at the same time. This is somewhat difficult because the Color Variations dialog box is rather large, but you can move the dialog box aside and partially off-screen to check the image window and then drag the dialog box back to use it for further adjustments.

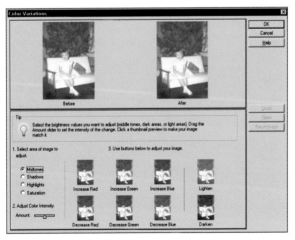

● 4.36

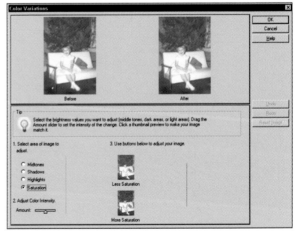

● 4.37

Eliminating Red Eye

The Red Eye Brush, found in the toolbox, literally enables you to click or paint away those glowing pupils that affect pets, children, or anyone wide-eyed and close to the camera and its overzealous flash (4.38).

Using the Red Eye Brush requires use of the options bar (4.39), if only so that you can tell Photoshop Elements which color you'd like to use in place of the demonic glow. You can allow Photoshop Elements to pick for you, or you can select the color manually.

Using the Red Eye Brush

To use the Red Eye Brush, follow these steps to customize the tool's effects and apply them to the glowing eyes in question:

1. Check to see that the layer containing the eyes is the active layer.

2. Click the Red Eye Brush tool to activate it and consider the following options:

 • **Brush presets.** Choose the style brush you want to use. A solid brush is preferable. If your image is slightly blurry, you may want to choose one with soft edges.

 • **Brush size.** Pick one that matches the diameter of the pupil you are fixing. If you can't find an exact match, go with one slightly smaller than the pupil, to avoid an obvious edge against the color of the iris.

 • **Sampling method.** The default is First Click, and the alternative is Current Color, meaning that whatever color is currently showing in the Current color box is used as the bad pupil color, and any pupil in that shade is replaced with the Replacement color.

 • **Tolerance.** This sets the threshold for spotting the sampled color within the pupil when you click to apply the Red Eye Brush tool. A higher number raises the bar and applies the Replacement color more liberally. A lower number lowers the threshold, and more of the pupil is recolored, even the parts that aren't actually glowing.

[N O T E]

The other options (Current, Replacement, and the Default Colors option button) come into play later as you use the brush.

3. **Set your Current color, which is the color of the glowing portion of the pupil. I prefer to set this myself by using the First Click sampling option.** With this Sampling mode in place, click once on the portion of the pupil that's glowing.

4. **Set the Replacement color. If you click the displayed color, you open the Color Picker from which you can choose the color the pupil should be.**

● 4.38

● 4.39

[T I P]

If you click the Default Colors button, the Current color becomes red, and the Replacement color is set to black.

● 4.40

● 4.41

5. **Click on the pupil to apply the Replacement color.**
 The glow is removed in favor of the color you selected. If the pupil is larger than your brush or not shaped like your brush tip, you may have to drag to apply the Replacement color to the entire glowing area.

6. **If both eyes are glowing (they usually are), you can repeat this process for the second eye (4.40).**
 You may want to choose a different size brush and a slightly different Replacement color for the second eye, especially if the subject's head is at an angle. Chances are, the light didn't hit both eyes the same way, and an identical pupil in different sized and colored eyes will look fake.

Getting Rid of Red Eye Manually

You can also get rid of red eye manually by using the Eyedropper tool to select a Foreground color from the very edge of the glowing pupil (4.41). This is usually the color that the pupil would have been had the red eye effect not occurred.

Then, use the paintbrush (sized to match the pupil) to paint out the glow. This can be done with a single click, or if the pupils are oblong, two clicks or a short drag with the brush (4.42). Be careful to use a brush that's slightly smaller than the pupil so you don't end up with a crisp edge — it looks funny against the iris, and consider reducing your brush Opacity setting so that your color isn't too dense.

You can add a light or white glint on the pupil with a small-sized paintbrush for a shiny-eyed effect. Just take note of where any light spots are on the iris, which indicates where reflected light is already appearing. Make the glint very small and subtle — and don't drag the mouse. Any attempt to "draw" the shine on looks just that — drawn. Instead, click once or twice to create a very tiny, crystalline spot of reflected light (4.43).

When manually removing red eye, it's good to work with your zoom set to a very high magnification. Get

right in there and work as close to the eyes as you can. You may find, however, that working at that close a zoom, you can't tell if your results are very natural looking. When you zoom out, which you can do intermittently during the red eye removal process, you can see how the image will look when printed or viewed in actual size onscreen (4.44).

The Big Picture

In this chapter, you discovered how to control the amount of light in your photo, adding it where there wasn't enough, or changing the direction of new and existing light sources. In the next chapter, you read how to rearrange and get rid of any undesirable content in your image, from people to inanimate objects and backgrounds, and how to make your changes and additions appear as seamless as possible.

● 4.43

● 4.42

● 4.44

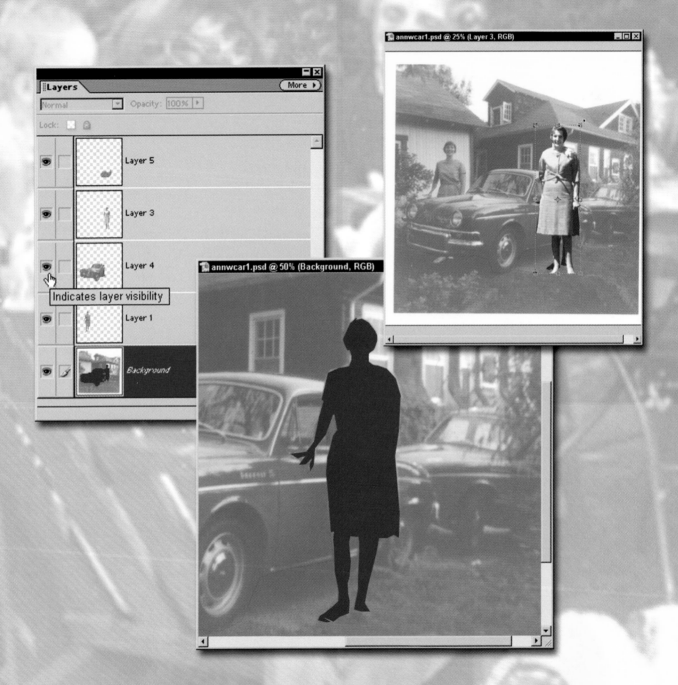

Moving and Removing Unwanted Content

All that is not useful in a picture is detrimental. A work of art must be harmonious in its entirety; for superfluous details would, in the mind of the beholder, encroach upon the essential elements.

<div align="right">HENRI MATISSE</div>

Most photographs, even those produced by seasoned photographers, exhibit the occasional bad composition. By composition, I mean *arrangement* — the way the objects in the photo are "framed" by the edges of the photo, how they work together, and whether or not the overall photo is balanced. When a bad composition happens, you may look at that photo and wish you could move this there, that here, and nudge something one way or the other. With traditional photographic editing methods — literally slicing up photos, cutting and pasting content between prints, and reshooting them — editing would be an arduous, probably prohibitive task for anyone but a professional, but with Adobe Photoshop Elements, it's relatively easy for anyone to do it.

Photoshop Elements' tools also make it easy to remove unwanted content. For example, maybe you wish everyone in the photo hadn't been standing in front of the garage, and you wish they'd been in front of the house. If you have a picture of the house, you've got it made — the garage can go away, and the house can take its place!

In this chapter, you discover how to select objects in your photo and move them to their own layers so that you can rearrange the photo's components, how to get rid of unwanted content entirely, and how to replace what you've moved or removed with desirable

filler. You also read how to take objects from one photo and use them in another, combining everything you like into one good picture.

Rearranging Image Content

So a lamp is right behind someone, and the shade looks like a hat, or your great aunt, who is no longer with us, is partially obscured by a large bit of shrubbery, and you'd like her to have a more prominent position. Whatever you want to move and whatever reasons you have for moving it, Photoshop Elements is there to assist.

To rearrange content in your image, you need to do four things:

- Select the items to be moved, placing each item on its own layer.
- Decide where the items should go.
- Fill in where the items were, so that there isn't a gaping hole left in their wake.
- Make the moved content blend into its new surroundings.

These steps aren't the whole procedure, but they constitute the major parts of it. The detailed steps follow in the next sections.

[T I P]

Saving an untouched version of your photo is a good idea before doing anything as drastic as rearranging or deleting content in the image. To do so, choose File → Save As and rename your photo. The original version closes, and you can work with the new version. You can delete the original version later, if and only when you're sure you love the new, edited version and have absolutely no possible need for the photo in its original state. I rarely delete original versions due to the number of times I've been very relieved to have them!

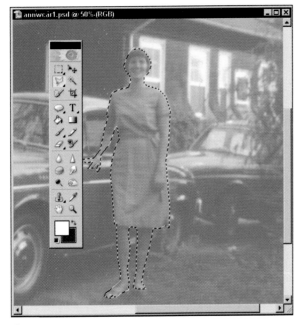

● 5.1

Selecting the Content to be Moved

The first step in rearranging image content is to select what you want to move. If you want to move a detailed object — a person, some trees, a car — use the Lasso tools. The Magnetic Lasso works well if there's a lot of color or lighting difference between the item to be moved and its neighboring objects. Or, use the Polygonal Lasso if you want to do it free-hand. I suggest using the Polygonal Lasso, even for objects with soft, rounded edges, simply because it gives you more control than the plain Lasso (5.1).

[T I P]

If you want to select a large area — say several people standing together or a large object behind people — use the Rectangular Marquee tool and use the Add to or Subtract from Selection modes after you switch to your favorite (or the most appropriate) of the Lasso tools. You can then augment or reduce the basic square or rectangle to allow for the detailed shapes on the edge of the area you want to move.

1. **With the photo open, and the layer containing the content you want to move activated, choose a selection tool that enables you to select the first (and perhaps only) item you want to move.**

2. **Select the object to be moved. It usually helps to zoom in (use the Zoom tool or the Navigator palette) so that you get a detailed view of the object you're selecting.**

3. **Cut the object to its own layer by choosing Layer → New → Layer Via Cut.**
 This cuts the selected content to a new layer (5.2). It looks as though nothing has happened, because the selected content is in the same position it was in before it was cut.

Moving the New Layer's Content

After you have a new layer for the cut content, acti-vate that layer by clicking on it in the Layers palette and then use the Move tool to place it anywhere on the image (5.3). Using the Layers palette, you can also change the stacking order of the layers. This makes it possible to move something so that it's now behind something else (5.4), or in front of things that once obscured it.

[T I P]

To make it easier to restack the items in your image — controlling the overlapping of content within your photos — you may want to put each of the photo's major components on its own layer.

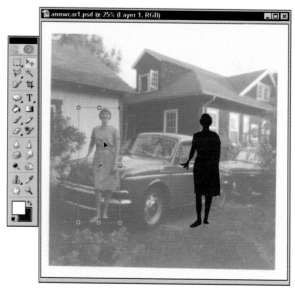

● 5.3

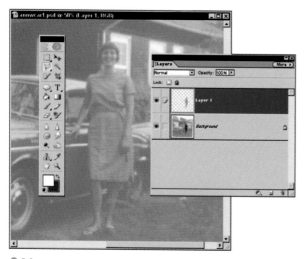

● 5.2

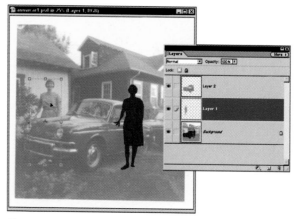

● 5.4

● 5.5

Moving your layers is easy: Click on the layer to activate it and see the bounding box that appears around your layer content (5.5). Point anywhere inside the box (not to an edge or a handle), and drag. If you accidentally resize the layer by dragging from one of the handles on the sides or corners, simply choose Edit → Undo or press Ctrl + Z (Command + Z if you're on a Mac) to go back a step.

To rearrange your layer's stacking order, simply drag them up and down in the Layers palette. The pointing finger turns to a clenched fist as you grab and drag a layer (5.6). Just let it go when the ghost box that follows you as you drag is above the layer your content should overlap (5.7). You know if you achieved the right stacking order when you look at your image.

Making Moved Content Feel at Home

When content is moved, it may not fit in. There may be sharp edges (5.8), or you may have accidentally left some of the object behind. You may have also selected (and therefore cut and moved) some of the object's neighboring content, and this can make the moved content stand out like a sore thumb. You may also need to resize the content or adjust its lighting so that it fits in with its new neighbors.

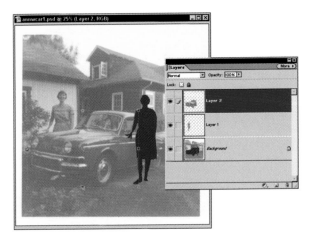

● 5.7

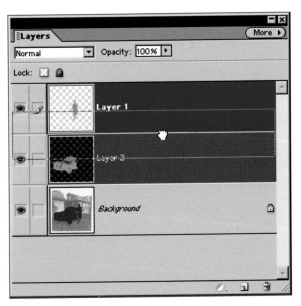

● 5.6

You can use the Blur tool (set at 50% or lower strength) to soften sharp edges (5.9), and you can use the Eraser to get rid of extra stuff around the object — because the content is on its own layer, blurring or erasing the edges won't affect anything else. Of course, if the old location looks hacked up because you cut away more than just the content you wanted to move, you can select the extra bits around your moved content and then cut them to a new layer and move them back to their original location. This can be tricky, so it's best to avoid this problem in the first place by making a clean, neat, and tight selection of the content to be moved.

Covering Up and Blending In

One of the more difficult adjustments your moved content has to make occurs when you move an object that was once partially obscured by other content to the foreground or to a spot where it's no longer totally obscured. When this happens, you have to put something new in front of it to cover the parts of the object that don't exist. You also have to find something to cover up the hole left by the object you moved (5.10).

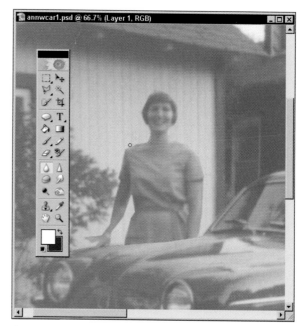

● 5.9

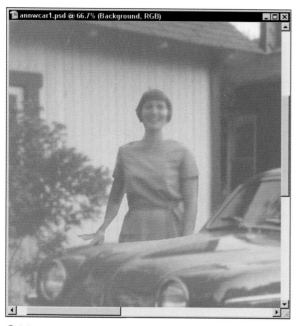

● 5.8

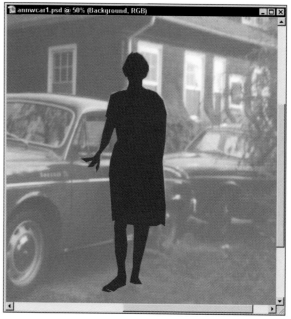

● 5.10

Placing new content in front of the moved content or to fill the hole left behind requires reusing existing content, and this is done by selecting content from elsewhere in the image and placing it on a new layer by using the Layer → New → Layer Via Copy command (5.11). After the copied content is on its own layer, you can move it into position.

[T I P]

You can use the Image → Transform → Free Transform command to activate a bounding box and rotate a layer's content so that it fits better over the hole.

If nothing in your image or any other image is large enough to cover the hole left by your rearrangement, you can use one object repeatedly. A small shrub can become a large one if you place two or more iterations of it on the image. All you have to do is duplicate the layer you created once (drag the layer down to the Create a New Layer icon at the foot of the Layers palette) and position each of the duplicates over the hole (5.12).

If you want to use content in another image as your cover-up content, open that image (think of it as your source image), and select the portion you want to use in the other image (which you can think of as the target image). After selecting the source content, use the Layer → New → Layer Via Copy command to leave the source content in place, and to create a duplicate version on a separate layer (5.13). You can then drag that layer from the source image's Layers palette onto the target image. As soon as you release the mouse, the

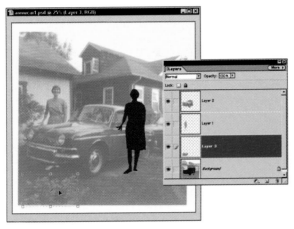

● 5.11

● 5.12

● 5.13

layer becomes part of the target photo, and you see the layer in the Layers palette (5.14).

After the new layer is in the target photo, you can move it into place, moving it up or down in the Layers stack, and moving it to the spot where you need it to cover a layer with incomplete content.

Resizing Your Rearrangement

Finally, you may need to resize the moved content to make it fit in its new location. If the moved content used to be in the background and now it's in the foreground, it may need to be enlarged. If the content used to be closer to the camera and now it's in the background, you'll probably need to make it smaller. Making either sizing change is simple — just select the layer containing the moved content and choose Image → Transform → Free Transform (Ctrl + T in Windows; Command + T on a Mac). This gives you a chance to purposely use those bounding box handles (5.15). You can drag from any corner, and if you press the Shift key as you drag, you preserve the content's current width-to-height proportions, also known as the *aspect ratio*. If the object won't look funny if it's a bit wider, narrower, shorter, or taller, you can use the corner, side, top, or bottom handles to resize it, and don't use the Shift key.

Creating a Clever Cover-Up

You can also use the Clone Stamp to create the cover-up, repeating content from elsewhere in the image and painting it into the spot needing coverage. Or you can draw the coverage, using the Brush and Pencil tools, and the Paint Bucket to fill in. Of course, drawn content may look like just that — something you drew in to fill in where a person's legs should be or where the back half of a car would have been if it hadn't been obscured by something else when the picture was taken. It's best, therefore, to use existing content from this or another photo to create the coverage. If you find that there's no way to cover the problem, you may want to put things back where they were, or use the File → Revert command to go back to the photo's pre-rearrangement state.

● 5.14

● 5.15

Shedding the Right Light

Just as the size of content that was in the back of the image may be different from the content in the front, so may be the lighting. Your background content may have been in shadow, or it may have been getting sunlight that the foreground wasn't, or vice versa. People you moved from the left side of a photo to the right may have been next to a lamp in their original location, and now they're not. What to do? Use Photoshop Elements' lighting tools (which Chapter 4 covers in detail) to make your moved content blend in nicely. Your options:

- Use the Lighting Effects filter to apply the illusion of lamplight, sunlight, or a bright camera flash.
- Use the Dodge tool to make content lighter and bring out highlights.
- Use the Burn tool to add shadows and overall darkness.

- Use the Quick Fix or Variations dialog box to make an all over change to your layer, adding more of a particular color, more or less light, or to change brightness and contrast.

[T I P]

Whichever lighting effect you choose to apply, you may need to apply it to the surrounding content's layer, too – if only to make sure that the artificial effect you apply to the moved content really matches the content's new surroundings. If the lighting in the entire image was fairly uniform to start with, however, all of this will be much simpler, and you may not need to do much light adjustment at all.

After adjusting the size, lighting, and position (and perhaps placing a few bits and pieces from elsewhere in the image to fill in places where the cover-up layer didn't quite fit the hole left by the moved content), you hopefully have a photo that doesn't look doctored — if you play your cards right, it should look like the current scene is exactly what was in place the day the photo was taken (5.16).

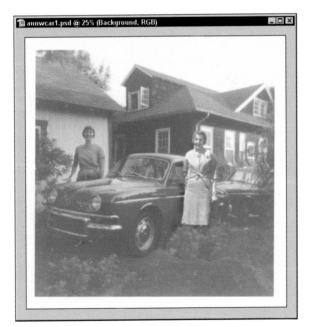

● 5.16

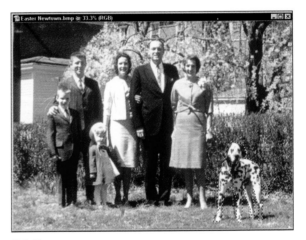

● 5.17

Removing Undesirable Content

Sometimes moving things around just isn't enough. You may have content in your image that you simply want to be rid of — people, cars, garbage cans, mud, buildings, plants, trees — just about anything can become objectionable if you didn't want it to be in the picture in the first place. If you're no longer with your significant other or spouse, don't tear all your photos in half — consider replacing the unwanted person with more of the background, a large potted plant, or your new spouse or significant other. With few exceptions, there aren't too many things you're stuck with — in life, or in your photos. You don't need to hide photos in a drawer just because there's something or someone in them that you now regret — just delete them and place something pleasant in their stead.

Selecting and Deleting the Unwanted Content

It might seem like some sort of complicated slight-of-hand, but replacing one piece of content with another is really rather simple, and just a few steps are required — starting with selecting the unwanted content and ending with its disappearance:

1. **Identify the unwanted content, and use a selection tool, preferably a free-form or magnetic selection tool such as Photoshop Elements' Lasso, to select it** (5.17).
2. **Press the Delete key to get rid of the selected content.** The background layer or any other underlying layer's content now shows through the hole.

[T I P]

If you think you may want to bring the unwanted content back, you can use the Layer → New → Layer Via Cut command to place the unwanted content on a separate layer. You can hide that layer by clicking the eye next to that layer on the Layers palette. If you ever want the content to show again, just click the box where the eye once was, and the content reappears.

Filling In the Void

Filling in the hole left behind by your deleted content is the trickiest part of this process. Not because it's procedurally difficult, but because some photos make it more complicated due to a lot of surrounding content that the fill-in content has to blend in with, or because there isn't any content that makes sense to copy and reuse to fill in the hole left by whatever you deleted. Depending on the problems your specific photo presents, you may want to use one of two procedures:

- Cloning content from somewhere else in the image — existing background or landscaping
- Creating a new layer from an object elsewhere in the same image or in another image and positioning that layer over the hole

Cloning to Fill the Void

If the deleted content is up against a background, such as a hedge, wall, or other fairly simple texture, your job is easier — just extend the background to fill in. This can be done with the Clone Stamp, as you paste content over the hole with this brush-based tool (5.18).

● 5.18

Using the Clone Stamp to extend the background (or to fill in one part of the image with content from elsewhere) is simple if you follow these steps:

1. **Decide which part of the image you are cloning.**
 It might be a small spot that you can repeat many times or a larger area that you can clone just once.

2. **Click on the Clone Stamp to activate it.**
 Be sure the Aligned option is off on the options bar (5.19), and leave the defaults in place for Mode (Normal) and Opacity (100%).

3. **Set your brush Size so that you clone as much of the source area as possible without getting any undesired surrounding content or creating an obvious cover-up** (5.20).

● 5.19

● 5.20

● 5.21

4. **Press the Alt key and while holding it down, click on the spot you want to clone.**
 A small crosshair appears in the brush's circle, indicating that you're cloning the content beneath your cursor.

5. **Release the Alt key and begin placing the cloned content over the hole left by your deleted content.**
 You can click one or more times, moving the mouse slightly between clicks. Try to avoid the creation of a pattern, which can occur if you click in straight rows or columns or follow a geometric path with your clicks. Click somewhat randomly, so that the fill looks natural (5.21).

[T I P]

When cloning, you can use a very small brush to do fine work, creating details, such as patterned fabric, or a natural, unstructured pattern, such as a flowerbed or a patch of grass. You stamp with your mouse more often with a small brush if you're filling in a large area, but you also avoid an obviously doctored look.

Creating a New Layer to Fill the Void

If using the Clone Stamp is out — perhaps because there's too large a hole to fill or because you want to use an object to fill in rather than extending some shrubbery or background — you can take an object from elsewhere in the image and repeat it, or you can take an object from another image and use it to fill in the hole. This procedure is nearly identical to that which you use to fill in a hole after content was rearranged, and if you already did that sort of work, this will be very simple for you.

To create a layer from content in your current image, follow these steps:

1. **Select the object you want to use as filler.**
 It's best to use the Lasso selector tools — Polygonal or Magnetic for the most control — because it's unlikely that your object is a perfect rectangle, square, oval, or circle. You can also use the Selection Brush if you can size it appropriately and control it well enough — it's a bit more controllable than the plain Lasso, but is not quite as precise as the Polygonal or Magnetic Lasso tools.

2. **Turn the selection into a new layer by choosing Layer → New → Layer Via Copy.**
 This does two things: It copies the selection and puts it on a new layer, all in one step. The reason you're copying instead of cutting is that the content you're using should also remain where it is — otherwise you have another hole to fill!

3. **Observe the new layer.**
 You can rename it (double-click the name in the Layers palette and type a new one, and then press Enter/Return), or just leave the generic numbered name that Photoshop Elements applied by default.

Free Your Creativity with Fill Layers

You can also create Fill Layers (Layer → New Fill Layer → Solid Color, Gradient, or Pattern) and then resize and move that layer into place on top of the hole you wanted to fill. This won't work in many situations, but if you're taking a more "artistic" approach to ridding your photo of unwanted content, you may like some of the effects. You can fill the hole with all sorts of patterns, a gentle gradient, or a solid color — whatever makes the most sense for your artistic vision. If you need to reshape the new layer, use the Eraser to whittle down the edges so that the pattern, gradient, or solid color is the right shape for the hole left by your deletion.

4. **Move the layer up or down in the Layers palette stack.**
 The stacking order in the palette is the same as the stacking order in the image. If your content should be on top of something else in the image, drag the new layer up in the stack so that it appears listed before the layer it should overlap.

5. **Use the Move tool to position the layer so that it fills the hole.**

[T I P]

As soon as your layer is in position, you can tweak its location slightly by using the arrow keys to nudge it in tiny increments. This can be easier than using the mouse for fine movements.

Creating a Layer with Content from Another Image

If you have nothing in your current image that can serve to fill in the hole left by the content you deleted, you can go to another image to get the filler you need. With that image open on-screen, simply select the content you want to use, and repeat Steps 1 through 3 from the previous section: Select the content and copy it to a new layer. Then take the new layer and drag it onto the image window where you need the filler. As soon as you release the mouse, the layer then appears in the Layers palette, and you can move it up or down in the stack so that it overlaps or is overlapped as desired, and then use the Move tool to put it into its final location, filling the hole left by your deletion.

Retouching the Filler Content

Just like content that was moved from one place to another in the same image, the content you use to fill in after a deletion may need to be retouched so that it blends in seamlessly. You don't want it to look like one of the tabloid photos where heads are pasted onto other people's bodies, right? As discussed earlier in this chapter, your options are as follows, and depend largely on the sort of problems you're faced with after your filler content is in place:

- Adjust the lighting of the filler, by using the Lighting Effects filter, Dodge tool, Quick Fix, or Variations commands (all discussed in Chapter 4).
- Use the Blur tool to get rid of any sharp, obvious edges on the content.
- Erase edges that don't fit or where your selection process accidentally included surrounding content.

● 5.22

To Merge or Not to Merge

After you place a new layer in your image, whether you did so to rearrange existing content or to fill in a hole where something used to be, you may want to make that layer's content part of the entire image, turning the photo back into a single layer. Some reasons why:

- So that you can apply retouching tools to the entire image in one step, rather than applying them to individual layers, which risks a lack of uniformity
- To reduce the file size
- So that you can select content that would have been on separate layers

If any of these reasons are valid in your situation, you can merge your cut or copied layers by choosing Layer → Merge Visible (Shift + Ctrl +E in Windows; Shift + Command + E on a Mac). This command enables you to merge only certain layers (those that you need to retouch together or that you want to put together for selection purposes) by hiding those that you don't want to merge.

To hide layers, which keeps them out of the merging process, simply click the eye icon next to those layers in the Layers palette (5.22). Of course, you want to make sure that there is an eye icon next to all the layers you want to merge.

You can also link layers that you want to merge, which enables you to leave some layers out of the merging process (if they're not linked to the active layer). To link layers, click in the Link box (next to the eye icon), and you see a chain symbol appear (5.23). The layers with chains next to them are then linked to the active layer, and you can choose Layer → Merge Linked. The linked layers become one, and the layers that weren't linked remain separate layers, just as they were.

You have plenty of reasons to leave your layers intact, each separate from the others. Consider these scenarios:

- You may want to move a layer later, or hide it at some point.
- You may need to use one of your layers in another image.
- You want to be able to retouch the layer on its own, not risking blurring, erasing, recoloring, or relighting any of the surrounding content on other layers.

If any of these scenarios seem valid in your situation, by all means, leave your layers separate. You can lock your layers so that no one — you or anyone else working with the photo — can move, delete, or in any way edit them, which gives you some of the

security that merging them does, but it doesn't eliminate your ability to deal with distinct parts of your image on their own. To lock a layer, simply click on it to select it and then click the Lock All icon (the tiny padlock) on the Layers palette (5.24).

The Big Picture

In this chapter, you learned to recompose your photos — moving people, animals, objects, and background around to create a more pleasing arrangement. You also found out how to get rid of content that's not just in the wrong place, but completely unwanted in the photo itself. In the next chapter, you learn to repair scratches, tears, and small spots — the sort of common damage that you find in both old and new photos.

● 5.23

● 5.24

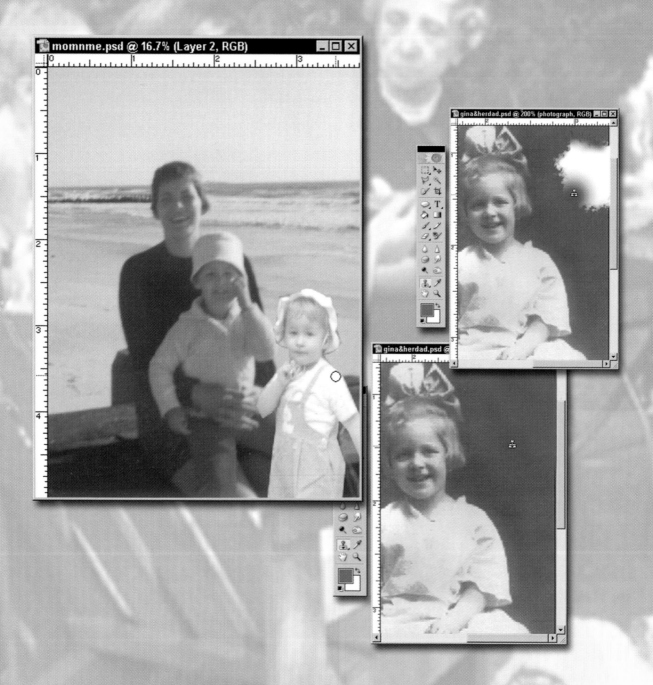

Repairing Scratches, Tears, and Spots

My great longing is to make those very incorrectnesses, those deviations, remodellings, changes in reality, so that they may become, yes, lies if you like — but truer than the literal truth.

<div align="right">VINCENT VAN GOGH</div>

In paintings, yes, imperfections can be an integral part of the picture and can add authenticity to the subject matter, but in photos, the scuffs, scratches, rips, and torn corners don't necessarily add any value — aesthetically or otherwise. Of course, we expect and maybe enjoy the tiny signs of age as they appear on truly vintage photos, but when the signs of wear and tear distract the viewer or detract from the perceived quality of the image, you want to be rid of them. Luckily, Adobe Photoshop Elements provides a bevy of tools for just that purpose — to make the picture perfect, or at least restore it to the way it was before time, improper storage, or vandalism took its toll.

In this chapter, you learn to build back content that's been lost — literally removed due to tears, rips, or purposeful damage. You discover how to use tools that create new content from existing content and to make the patched spots blend in with their new surroundings. You also learn to use blending tools to gently smudge, paint, and generally touch up a photo to remove the signs of age (in the photo, not in the subjects — that's covered in Chapter 9). In addition, through the use of color and lighting tools, you learn to remove stains by eliminating their color and texture, and should a particular stain or other surface mark prove to be a formidable foe, you learn how to mask spots and stains creatively.

Reconstructing Torn Images

When a photograph is torn, the content along the tear is usually unsalvageable. If a corner or more of the image is torn and literally torn *off*, of course that content is gone, too. Before the advent of photo editing software, you would have to crop the image to what was untouched by the tear, and resign yourself to the loss of the torn or missing content. With Photoshop Elements, however, you have the tools to reconstruct and literally recreate the content that's been torn

through or torn away. You can take a significantly damaged photo (6.1) and restore and repair it (6.2). The degree of effort involved depends solely on the amount of the image that's missing and what other content you have to work with in recreating the portions that are gone.

In the reconstruction process, you primarily utilize two features:

- The Edit menu's Copy and Paste commands, which enable you to take sections of any image and duplicate them for positioning elsewhere — somewhere else in the same image or in another image entirely
- The Layer Via Copy command, which creates a new layer in your image, based on content you select in the same or another image

[N O T E]

For smaller tears, you can use the Clone Stamp to rebuild what the tear itself has damaged. See the section, "Fixing Minor Rips, Tears, and Scratches," later in this chapter for complete instructions for using this tool. Generally, the Clone Stamp is not the best choice for rebuilding large sections of an image.

Of course, as soon as your repairs are in place, you'll want to make them blend into their surroundings.

You can do this with various lighting, color, and sharpening/blurring tools, making it possible to use content from just about anywhere to rebuild the content that is missing from your damaged photo.

Rebuilding Missing Content

The missing corner, the big chunk out of the middle of a photo, the strip of content lost to a huge rip — this content can be rebuilt by using other content within the same image, or by "borrowing" content from another image. Of course, to simplify your life, if you grab content from another image, it helps if that image is similar to the damaged one — the same age, similar lighting (indoor versus outdoor), taken at a similar distance (to avoid having a lot of resizing to do), and so on. Images taken on the same day or at the same event provide a lot of potential content for rebuilding a damaged image (think of wedding photos taken by the same photographer, shots taken on vacation) as do vintage photos that are the same shade of sepia, printed on the same kind of paper. The more elements your damaged photo and the "donor photo" have in common, the easier it will be to make the donated content blend in.

If another photo is not available for the rebuilding process, you'll have to use other content from within the same damaged image. This usually solves the problem of making content match, although one part

● 6.1

● 6.2

of an image can have different lighting or focus than another part of the same image. When using content from within the same image, it can mean taking one of the undamaged corners and reusing it, rotated to fill in for a missing corner, or taking content right next to the rip or hole, and using it to make the rip or hole go away (6.3).

The process of using content from within the same image or from another image is the same — you're duplicating the patch material and positioning it over the damaged area, and then making the repairs blend in. This three-phase process is made simple in Photoshop Elements, using selection tools to choose the content that will be reused, the Layer or Edit menus' commands to create the patch content, and Layers palette to position the patch content where it does the most good.

Using Copy and Paste

If you want to select a section of your image (or another image that's also open on the Photoshop Elements workspace) to use as the patch for your repair or a portion thereof, you can use any selection tool to select the content and then choose Edit → Copy to make a duplicate of the selection. Be sure, of course, that the appropriate layer is active so that you get the content you want.

[T I P]

You can also issue the Edit → Copy command via the keyboard. If you're using Windows, you can press Ctrl + C to copy and Ctrl + V to paste. If you're on a Mac, the shortcuts are Command + C and Command + V, respectively.

After the copy is made, choose Edit → Paste (in the image to be repaired), and the copied section appears on the image. If you copied from the same image, the duplicate you paste appears on top of the original selection — making the duplicate nearly invisible. You only know it's there because a new layer appears in the Layers palette (6.4).

[T I P]

When selecting the portion of the image that will serve as the patch, consider whether or not it will be easy to hide sharp corners or overly straight edges, such as you find if you use the Rectangular or Elliptical Marquee tools. I prefer to use the Lasso tool, or the Selection Brush tool, so that I select only what I need and can achieve an edge that's more natural – perhaps even managing to select a shape that matches the damaged area.

● 6.3

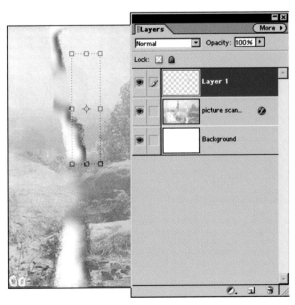

● 6.4

If you Paste into an image other than the one from which the copy was taken, you can spot the pasted content immediately (6.5), and you can also see a new layer appear in the Layers palette.

Once the pasted content is in the damaged image, switch to the Move tool and drag the patch into position (6.6). It may not blend in seamlessly, as it is likely to have sharp edges, and if it came from a spot on the image or another image that isn't the same in terms of lighting, texture, and color, it will stand out until you tinker with those aspects. As I discuss later in this chapter, you can make just about anything blend in — removing or adding color, changing contrast, adding or removing light, using tools to soften edges so that the pasted patch looks like a part of the original image.

Creating and Positioning New Layers

Another way to duplicate content from an image (the damaged one or another image) for use in patching a scratch, tear, or large hole, is to create a layer based on a selection. Using the appropriate selection tool, select the area to be used as the patch, and then choose Layer → New → Layer via Copy. This places the selected portion of the image (from whichever layer was active at the time) in a new layer (6.7). You can then drag the new layer onto the damaged area with the Move tool.

[T I P]

You can rename any layers added through pasting or using the Layer via Copy command to make them easier to find and use. If you have a lot of generically-named layers — "Layer 1," "Layer 2," and so on — double-click the name of the layer you created to serve as a patch, and type a new name for it. "Patch" or "Cover-up" are good choices. After you type a new name, press Enter/Return to confirm it, and now you can spot the layer quickly whenever you need to select it for moving, resizing, or any other layer-specific treatment.

Making Repairs Blend In

As soon as your patch is in place, you can assess its effectiveness. You may need to go get more patching material by selecting more content from the same or another image and repeating whatever duplication and positioning procedure you used in the first place. As soon as all the patches are in place, however, it's time to make sure they do the best job they can. This often means:

- Changing the light levels
- Adjusting saturation and hue
- Tweaking the color levels
- Blurring the edges of the patches
- Using the Sharpen or Blur tools to create the same level of focus in the patch as exists in the surrounding content

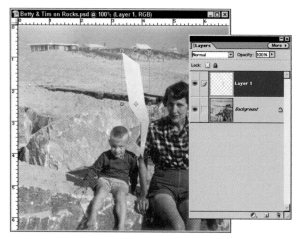

● 6.5

● 6.6

Creating Shadowy Illusions

If you're adding something new to the image to cover damage — say a shrub or a person, or a slab of grass or roadway — don't forget to make changes to the surrounding area. The new landscaping is bound to cast a shadow, and you can to use the Burn tool to create the shadow, or duplicate the area that would be in shadow, and apply color-adjustment commands (Color Variations, for example) to darken the duplicate content. To make the shadowed duplicate blend in, reduce the Opacity settings for the duplicate layer and/or soften the duplicate with the Blur tool. You can make anything appear to be sitting heavily in its new spot by creating a shadow beneath it, or by darkening surrounding content just a little bit, so that the new content seems more at home.

[CROSS-REFERENCE]

All of the tools involved have already been covered to this point in this book — you can check Chapter 3 for more information on adjusting color and Chapter 4 to read more about adjusting light. For any tool you want to use, check Chapter 1 where all of the tools, option bars, and palettes are introduced and explained.

Adjusting Light Levels

To make the patch content blend in, you may have to make it darker or lighter, so that it matches the surrounding pixels. You can do this in a number of ways:

- Use the Dodge and Burn tools to apply more light or shadow with your mouse.
- Work with the Adjust Lighting submenu, which you find in the Enhance menu.
- Access the Quick Fix command, which you find at the top of the Enhance menu.
- Use the Color Variations command, which you find by choosing Enhance → Adjust Color → Color Variations.

Whichever tool you use, be sure to select the patch first, and make sure that the patch content layer is active before you make any changes. You don't want to accidentally lighten or darken the main image, leaving the patch untouched. On the other hand, if only the pixels immediately surrounding the patch are not a good match for the patch content, you can lighten or darken those pixels, making the patch blend in as well as solving a lighting discrepancy that already existed in the original image.

Softening the Edges

When the patch is first positioned over the damage, it will probably stand out like a sore thumb by virtue of its crisp, sharp edges (6.8). You can eliminate them

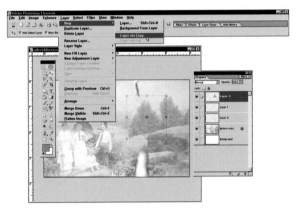

● 6.7

● 6.8

by using the Blur and/or Smudge tool to soften them, scrubbing over the edges until they blend in with the rest of the image.

If the image you're patching is sharper or softer-focused than the patch content, use the Blur or Sharpen tools to make things match — adjusting the focus of the patch to match its new surroundings or adjusting the focus of the damaged image to match the patch. Whichever is less work (requiring less tinkering) is the way to go. If you can make a slight adjustment to a small area, that's always a better idea than making intense changes to a large area.

There's one exception: Imagine that your patch comes from an image that's very sharp and crisp and you're using it in an image that's very much out of focus. In such a case (6.9), it may be impossible to use the Sharpen tool or Sharpen filter to make the entire image sharp enough to match the patch — you can end up with bright spots and odd coloration if you overuse the sharpening tools and filters. If this happens, it might make more sense to soften the patch so that it's as out of focus as the rest of the image — again, taking a path of least resistance.

As you work with your damaged photos and the patches you bring in to repair them, each situation can direct you, and you find the right combination of tools and techniques to solve individual problems if you experiment and refer to guides, such as this book.

Merging the Patch Layers

After you add a layer to patch your image and do whatever's needed to make that patch blend in with the surrounding pixels, you may want to merge the patch with the original image. Why? So that you can deal with the image as a single unit, simplifying any resizing, moving, or editing that involves the damaged area and its patch. You only want to do this if your patch is perfect (or as close to perfect as possible) in terms of blending in — the lighting, focus, and texture adjusted to make it a seamless repair. As soon as this is achieved, choose Layer → Merge Visible (6.10).

● 6.9

● 6.10

This option makes one layer out of all the layers that can be seen in the image and enables you to hide any layers that you don't want to include in the merge, such as any Type layers you may have added. Of course, you want to hide the layers that shouldn't be merged before you issue the Merge Visible command.

Fixing Minor Rips, Tears, and Scratches

Unlike big tears that result in completely mangled or missing content, you'll find that minor scratches, tears, wrinkles, and rips are far more commonplace, and luckily, far easier to repair. Instead of having to recreate missing content, you simply need to eradicate the small signs of damage (6.11).

The tools you can use to make these simple repairs include

- The Clone Stamp
- The Paint Brush
- The Smudge tool

With these tools, you can patch any kind of simple tear or rip, eliminating any sign that your photo was at one time torn in two, ripped along a fold (which you can also get rid of), or seriously scuffed. You can also paint out the signs of damage by applying a solid color or pattern to the image. Finally, if your damage is slight — tiny spots, very small scuffmarks — you can Smudge them away, utilizing Photoshop Elements' Smudge tool to literally smear the spots away.

You can apply these restorative tools to extremely small areas, eliminating signs of damage one pixel at a time, or to larger areas if the damage is widespread or is repeated in several contiguous areas. Because all three tools are brush-based, you can decide how much of your image to repair with each click or drag of the mouse by setting the brush Size before using the tool.

[**N O T E**]

If any single site of damage takes up more than 10 or 20 percent of your image, don't use the Clone Stamp, Paint Brush, or Smudge tool to fix it. If you try to use these tools to repair a large area or to reconstruct a great deal of missing content, you'll find that your restorative measures can be too obvious, and the image can look "doctored." Tools like these, which can be used to tinker with very small areas, don't lend themselves to large seamless repairs.

Using the Clone Stamp to Fix Rips and Tears

The Clone Stamp duplicates content from one place and enables you to click and place it (thus the term

● 6.11

"stamp" in the tool's name) one or more times in the image, covering existing content or restoring content lost to significant damage (6.12). You can clone content from within the image you're repairing, or you can clone from within another image — it all depends on what you need to restore or rebuild and where the most likely content to serve can be found.

To use the Clone Stamp, follow these steps:

1. **Check the Layers palette, making sure the layer containing the content you want to clone is the active layer.**

 You can switch to another layer later as needed when you stamp the content onto the image.

2. **Click on the Clone Stamp tool to activate it.**

 The Clone Stamp's options bar (6.13) appears

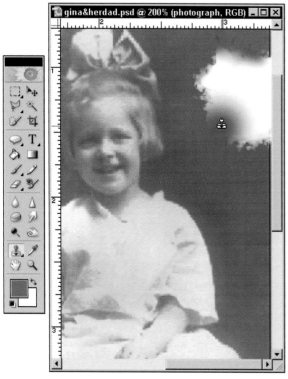

● 6.12

and offers several settings you can tweak to control how the tool is applied:

- **Brush preset.** These are the brush styles you set for painting, erasing, or using any brush-applied tool.

- **Brush size.** Pick one based on your target area, going for a size that's just a bit smaller than the area you want to stamp over. Why? So you don't leave an obvious edge to a single stamping of content. With two or more stamps in the area, you can avoid a clumsily-pasted look.

- **Mode.** When the cloned content is pasted, you can choose a mode to control how the stamped content is lit, colored, and shaded. Normal works for most jobs, but you may want to experiment.

- **Opacity.** If you want to see through your stamped content, reduce the opacity from the default 100%.

- **Aligned.** This option keeps the same distance/offset between the sampled spot (where you clicked the Alt (Option) key) and the stamped area. If you leave this off (the default), the cloned location keeps changing as you move your mouse and continue stamping.

- **Use All Layers.** Turn this option on if you want to clone content from all of the layers in your image at once, not just from the active layer. When the option is on, the cloned content is also applied to all layers.

3. **After you customize the tool as needed, you're ready to clone and stamp.**

● 6.13

To clone the spot that will be used to cover unwanted content, press and hold the Alt key (Option on a Mac) and simultaneously click on the spot that you want to clone. The mouse pointer changes when you're in clone mode, and a crosshair appears in the center of your brush point.

4. **Release the Alt (Option) key and apply the cloned content by clicking to cover the unwanted content** (6.14). You can click as many times as you need to to create the repairs you need.

Painting Out Scratches

Sometimes, the answer to your image restoration challenges is much easier or more straightforward than you thought it would be. When it comes to photo editing, one of the simplest tools to use is the Paint Brush, because it works very much like the real-life version of the same thing by applying color wherever you want it. You can pick the color you want to paint with, and you can set the Size and style of the brush (by selecting a brush Preset), and you paint over the scratch, scuffmark, or other type of small mark on your image.

Another detail to remember when painting out scratches — the scratch needn't only traverse parts of the image that are the same color or texture. You can paint over just a few pixels, and then switch to a new color, paint a bit more, and keep going along the length of the scratch, tear, or scuff-mark, until you obliterate it, one section at a time. You can change brush sizes and shapes when the scratch/scuff changes thickness and texture, and by the end of the process, the scratch is gone, and the repairs should be virtually (if not entirely) invisible. If you mess up along the way, Undo what you've done to the point where things went awry, and then redo. Depending on the scratch in question, the process might require some painstaking steps, but overall, the tool and its options are your easiest retouching solution.

So, when you're ready to take the easy way out, follow these steps with the Brush tool — you can even use a Pencil tool if your scratch is very thin:

1. **Click on the brush for larger areas or damage with edges that are soft — such as scuffmarks, abrasions, or tears.**
 Use the Pencil tool if your scratches are very fine and sharp-edged.

2. **When the tool becomes active, so do its options** (6.15). You can adjust the size, shape, and style of the brush or pencil tip, which controls how and how much color it applies.

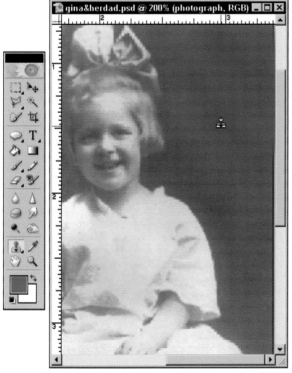

6.14

6.15

3. **Next, set the color that the Paint Brush or Pencil is to apply.**

 You can do this by sampling pixels next to the damaged area by using the Eyedropper (6.16), or open the Color Picker by clicking the Foreground Color button in the toolbox.

4. **After the right color is selected, go back to the Brush or Pencil and begin painting or drawing out the unwanted scratches, scuffs, and spots (6.17).**

 You can click to get rid of a small dot, or drag to get rid of a scratch.

[T I P]

If you find that your painting appears obvious no matter what you do, try painting with your Brush set to a lower Opacity. By not applying dense paint (even thin, textured lines can look painted on, sort of like a face with too much make-up), you allow just a little of the content underneath the paint to show through. If the scratch still shows too much, put another very see-through layer on, perhaps an even thinner line, if possible. Keep layering it, experimenting with brush sizes and textures, and always keeping the Opacity low, until you get coverage that doesn't look like coverage!

Smudging Blemishes Away

The Smudge tool works like your fingertips do when you're blending in make-up or if you're softening the edges between two areas in a pastel or chalk drawing. By mixing color from one area of the image onto another area, you make divisions between differently-colored areas less obvious. You can use this tool to blend hard edges and to soften or smudge away blemishes when actually patching them would be too obvious or might rob the image of too much texture. You can use the tool in black-and-white or color images, and by utilizing the tool's options, even add a third color — the current Foreground color — to the smudge.

Using and Controlling the Smudge Tool

To use the Smudge tool, just click on it in the toolbox to activate it and start smudging. The default settings (6.18) are appropriate for most uses, but you can adjust them. The most effective setting to adjust is Strength, which controls the severity or intensity of the smudge. A low strength creates very subtle results, and a high strength achieves dramatic results. A setting in the middle (50%) gives you an effective smudge without making a mess.

Other options you can set include the Mode (6.19), which enables you to control which aspect of the smudged pixels is affected by the smudging process. You can choose to Darken or Lighten the pixels, or

● 6.16

to affect their Hue, Saturation, Color, or Luminosity. Not sure which one to choose? Experiment a bit, using Undo if you don't like the results. The Normal Mode, which is the default, doesn't change anything about the colors or smudged pixels. It simply spreads color from the starting point to the ending point and is good for most jobs. If you want your smudge to also affect the lighting or some quality of the colors involved, you'll want to try some of the other Modes.

Smearing with the Finger Painting Option

The Finger Painting option, which is off by default, enables you to smear the current Foreground color into the area you're smudging (6.20). You can use this option to imcorporate new colors, or brighter, more vibrant versions of existing colors by finger painting them in.

● 6.18

● 6.19

● 6.17

● 6.20

[N O T E]

The Smudge tool may mimic the effects of finger painting or fingertip smearing, but it is a brush-based tool. You can set the size and texture of your fingertip by using the Size option and by choosing from the same group of Brush Presets that are available when you're using the actual Brush tool. Sometimes, a textured fingertip can achieve a more natural-looking result than a smooth one.

Getting Rid of Spots and Stains

When my aunt was a little girl, she took great delight in drawing on photos, especially those that had my mother (her sister) in them. Consequently, the family has a lot of photos with pen, pencil, and crayon streaks across them. We also have the normal number of photos on which someone rested a coffee-cup, photos that got wet and developed water "rings," and photos that picked up the tannins from a leather wallet pocket or other discolorations from the paper to which they were taped.

The stains and spots that result from accidents, poor storage decisions, and vandalism can be just as damaging as rips and tears. The stain may entirely obscure image content, or it may render a previously frame-worthy image fit only for the back of a drawer. If you have a stained or spotted photo, however, don't despair. The same tools you'd use to get rid of scratches, dust spots, and the changes in color that occur with age can be used as the "detergent" to make your photos look clean again.

Washing out Stains with the Sponge Tool

If the spot in question is a brown, rust, or some other-colored stain (6.21), you can wash out its color by selecting it (using the Magic Wand, if possible, so that only the stain is selected) and then using the Sponge tool set to Desaturate mode. With the Sponge tool, you can literally scrub away the color with your mouse, hopefully leaving the image intact

beneath it (6.22). If it also washes away the color from the image, you can reapply that color using the surrounding un-stained content to supply the color information.

To use the Sponge tool to remove a stain, follow these steps:

1. **Activate the Magic Wand tool and set its Tolerance option so that when you click on the stain, only the stain (or a portion thereof) is selected.**

 If the stain's color or intensity is not uniform, you may have to perform this and the subsequent steps for each varied area of the stain; or by pressing and holding the Shift key, you can keep clicking on areas in the stain to add to the selection.

2. **With as much of the stain selected as you can get without selecting other parts of the image, activate the Sponge tool.**

3. **Change the Mode to Desaturate, so that instead of increasing color saturation, the tool reduces it.**

● 6.21

4. **Reduce the Flow to 50%.**

 You may move up or down from there when you see the results, but reducing it is a good idea so that you don't wash out all the color — the stain and the image beneath it — as you drag over the stain.

5. **Continue selecting and desaturating sections of the stain if you can't do it all in one fell swoop.**

 It may be a better idea to do it in sections anyway, so that you can adjust the Sponge tool's Flow to match the intensity of the stain's color — more Flow removes more color with each drag of the mouse.

[T I P]

After you use the Sponge tool to remove as much of the stain as you can, you may be left with remnants of the stain to deal with. Based on the nature of the remnants, their placement, and how much of a problem you still have, you can use the Eraser set to a low Opacity to remove more of the stain, or you can use

the Clone Stamp to cover up the stain with content from surrounding, unstained areas of the image.

Selecting and Recoloring Stained Content

If the Sponge tool isn't working or has removed the color (and not just the stain) from your image, you can recolor the stain to get rid of it. The first step in this process is much the same as the Sponge tool procedure discussed previously — you want to select the stain (and none of the surrounding pixels, if you can avoid it) and therefore focus your recoloring tools on the stain alone.

After you select the stain, in whole or in part, you can use any of the following tools/commands to eradicate the unwanted wash of color:

- Use the Color Variations dialog box (6.23) to remove the color of the stain. Reduce the amount of Red to get rid of a brownish or rust-colored stain or reduce one or more of the other reducible colors (Yellow, Green, or Blue) and experiment to see which ones get rid of the stain or a portion thereof. Open the dialog box by choosing Enhance → Adjust Color → Color Variations.

● 6.22

● 6.23

- Use the Enhance → Adjust Color → Color Cast command to get rid of the stain's color. You use the eyedropper button (active by default in the Color Cast Correction dialog box) to select gray, white, or black areas within the selection, which helps Photoshop Elements to determine which color is overwhelming the others (6.24).
- Use the Enhance → Adjust Color → Hue/Saturation command to open the Hue/Saturation dialog box (6.25). With the dialog box open and the stain selected, use the sliders to reduce the Saturation, increase Lightness, and with the color of the stain selected from the Edit drop-down list, adjust the Hue setting until the stain is mitigated.

When All Else Fails: Spot and Stain Camouflage

Some stains are stubborn and amount to more than an unwanted wash or smear of color. Sometimes they

have texture, and sometimes their removal leaves (or would leave, if you pursued it) a big hole in your image.

If you opt to skip removing the stain or if you attempted to do so and have damaged the image beneath it, the next best solution is to cover up the stain. You can use the following tools and techniques to camouflage the stain, hopefully eliminating any sign of it:

- Use the Clone Stamp to apply content from the surrounding areas to the stained area (6.26). If the stain is small, this can happen with just a few clicks of the Clone Stamp. You can extend an area into the area of the stain, or you can duplicate undamaged portions of the content that's partially obscured by the stain, and use that duplicate content as cover-up.

● 6.24

● 6.25

- Select and duplicate undamaged content by using the Layer → New → Layer Via Copy command to create a layer that can be positioned on top of the stain. You find complete coverage of this and the Clone Stamp earlier in this chapter, where major rips, tears, and missing areas of content are covered.

[T I P]

If the stain is on a non-crucial part of the image and the photo's composition won't suffer for it, consider cropping to just inside the area where the stain ends. While you may end up with a smaller photo, it can be worth it to avoid a potentially difficult restoration process. Most stains and spots can be eradicated, however, so if the cropping will ruin your composition or if the stain involves an important component of the photo, use the recoloring and camouflage techniques discussed in this section to get rid of the stain as best as you can.

Understanding the Special Needs of Vintage Photos

Vintage photographs present some very common problems. Over the years, images fade due to the passage of time, developing procedures, the paper that the image was printed on, exposure to the sun, and exposure to extreme heat or dampness. Dampness can cause even more harm, because mold can develop, which eats away the coating on the photos and can damage the paper as well. In many cases, multiple culprits have been and are at work, and you may have multiple problems — faded image content along with scuffs, scratches, stains, mold, dust, and outright damage in the form of rips, tears, and missing corners (6.27).

When faced with an image with more than one problem, you need to perform triage — the process of

● 6.26

● 6.27

deciding which "injuries" are the most serious and which ones should be addressed first. Should you repair the scratches and scuffs before you adjust the color? Will it help to replace the corner before you tinker with the exposure or saturation? The order in which you deal with an image that exhibits multiple problems really depends on the location and severity of the problems, and which one/s bother you the most.

Consider these scenarios when determining the right order in which to deal with a vintage image and its problems. You may not have the exact same problems, but these situations may still help you make decisions about your images:

- If there are multiple problems in a single area, solving one might solve the other, or make it a moot point. Consider a torn corner, with a big stain on it (6.28). You can paste content from the opposite corner over it (rotating the pasted content with the Image → Transform → Free Transform command and your mouse), and in that process, you may get rid of the stain, too.

- If there's a portion of the edge or frame missing, you can simply crop around the image to eliminate the need to replace the missing corner or side. If the missing portion includes part of the image, consider whether or not that portion is important to the composition of the image. You may be able to crop away the damage and leave the important parts (6.29), eliminating hours of restoration work.

- If you can't crop, decide whether or not the damage is really that bad. This may sound like a cop-out or some giant rationalization, but does the damage lend an air of history to the picture? Part of the charm of vintage photos is that they look old — the places and people depicted are old — their clothes worn by people in the image, the scenery, the architecture, and so on. If the photo was taken in the 1800s, there's no harm (perhaps) in it looking like an image that's over 100 years old. However, if the damage is on someone's face or across the front of the family home, yes, try to fix it. If the damage is on the periphery or doesn't detract from the overall appeal of the image, consider leaving it alone.

● 6.28

● 6.29

• If you've decided to fix the problems, tackle the structural ones first. After you've replaced the corner or filled in the hole or scratch, then go about improving color quality, eliminating tiny scratches and spots, or bringing out detail lost to fading or bad lighting. There's no sense making these changes to the overall image and then having to do them again to make a patch blend in.

• Work slowly and deliberately. Don't try to do too many things at once. If the picture is that precious or historically important, it's worth laboring over it, working zoomed in to get things right, and editing pixel by pixel.

[T I P]

Be patient and don't be surprised if it takes many hours to get the picture "just right." For photos that may be the only tangible evidence that a now-deceased relative ever lived, or for photos that depict special events, such as weddings or vacations to places that don't exist anymore, it's worth it to take whatever time is required to bring the photo back to its original glory. Don't make yourself crazy, however and do give yourself breaks. There's no harm in taking several hours or even a few days off between retouching sessions. Give your eyes a rest and come back to the task refreshed and ready to do the best job you can.

The Big Picture

In this chapter, you read how to repair minor damage — small tears, rips, scratches, and spots. You used a variety of tools, some you've seen before in earlier chapters, others you'll see again as they're used in other types of repairs and retouching tasks. The goal of this chapter, like all chapters, is to show you how to use Photoshop Elements' tools precisely and creatively, adjusting the tools' settings for specific jobs and different situations. In the next chapter, you discover how to deal with scourge of mold and dust and their effects on your photographs.

Amos 'n Frances.psd @ 33.3% (RGB)

Alfred H Miller.psd @ 93.9% (Gray)

Dust & Scratches

OK

Cancel

☑ Preview

100%

Radius: 8 pixels

Threshold: 57 levels

David H Miller.jpg @ 200% (RGB)

Removing Dust, Mold, and Unwanted Textures

The artist who aims at perfection in everything achieves it in nothing.

EUGENE DELACROIX

A little character is good for the subjects of paintings. The little imperfections make the artwork seem to be more of a reflection of life, of reality. Eugene Delacroix felt that if a painter strives for perfection, he or she would miss the beauty in the subjects' imperfections — the true beauty of what's real.

When it comes to your photos, however, the subjects will have enough of those imperfections of their own — people with hair out of place, children with grass-stained knees, gardens with wilted flowers, driveways with oil spots, beautiful vistas marred by a string of telephone lines or billboards. These little signs of life are enough to add the beauty of reality to your photos, and you don't need the realities of dust, mold, the paper the photo was printed on or affixed to, or the odd textures that certain digital capturing methods can create.

With Adobe Photoshop Elements and the techniques described in this chapter, you can eradicate the imperfections that are part of the photo — not part of the picture. In the process, you use:

- Filters to remove and even out the signs of dust and small scuff marks
- Filters to add texture where there was none or to even out textures that have been altered through other restoration tools
- Blurring and blending tools to eliminate unwanted textures
- The Layers palette to keep parts of the image separate while you retouch other parts

[T I P]

If you don't want to keep the imperfections that *are* part of the picture – the oil spots, the stained clothes, the hair out of place – you can get rid of them, too. Chapter 5 will help you to get rid of unwanted content, replacing it with more desirable stuff, bringing you closer to photographic perfection.

Removing the Signs of Dust, Mold, and Mildew

An image that's been pitted and scuffed by dust and/or attacked by mold and mildew may have dulling clouds on the surface if it's a glossy or modern matte-finish print, or in the case of vintage matte-finish images, the surface of the image (and its cardboard mat) may be pitted and dotted from where the dust has been ground in and where mold has grown and eaten into the surface (7.1). When you scan these images, the mold and mildew, along with any dust that has been engrained into the image, may be exaggerated as the scanner creates shadows within the pitted areas, and where the change in the surface texture of the image eliminates the scanner's ability to capture the details of the image.

 When these things happen, you need to smooth out the textures, recreate the details, and where the small dots and scratches are so overwhelming, remove them. You may also want to use the imperfections to your advantage, if say, you're going for an interesting artistic effect that both masks the blemishes and creates an entirely new kind of image.

Using the Dust and Scratches Filter

The Dust and Scratches filter, which you find in the Filter → Noise submenu, works by changing adjacent pixels that are very different, into pixels that are more similar. This has a blurring, softening effect, as drastic differences between contiguous pixels are reduced.

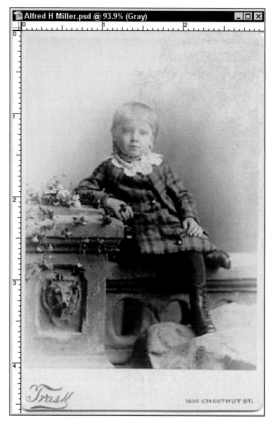

● 7.1

You can take a photo with lots of little dark dust and mold spots on it (7.2) and soften the look of those spots to the point that they're nearly invisible, if not completely eradicated (7.3).

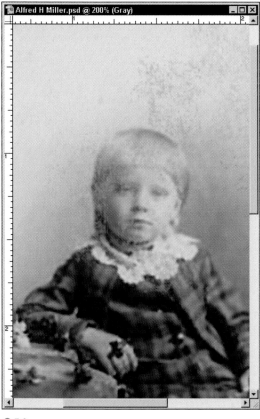

● 7.2

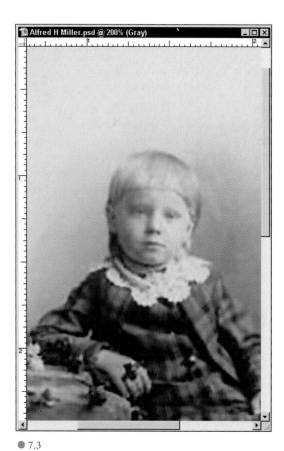

● 7.3

The Dust & Scratches dialog box contains a Preview area and two sliders: Radius and Threshold. You can use these sliders (or their accompanying text boxes) to control the effects that the filter has. For example,

- **Radius** determines how many contiguous pixels are compared, as Photoshop Elements searches for differences among groups of pixels. A Radius of 10 creates a fairly blurry image (7.4); a Radius of 80 creates a virtually unrecognizable image, as pixels in groups of 80 are changed to a similar color (7.5); but a Radius of 3 has a much more subtle effect (7.6), as every group of three pixels is adjusted to match each other, providing a gentle softening of all the content.
- **Threshold** determines how varied the pixels (compared within the established radius) must be in order to be adjusted or eliminated. A low Threshold results in very subtle results (7.7), while a high Threshold results in a lot of pixels being adjusted, which provides more dramatic results (7.8).

● 7.5

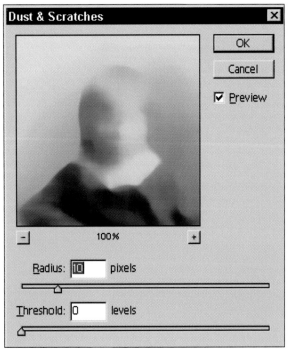

● 7.4

● 7.6

[N O T E]

As you increase the Threshold, the Radius setting has less of an impact. The Radius setting that made the image disappear into blurry nothingness when a low Threshold was set won't have that same effect when the Threshold is set to 10 or more.

As you tinker with the settings in the Dust & Scratches dialog box, watch both the Preview window and the image window. If you move the dialog box aside, you can see more of the photo and see

7.7

7.8

how the filter's settings are affecting it (7.9). After you like what you see in both places (or only in the Preview window if it's not possible to see both), click the OK button to apply the filter to your image.

Using the Median Filter to Soften Light and Dark Spots

Another filter found in the Filter → Noise submenu is the Median filter. Instead of changing the color values of pixels that are deemed too different from one another, this filter blends the brightness levels of pixels within a selected area, or across the entire image. The Median dialog box (7.10) enables you to set the Radius for the filter, and as in the case of the Dust & Scratches filter, the higher the Radius, the more drastic the changes are (7.11).

The Median filter dialog box doesn't have a Threshold setting, so you're leaving it to Photoshop Elements to decide which pixels are too different in

● 7.10

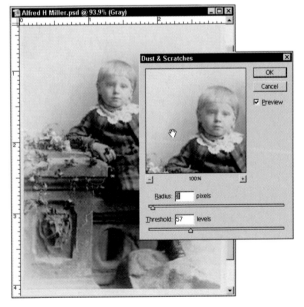

● 7.9

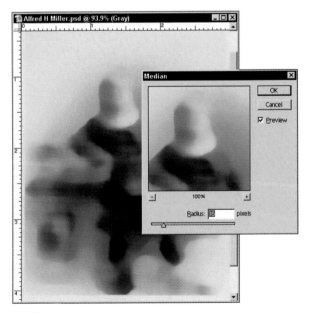

● 7.11

terms of their light levels. The results of these two filters are very similar and depending on the nature of your image and its problems, you may find them to be interchangeable.

[NOTE]

If your photo only has some areas that are affected by dust or mold, you can select those areas before using either the Dust and Scratches or Median filter. Be careful, though, when using the filters on selected areas rather than the whole image. If you create too much softness with either filter, the area can stand out and look blurry compared to the rest of the image. If you use the filters in subtle ways (with low Radius and/or Threshold settings), the area you filtered won't stand out as much when you deselect it.

Blending Out Individual Marks

When it comes to tiny spots formed by dust or a good crop of mold that's eaten into your photo, you can attack the little blemishes individually if you have the patience or if there aren't that many of them. You can use the Brush tool, applying the color that the spot *should* be, or you can use the Smudge tool to drag some of the surrounding color onto the spot. These techniques are discussed in previous chapters, but for the purposes here, I discuss the use of these tools to cover very small areas.

Before proceeding with any of the following tools or techniques, it is essential that you zoom in on your image. Zoom in to a very high magnification so that you can see the spot and surrounding pixels clearly (7.12). You can use the Zoom tool, the Navigator palette (7.13), or the Ctrl/Command + + (the plus sign key) shortcut to zoom in. Use the shortcut over and over until you're in close enough to see the pixels. You can zoom back out with Ctrl/Command + − (the minus sign key), which is easily remembered because the minus sign would indicate a reduction — in this case, a reduction in the Zoom.

● 7.12

● 7.13

[T I P]
If you're using the Zoom tool, click on the spot you want to get closer to and keep clicking until you're very, very close. You can also create a box with the Zoom tool and drag to "draw" a rectangle that encompasses the area you want to see up close. If you're using the Navigator palette, drag the red box until it's over the area containing the spot and then drag the slider to the right until you're right on top of the spot with a clear view of it and the surrounding clean pixels.

Painting Dots on Unwanted Spots

When you use the Brush tool to get rid of a spot, usually you don't have to drag the mouse. You're just going to click once, maybe twice, on the spot, depositing a dot of paint. You can adjust the Brush size, choose a textured or solid preset, and tweak the Opacity so as to not apply an obvious glob of paint where a subtle, slightly see-through dot is all that's required (7.14).

To keep your painted dot or dots from standing out, try using a textured brush — one of the Charcoal or Dry Brush presets or any preset that doesn't apply a round, discernable dot (7.15). Experimenting is a good idea (you can always undo) with a few different Brush and color settings until you find the one that eliminates the dot without leaving an equally unsightly and obvious dot behind (7.16).

● 7.15

● 7.16

● 7.14

Why use an Opacity setting that's less than 100%? Because if the area containing the spot is slightly textured, or there are many colors making up the look of a single, solid color, using a see-through Brush enables you to apply color without masking those subtle details.

Doing a Quick Smudge

The Smudge tool smears color from one place to another, enabling you to smooth over blemishes much as you would with make-up on your face — spreading a dot of cover-up onto a freckle or other spot you don't want the world to see. When it comes to tiny spots on an image, the Smudge tool can be quite effective in that you don't need to select a color first to paint over the spot. You're dragging the color from adjoining pixels onto the spot, so there's no risk that the colors won't match. If you're zoomed in close enough, you will literally be smudging colors from the pixels right next to the spot, and you can use the Smudge tool's Strength setting to make sure the smudge is subtle. By adjusting the size of the brush with which you're smearing color, you can make sure you smudge just enough to cover the spot (7.17), and no more. A short, quick smudge should be all it takes (7.18).

[W A R N I N G]

Be sure the Finger Painting option is Off on the Smudge tool's options bar. Otherwise you'll smudge in the current Foreground Color and that may not enhance your results.

Cleaning and Cloning Backgrounds and Large Areas

The Clone Stamp, which is also used in the other types of restoration and retouching tasks covered elsewhere

● 7.17

● 7.18

in this book, can be used to stamp clean areas from nearby the spot onto the spot or to duplicate areas that you already cleaned. This can clean up a formerly spot-covered sky, a moldy road, a splotchy background — any larger area that's covered with spots or mold.

If you're cloning out an individual spot, you want to set the Clone Stamp to a Brush size that's about the same size as the spot you're covering. This prevents any unwanted pattern or apparent texture being created by dragging or repeated clicks with the Clone Stamp. Simply size the Brush setting on the Clone Stamp's options bar (7.19) to a brush that's roughly the same diameter as the spot. Then use the Alt key (Option if you're on a Mac) to sample the area that you want to clone, click on that area, release the Alt/Option key, and then click on the spot. One click should do it, but if you accidentally don't quite cover the spot, click again.

[T I P]

If your cloned cover-ups are too obvious, try a textured brush preset, which won't apply the cloned material as an obvious circle of content. If that's not the problem, reduce the Opacity. If that's not solving the problem of your telltale cover-up, try using the Blur tool along the edges of the cloned content (Zoom in close so you can see the edges) so they blend in better.

● 7.19

Dealing with Noise and Textures from Digital Captures

Digitally-captured images, taken with a digital camera or scanned from printed photos, can contain noise and textures that you won't want to keep— artifacts along the edges of shapes or within large fields, such as skies or other backgrounds (7.20), and an odd pattern effect, called *moiré*, which is a distortion of

● 7.20

colors and light (7.21). You can reduce the amount of noise and artifacts by shooting or scanning at higher resolutions (300 pixels-per-inch, or ppi, minimum), and you can eliminate some moiré effects by not scanning offset-printed originals (pictures from magazines or brochures). However, if there's no way around the problem, either through settings on your digital device or the nature of the original, you're stuck with the problem and have to use Photoshop Elements to fix or mitigate its effects.

To get rid of artifacts, noise, and non-moiré textures, you can use a variety of Noise filters, including Add Noise, Despeckle, and Median.

These filters work by making the noise stand out less, just as they can help mitigate the effects of dust and mold. You can refine their effects by setting preferences in their dialog boxes and by making a selection in the image before issuing the individual filter commands.

To get rid of offset moiré effects or the moiré that can occur due to different digital capturing methods, you can use blurring filters (Blur and Blur More) followed by other filters to bring back detail without losing the pattern-softening effect of the blur. You can also use manual blurring tools to soften the moiré and then clone the results of a small area all around the other spots that have an undesirable texture in them.

Using the Noise Filters

Noise filters work by adding or removing pixels with randomly distributed color and light levels. When noise is added, the noise that was already present in the image becomes less of a visual distraction, because there's more of it, and it's now evenly distributed, thanks to the filter. It can also be an artistic effect, simulating photos taken on high-speed film or giving the impression of age to a relatively new photo. When noise is taken away, it is done by making some or the entire photo blurry, either by closing the color gap between adjacent pixels or reducing the difference in light levels throughout blocks of pixels.

● 7.21

Whether you choose to add noise (7.22) or take it away (7.23), the results can be quite subtle or very dramatic. It all depends on the dialog box settings (if any) for the filters and how you adjust them, whether you restrict the filter to a particular area by making a selection first, and/or what filters or tools you use afterward.

Working with the Add Noise Filter

As the name implies, the Add Noise filter adds randomly colored and lighted pixels to your image, increasing the number of differently colored pixels. It's handy for hiding any kind of banding, where there are obvious strips of color, lightings, or a pattern created by previous retouching efforts.

● 7.22

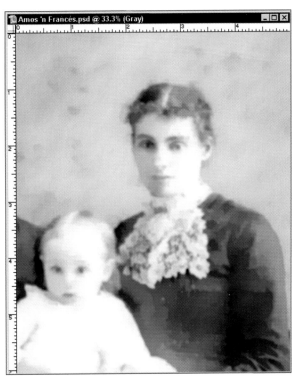

● 7.23

The Add Noise dialog box (7.24) offers two Distribution options — Uniform, where the distribution is — you guessed it — uniform (7.25), and

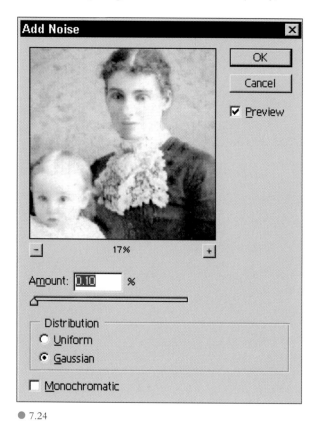

● 7.24

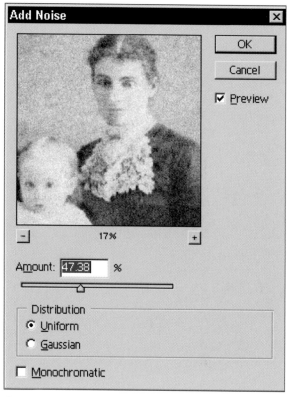

● 7.25

Gaussian, where the distribution is less uniform and more speckled (7.26).

Obviously, with either Distribution method, the Amount slider (or the text box into which you can enter any number from 0 to 400) determines the number of noisy pixels added to your image. Higher numbers result in more noise; lower numbers in less noise. A very high setting obliterates your image entirely, but you can use it on selected parts of the image (select them first) with those areas turned entirely to noise (such as a snowy TV screen) for an interesting effect of contrasting noise levels (7.27).

[T I P]

If you turn on the Monochromatic option (it's off by default), your effects use only the tones currently found in your image, and no colors change.

Despeckle-ing an Image

The Despeckle filter offers no dialog box, so you can't adjust its intensity or customize its effect. When you choose this filter, Photoshop Elements detects the edges within the image and blurs everything but those edges. The results can be mixed with some

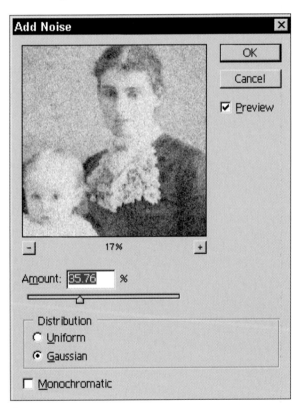

● 7.26

● 7.27

noise being added, along with the newly-defined edges (7.28). It may seem highly intuitive for the software to detect an edge, but it's done simply by comparing ranges of pixels. Where color and/or light are different over a series of several contiguous pixels, the lines where those differences are most extreme are seen as edges.

One of the benefits of the Despeckle filter is that you preserve overall detail, or the illusion of it, by preserving the detail of the edges. This is a welcome advantage, as many of the techniques for removing noise and textures involve blurring, and you lose a lot

of detail if you don't go back and add some focus with sharpening tools. The Despeckle filter sort of does both things in one step, although nothing is sharpened — the edges just look sharper by comparison to the blurred areas.

Despeckle-ing also saves the image from being so blurry that it looks totally out of focus. You'll find it helpful when you see color banding in scanned magazine or brochure photos, or where you've applied artificial coloring to black-and-white images and a "Colorized by Ted Turner" look has resulted (7.29).

● 7.28

● 7.29

By heightening the impact of the edges, objects in your photo don't look so flat (7.30).

[CROSS - REFERENCE]

You can find out more about colorizing black-and-white images in Chapter 8. You can also find out about removing color and creating sepia-tone images from both black-and-white and color images.

Using the Median Filter

The Median filter works by discarding any pixels that are substantially brighter or darker than the adjacent pixels, creating a more uniform lighting throughout an image or the selected portion thereof (7.31). You use the Radius slider to determine how many pixels are compared as a group, and obviously the fewer you compare at a time, the more subtle the effects of the filter are.

[WARNING]

The overall effect of this filter is rather blurring and at settings higher than 4 pixels (using the Radius slider), a great deal of detail can be lost.

Reducing the Impact of Moiré

Moiré is unlikely to occur in images that are mostly solid colors, low contrast, and scanned in or shot at a high resolution. Sometimes, however, you can't control the content of the image or the quality of the capture, and you end up with a pattern of shapes and edge distortions that you want to get rid of (7.32). As mentioned earlier in this chapter, if you scan magazine or brochure images that were printed with an offset printer, you may get bands of color, which are known as *offset moiré*. You want to get rid of these, too, because they make your image look striped, and the detail that depends on color is lost (7.33).

● 7.30

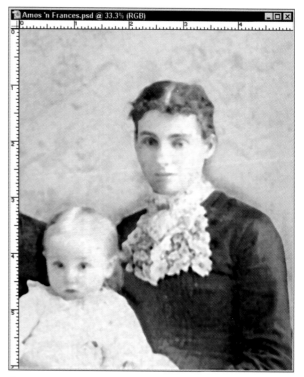

● 7.31

The options for getting rid of moiré include the aforementioned Median filter, and you can also use the Blur, Blur More, and Smart Blur filters to get rid of the texture that moiré creates.

Using the Blur Filters

The Filter → Blur submenu contains six filters, only a few of which really apply to the goal of removing noise and textures. You can try any of them, but you'll have the most success with the following three:

- Blur
- Blur More
- Smart Blur

The Blur and Blur More filters are essentially the same tool — the latter one does what the former does, but does more of it. First, how it works: Blurring by filter is the same as blurring by Blur tool in that Photoshop Elements averages the color values of the pixels over which the mouse is dragged (Blur tool) or within the image or selection (Blur/Blur More filter), resulting in a soft focus due to a lack of color diversity. When you zoom in on a blurred area, you can see the results on a pixel-to-pixel level, and compare them to an un-blurred area visible at the same time (7.34).

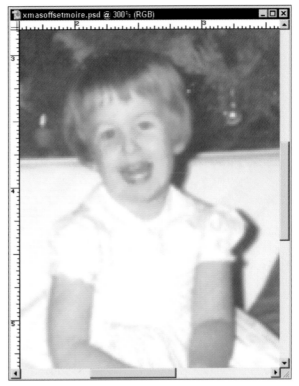

● 7.33

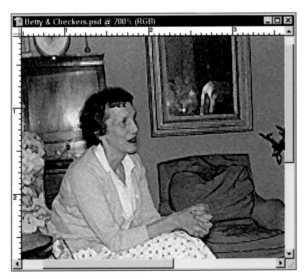

● 7.32

● 7.34

Neither of these filters has a dialog box, so you can't control their intensity. If you use the Blur tool and want it to do more, you can repeat it (Ctrl + F in Windows, Command + F on a Mac), or you can use the Blur More filter. I prefer to repeat the Blur filter until I get the desired result, because the Blur More filter often goes too far when it comes on the heels of the Blur tool. Bear in mind that you don't have to use Blur More after the Blur tool — it can be your first choice if you know you want substantial blurring.

The Smart Blur tool is effective in that it's not so even or heavy-handed. It blurs more precisely, given the presence of a dialog box (7.35) that enables you

But I Don't See a Difference

You may find that you can't tell any difference between the results of the Blur filters and the Noise filters, given that blurring or softening is the goal for most of them. If you feel like you're not observant or that you don't understand what's going on, *don't*. Depending on the problems in your image, the colors or lack thereof in the photo, and the other retouching steps that you've taken previously, any of the filters discussed in this chapter can be used, often interchangeably. The key is to find the one that looks right to you — there are no "rules" to follow.

to control what's blurred and how much blurring is applied.

You can also choose a Quality for the Smart Blur filter's results, selecting Low, Medium, or High, and then use the Mode setting to choose a Normal, Edge Only, or Overlay Edge blur. Each image requires different settings, so it's good to experiment, taking advantage of the Preview window to see what happens at different settings. Generally, High Quality and Normal Mode give you the best results (7.36). The

● 7.35

● 7.36

Edge Only and Overlay Edge settings create a very distinctive result (7.37), where the edges actually stand out so much that the image can be distorted, especially in images without a lot of colors or intense lights and darks in them.

Blurring Manually

You can also use the Blur tool to rub over areas that are textured with moiré. Just select the area first (you want to confine yourself, so you don't drag the mouse over a non-textured area), and then scrub away with the mouse (7.38). The Blur tool's Strength setting enables you to make your blurring very subtle (a low setting, typically at 30% or less) or more extreme (a high setting, or anything over 50%). By using a brush Size that's suited to the size area you're blurring and by selecting the area first, you can have very specific effects on very specific areas.

[T I P]

If, after deselecting, the edges of your blurred area stand out because it's drastically different from the surrounding areas, use the Blur tool again. Set it to a low setting (somewhere around 30%) and drag over the edges to make them blend in.

Using the Unsharp Mask Filter to Add Clarity

After you blur your image or add or reduce noise, you may find that the image has lost a lot of its detail, and it may look kind of flat. To solve that problem,

● 7.37

● 7.38

go to the Sharpen submenu in the Filter menu and choose Unsharp Mask (7.39).

The name may be a bit confusing, but suffice to say the filter sharpens the edges within your image, getting rid of the flatness and detail-dulling blur where an edge or distinct change in pixel color is detected — shadows on folded fabric, highlights from sunshine or indoor lighting, literal edges between objects (7.40).

The Unsharp Mask dialog box offers three sliders:

- **Amount.** This slider determines how much of an increase in contrast is applied to the detected edges. A high amount causes the edges to be dramatically sharpened; a low amount gives you a more subtle result.

- **Radius.** Use this slider to establish the width of the area around each detected edge to include in the effects. If your image is at a high resolution (300 ppi or more), set the Radius to a low setting, no higher than 3. If your image is at a low resolution (150 ppi or lower), you can increase the radius to increase the apparent results of the filter. The thinking here is that at a high resolution, there should already be a lot of detail and distinction between pixels and therefore your edges should already stand out more than low resolution images, even if blurring or noise reduction has already taken place.

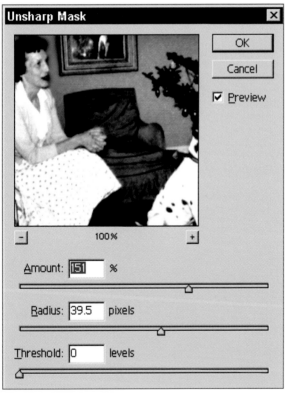

● 7.39

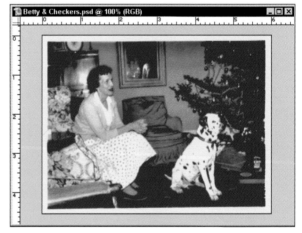

● 7.40

- **Threshold.** This slider determines how different pixels have to be before the software decides whether or not an edge is present. A high threshold results in fewer pixels being sharpened; a low threshold results in more pixels being sharpened. If you leave this slider at its default (0), all of the pixels will be sharpened, not just the edges.

[WARNING]

The results of the Unsharp Mask are more obvious when the photo is viewed on-screen. If your ultimate use of the retouched photo is in print, you'll want to do a test print and see if you need to heighten the effects of the Unsharp Mask in order to get the results you want to see on paper.

The Big Picture

In this chapter, you learned how to get rid of the signs of dust, mold, and mildew, and how to eliminate or lessen the signs of unwanted textures — those caused by scanners and digital cameras, and those that come from the paper the scanned photo was printed on or affixed to. In the next chapter, you find out how to polish your images, applying artistic filters, changing from color to black-and-white, or vice versa, and adding finishing touches that make your retouched photos something to be proud of.

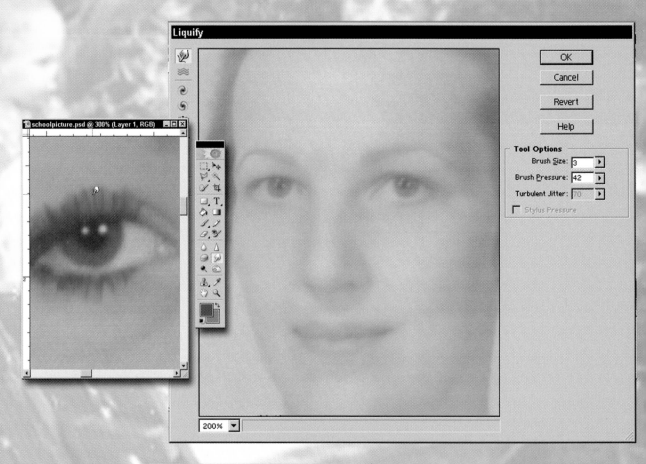

schoolpicture.psd @ 300% (Layer 1, RGB)

Liquify

OK

Cancel

Revert

Help

Tool Options

Brush Size: 3

Brush Pressure: 42

Turbulent Jitter: 70

☐ Stylus Pressure

200%

laurie1.psd @ 100% (Layer 1, RGB)

Performing Plastic Surgery with Photoshop Elements

Art is the increasing effort to compete with the beauty of flowers — and never succeeding.

MARC CHAGALL

Performing plastic surgery on the subjects of your photos with Adobe Photoshop Elements can be a challenge, and not just in terms of using the software effectively. On the one hand, there are times when the subject of the photo is glad to see their temporary blemishes banished or their unruly hair tamed. On the other hand, if you really alter a person's photo, attempting to make them more beautiful by making them thinner or taller, giving them higher cheekbones and a more chiseled chin, your changes may be viewed as a statement that you don't like the person the way they are. I wouldn't suggest doing more than basic "housekeeping" on the faces, hair, and figures of people you know and love in your photos — your efforts beyond that may only be misinterpreted and cause resentment. Few will mind if you get rid of their cowlick or blot the shine on a forehead, but they may mind if you give them an unsolicited or extensive makeover.

If you're retouching a professional model's photo, however, the subject expects some airbrushing. It's all part of the process of selling beauty and the products and services that promise beauty to the rest of the population. It's important to note for the purposes of this book, and for most people's self esteem, that the models in the magazines don't really look perfect when you catch them at the grocery store or walking down the street on a Sunday afternoon. They have bad hair days and can look pretty scruffy without a hair dresser, makeup artist, and you, the final photo fixer-upper who smoothes the skin, softens the hair, reshapes the eyebrow, or makes their features a little more appealing.

In this chapter, you learn to use the same tools you worked with in other chapters, but this time, instead of repairing scratches, replacing torn edges, or improving color and contrast, you use the tools to make your subjects more beautiful — even if you can only change them on the outside.

Removing Blemishes and Wrinkles

You can treat the blemishes on your subjects' faces the same way as the blemishes you may find on a photo due to dust, mold, or the various signs of wear and tear that your prints often endure. The difference is in the need to make the repair completely invisible

and to match tones and textures exactly. Where you can paint a small dot of color onto a photo to cover a random scratch or nick and not worry if it's an absolutely invisible repair, if you're covering a mole or scar on a face, matching the exact shade of the skin and making sure that it's not obvious that retouching has been done is essential. When it comes to faces and bodies, if the repair is evident, it's nearly as bad as if you'd left the scar or other mark in place.

To get rid of blemishes and wrinkles, you use the following tools:

- The Clone Stamp
- The Smudge tool
- The Paint Brush
- The Blur tool

Smoothing Out Freckles and Scars

Freckles, moles, and scars can be tricky to get rid of because of their construction and/or locations. Freckles tend to appear over a large area — the entire face, along arms, across a chest — and therefore the tool you use to cover them has to be easily customized for different amounts of light, different skin tones, different skin textures, and so on. Moles can pose a problem because they're often raised, and sometimes the face looks funny without them — imagine Cindy Crawford without the mole above her top lip. The absence of it would be as odd as if she had no eyebrows. When it comes to scars, if they have affected the contours of the face, or if they bisect a lip, eyelid, or cut through a nostril, the repair can be more extensive than simple cover-up. You need to do some reconstruction by filling in areas where the original injury left a dent or valley and slicing off the raised parts without leaving unnatural-looking plateaus — on the curve of a cheek or a chin, for example.

When I clean up marks on skin, the tool I go for first is the Clone Stamp. Why? Because I can use skin right next to the blemish or scar and clone it for use on top of the mark I want to get rid of (8.1). This enables me to match the color, lighting, and skin texture quickly and easily. By choosing different brush presets and sizes for different problems, I can match the size of the patch to the blemish/freckle/scar, so that in many cases, I can cover the offending spot in one click.

When using the Clone Stamp repeatedly in the same area, for example, to cover a long scar or a big scattering of freckles, make sure you don't create an unpleasant pattern with your clicks (8.2). Tinker with

● 8.1

the Aligned setting (found on the Clone Stamp's options bar) and see if it helps or hurts you in terms of creating an unwanted pattern or obvious signs of having cloned several times. It all depends on the clone-able content surrounding the content you're trying to cover up. I also like to leave the Opacity set to the default 100%, but for freckles, sometimes I lower it to 60% or less, so that there's still a trace of what is often considered a cute feature on someone's face, especially in the case of children.

[T I P]

Be sure to Zoom in as close as you can (without losing sight of the context) when making fine restorations

and repairs. Your results are much neater, cleaner, and you won't risk leaving any obvious signs of your restoration technique behind.

The Paint Brush should only be used on blemishes that don't change the texture or height of the skin. For example, you can paint out a small, flat freckle, but you shouldn't try to paint out a scar that's deep or textured. If you attempt the latter, chances are quite good that you'll end up drawing more attention to the problem by creating an unnatural-looking effect (8.3).

Instead, stick to painting out small, simple problems, and use the Eye Dropper first to sample a pixel

● 8.2

● 8.3

near the offending spot (8.4), and then paint with a single click if you can, or with a very short drag of the mouse. Long, painted strokes do not work well, even along a long scar. Better to pepper the long scar with small drags and quick clicks than to try to paint the entire length of the scar in one go.

To make your painting and cloning efforts blend in, be prepared to do some blurring, preferably with the Blur tool, rather than a Blur filter. Set the Blur tool to a low Strength (30% or less), and gently rub the edges of an obvious cloning or along any painted areas that don't blend in well enough (8.5). If you didn't match the color of the skin perfectly, you can use the Smudge tool to pull some of the adjacent pixels' color onto your repair, making it match more effectively (8.6).

● 8.5

● 8.4

● 8.6

[WARNING]

If you apply your cover-up and it looks fake or fails to do the job in terms of masking the blemish, don't keep applying more color or using more tools. Rarely do the results of such an approach look natural. Use the Undo History tab to go back in time to the last time you were on the right track or to the point before you even started restoring the photo. If you haven't saved yet, you can use the File → Revert command to go back to the last saved version of the file, and start over completely.

Turning Back the Clock with a Photographic Facelift

Laugh lines aren't very funny to a lot of people, and you can really perk up a face and make your subject look happier, healthier, and more relaxed if you smooth out some of the lines that time and repeated facial expressions have carved into the skin. Wrinkles can appear on the face, neck, chest, knees — just about anywhere on the body where the skin is stretched over bones and/or muscles and then allowed to go back to a non-stretched state. You don't need to get rid of every little line when you're retouching

someone's picture, but you may want to get rid of the deepest, most distracting ones. To do this, you use:

- The Clone Stamp
- The Blur tool

I mention the Blur tool second, because it's the last tool you want to use for removing wrinkles. The Blur tool is best used to make your other "surgical" techniques blend in. If you try to blur out a wrinkle or a group of laugh lines, it will be obvious what you did unless you blur the rest of the skin in the photo, too. Rather, cover the wrinkle with the Clone Stamp tool, using skin from adjacent, non-wrinkled areas to cover the lines.

[NOTE]

If you're working with a close-up, or a very clean, detailed, and focused portrait, you may want to use the Clone Stamp to get rid of big wrinkles. This only works if the wrinkle doesn't span too much of the face. You don't want to have to clone from several different spots to get the right color, lighting, and texture along a long wrinkle. If you do, you only have to blur to make the various cloned areas blend in.

If your photo is slightly out of focus, you can use a soft-edged brush preset for the Clone Stamp (8.7), which puts a soft, diffused edge on your cloned content. This can prevent having to use the Blur tool to make the cloned-on skin blend in because there won't be a hard edge to the area. You can also set the stamp to apply content at a low opacity (8.8), to make your filler less dense, softening the effect of the wrinkle removal. This is especially useful for faces with a lot of lines, where the complete elimination of any of them looks totally unnatural.

Improving a Smile with Whiter Teeth

Very few things look more unnatural and ridiculous than overly-white teeth. Natural teeth (or even "false" teeth used in dentures or partial plates) are never pure white. They're an ivory or grayish white, and they vary person to person and even within a single set of teeth. If you want to whiten someone's teeth, use the Dodge tool to lighten and brighten the

teeth. Don't just pick white from the Color Picker and paint it on. It makes the person look like a ventriloquist dummy, with a set of bright, white, wooden teeth.

To brighten and lighten tooth color with the Dodge tool, use a brush Size that's about the same as the individual teeth you're retouching. Set the tool to a low Exposure, to prevent too much lightening. This helps prevent a solid, unnatural block of color from appearing on the teeth, or the creation of a shade of what doesn't occur in nature. This is especially important in close-ups, where the actual texture and construction of the teeth, layers of enamel on top of the tooth itself, are visible.

Re-contouring Facial Structure

When you need to change the way time has caused a jaw line to sag or how heredity has formed the subject's eyes, nose, and cheekbones, Photoshop Elements provides several tools that you can use to move facial features up, down, in, or out. You can make facial features larger or smaller, thicker or thinner, weaker or stronger. All of the tools involved should be familiar by now. You used them to blend and hide rips and tears, dust and mold, and to replace missing content. In this case, you use them with greater accuracy and attention to detail that avoids the appearance of any obvious changes.

The goal of any retouching of this type is to make it appear completely seamless and natural, so you want to be especially careful to use brush sizes that don't make too great a change or conversely, that require a lot of repeated strokes or clicks to get the job done. You also want to make use of all of the tools' options — Strength and Opacity settings, Flow options — and use brush presets to achieve natural-looking textures. There's no harm in experimenting,

● 8.7

● 8.8

as you can Undo anything that doesn't work as you hoped.

Enlarging the Eyes

When I plan on really revamping a face, I try to put all the distinct parts that I plan to retouch — eyes, nose, lips — on separate layers. When you're about to enlarge or otherwise resize or rotate one or both eyes, you can place them on their own layers by selecting the eyes, one at a time (8.9) — the entire eye and eye lids — and choosing Layer → New Layer Via Copy. This won't cut away the existing eye, but

duplicates your selection on a new layer, and the original eye remains part of the face as a whole. You can then use the commands in the Image → Transform menu to resize and otherwise manipulate the duplicate eye layer as a whole.

To make the eye bigger (always work with the eyes individually), select the new layer that contains a copy of the eye and choose Image → Transform → Free Transform. Handles appear around the layer content, and if you point to any of the corner handles and drag outward, you can resize both horizontally and vertically at the same time (8.10). To make

● 8.9

● 8.10

sure you maintain the same width-to-height ratio (also known as the *aspect ratio*), press and hold the Shift key as you drag. Don't release the Shift key until you release the mouse after dragging, or you don't maintain the proportions.

After the eye is enlarged, you can repeat the process by enlarging the other eye and keeping the angle of the head in mind. If the eyes were not the same size to begin with, they shouldn't become the same size even after you enlarge both of them. After you enlarge both of them, you can blur the edges of the eyes on the added layers, so that the edges blend in. If that doesn't do the trick, perhaps you can't blur the edges without the blurring being obvious, merge your layers (Layer → Merge Visible), and then use the Clone Stamp to even out skin tones and textures, should the enlarged portions of the eye not match their new neighboring pixels (8.11).

You can also rotate the eyes, which is often necessary after you enlarge them, so that they fit on the face and within the perceived hollows beneath the brow bone and alongside the nose. To rotate the eyes (they must each still be on a separate layer) select the layer and choose Image → Transform → Free Transform. When the familiar handles appear, go to a corner

handle, and hover your mouse outside it (8.12). The mouse pointer turns to a curved arrow, which indicates that you're in rotate mode.

As soon as you're in rotate mode, click and drag clockwise or counter-clockwise. After the desired rotation is achieved, press Enter to apply the transformation.

[T I P]

It's probably best not to blend, smudge, or otherwise attempt to make your enlarged eye fit in with the surrounding pixels until after you rotate it, if rotation is necessary. You may need some of the textures and tones that could be obliterated by blending tools and you won't know if you need them for cloning or smudging until the eye is in its final position.

● 8.11

● 8.12

Fixing a Nose

If your subject's nose needs a little adjustment — removing a bump, straightening a nose that's been broken, slimming a wide nose, shortening a long nose, softening a pointy nose — you can do this quite simply with the Liquify filter (Filter → Distort → Liquify) set to Warp mode.

[N O T E]

You can also do an all over shrink on a nose (if only the size, not the shape, is a problem) the way you enlarge an eye. Put the nose on its own layer and select Image → Transform → Free Transform to make it smaller. You can then do any blending or cloning to make the edges of the nose selection blend in with the skin around them.

You find the Liquify filter (yes, it's spelled that way in Photoshop Elements) in the Distort submenu of the Filter menu. This particular filter is so named because it enables you to manipulate image content as though it were made out of liquid, or, more accurately, some gelatinous substance. You can push, pull, stretch, and otherwise contort your image in subtle ways or very dramatically, depending on the Brush Size and Brush Pressure (8.13).

The Liquify window contains tools down the left side, the first of which is the Warp tool. With this tool, you can poke along the edge of the nose to straighten it, push up the end or nudge the bridge on either side to make it thinner (8.14). You can tinker with the other tools, but may find that the tools that twist and pinch your content don't really give you the realistic effects that you're going for if you're simply trying to improve someone's nose.

[T I P]

Need fuller lips? Use the Bloat tool in the Liquify filter window. Just set a brush size that's about the same size as the lips in question and click on the lips until you achieve the desired degree of fullness.

If the work you want to do on a particular nose is rather simple and subtle, such as raising the tip slightly, changing the curve of the nostrils, getting rid of a small bump, you can do it with the Liquify tools set to a very small brush size. Using your mouse, click and drag to gently push parts of the nose into place

● 8.13

● 8.14

(8.15). It can all be done with the same tool, or you can use the Smudge tool to soften whatever you did with the Liquify tools when making major changes to the nose.

[WARNING]

Bear in mind that if you use the Smudge tool to reshape the nose (a common, though misguided choice), it is also blurring the skin textures at the same time – it's just the nature of the tool, which is intended to smear pixels. If your retouches look too blurry or smeary, try using a very small brush size when using the Smudge tool, and then go back over the smudged areas with a small Clone Stamp to stamp the textures from un-smudged areas onto the smudged ones. Better yet, use the Liquify tools, which don't alter the texture of the content when small adjustments are made.

Raising Cheekbones

Cheekbones can be raised and widened easily, again by using the Liquify filter. By adjusting the brush size and pressure settings in the Liquify window, you can achieve dramatic changes (8.16) or simply refine the cheekbones in a subtle way (8.17). You can use the Warp tool, or try the Wave or Bloat tools. The Bloat tool fattens sunken cheeks, or you can achieve the opposite effect with the Pucker tool, which shrinks features, including noses, eyes, chins, and cheeks that are too round.

When using any of the Liquify window's tools on the face, use a brush size that matches the size of the feature or area of that feature that you're retouching. If you use too large a brush, parts of the face beyond the desired area will be adjusted. For example, if you use a brush that's much larger than the cheek you're attempting to move up or out, you may move the side of the nose or the skin under the eye at the same

● 8.15

● 8.16

time, truly distorting the face. It's always best to work small and to use the Zoom tool to get as close to the area being retouched as possible.

[T I P]

If you want a "do-over" without canceling out of the Liquify window, click the Revert button. Your image goes back to the way it was when you first opened the Liquify window, and you can start over.

Changing the Jaw Line

The problems you may be trying to solve with regard to a jaw line can be anything from an unwanted double chin to a very square jaw that needs softening to an undershot chin that should come forward and appear more forceful. The nature of the problem dictates the tool you use.

- To get rid of a double chin, you can use the Clone Stamp to stamp shadows from under the chin and apply them to the unwanted skin (8.18), or you can use the Liquify window's Pucker tool to gently push the extra chin up an into the main chin (8.19).

● 8.18

● 8.17

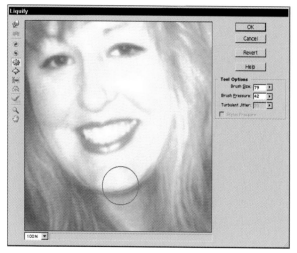

● 8.19

- To soften a square jaw or a jaw that's too wide, use the Pucker tool in the Liquify window (8.20), or again, try the Warp tool to push in the corners of the square jaw.
- You can bring an undershot chin forward with the Bloat tool (found in the Liquify window) and/or use the Warp tool to extend the chin down a bit. You may find it hard to do this with people who have beards, as the Liquify process distorts the hair, making it obvious that tinkering has taken place. You can try to put the hair back later with the Clone Stamp, cloning parts of the beard that weren't affected onto the parts that were, but if the image will be seen up close or at a large size (where minute details may be easily observed), you may not want to risk the beard looking patched together.

[T I P]

If the subject's hair is close to the area that you're trying to Liquify, use the smallest brush size you can and work around the hair, provided it won't adversely affect

the results. A smooth rounding of the cheek won't be possible with a small brush (smaller than the cheek) if you're trying to work around a tendril of hair that covers part of the cheek. You may want to select the hair and cut it to a new layer first (Layer → New → Layer via Cut) and hide the layer containing the offending hair. Then you can adjust the height, width, or roundness of the cheek without any interference, and after you finish, redisplay the hair layer.

Repairing the Signs of a Bad Hair Day

Flyaway hair, strands of hair that hang over the face, wisps, frizz, limp locks of hair that just hang and look terrible — these are common fears of those who are having their picture taken, and the woes of the person who must make these signs of the proverbial "bad hair day" go away. Several of Photoshop Elements' tools can be pressed into service to rid your photos of these hair-raising problems, each used in a unique way to resolve these unique situations.

- You can use the Clone Stamp to cover flyaways — just cover them with the background against which the subject is standing (8.21).

8.20

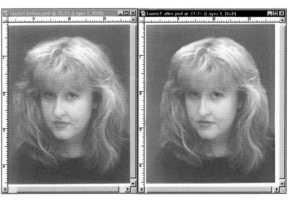

8.21

- The Smudge tool can be used to tame or redirect a curl (8.22). Just set the brush Size to a diameter that matches the curl in question and drag to pull the curl in a new direction or to expand or lengthen it. Don't use this technique for a full-head makeover. Rather, use it for small adjustments around the face or at the very ends of the hair. It's also a good way to do an all over softening, just smudging random locks over the whole head.
- Use the Clone Stamp to get rid of hair that's covering part of the face, neck, or shoulders in a distracting or unappealing way (8.23). You can stamp skin over the hair to get rid of a tendril that's covering the forehead or to take hair away from the face or neck. Be careful not to create any inadvertent patterns in the skin with repeated clicks. Keep re-sampling to choose the right source area for the cloned content, which assures you a more natural effect.
- Soften the look of kinky or very frizzy hair with the Blur tool. If the photo can do with a little softening in general, blur the very frizzy, out of control locks with a low Strength setting and small brush Size. You don't want the hair to stand out as this fuzzy, out of focus mass while the rest of the image remains sharp. Subtlety is your goal here.

Lengthening and Shortening Hair

Wish the hair were just a bit longer or shorter? You can give hair a trim by selecting the unwanted lengths with the Lasso tool (make a free-form selection and then delete the unwanted locks), or you can

● 8.22

● 8.23

Clone Stamp over the hair you don't want (8.24). You can also go the other way and apply some electronic hair extensions with the Clone Stamp or the Smudge tool. Use the Clone Stamp to add larger amounts of hair, carefully avoiding a choppy look by setting a brush size and preset that avoids obvious patterns in the new hair or use the Smudge tool to add just a little bit of length where you need it (8.25).

[T I P]

When using the Clone Stamp to add hair, watch the lighting and texture of the hair that you're cloning. If you're sampling from the top of the head or any place where light is shining on the hair, you don't want to stamp that content onto an area that's in shadow. You also don't want to clone hair from an area where the texture of the hair is distinct and apply it where there's little visible texture or vice versa. If you have no choice in terms of the available hair for cloning, you can use the Burn tool to darken the hair and/or the Blur tool to adjust the texture.

Applying Digital Cosmetics

Just as make-up is applied in real life to enhance the face, you can apply it with Photoshop Elements. Applying the appearance of make-up or through subtle changes in skin tone, texture, and shape, make certain features stand out without really changing them drastically. To make these changes, you need:

- The Paint Brush and Pencil tools
- The Smudge tool
- The Liquify filter
- The Color Variations command
- Selection tools to focus Photoshop Elements' efforts on specific areas of the face
- The Zoom tool to get close to the feature you're retouching

Getting in close and using tools set to their smallest, most subtle settings is key to the success of applying electronic make-up. You can apply it to men's faces as well as women's, making eyes appear more deep-set, making lips fuller or thinner, cleaning up eyebrows. It's not all about pink cheeks and long eyelashes, although these are also adjustments you can easily make.

● 8.24

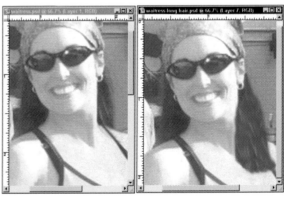

● 8.25

Creating Eye Make-up

When applying "make-up" with Photoshop Elements, you can take one of two paths. You can go for the natural look, where you simply darken and lighten what's there, creating eyes that look bigger, deeper set, and more intense, or you can literally apply eye-liner, add more and thicker eye lashes, and add colored shadow to the eyelids. You can "pluck" the eyebrows to clean them up and raise them, or you can simply lighten them if they're too overpowering as they are.

Thickening Eye Lashes

To make eye lashes look more lush and dramatic, you need more of them, or you need to make the ones you have look thicker. To do this, zoom in as close as you can (without distorting your view and losing perspective on the lashes in relation to the surrounding content), and using a very small, soft-edged Brush, add more lashes (8.26). You can also paint over the

ones that are there, making them seem thicker. This can help avoid the look of false eye lashes, something that drawing in too many new lashes can give you.

Before you paint, be sure to sample the color of the existing lashes (use the Eye Dropper tool) so that you're painting the right color lashes onto the eye. By using a soft-edged brush, you're avoiding lashes that look spikey or harsh, and it is easier to blend the new ones in with the old ones.

After the lashes are drawn, you can use the Smudge tool to blend them in at the lash line — that's if any of your painted strokes' beginnings or endings are obvious. I always smudge the very end of the lash (8.27) to make sure it doesn't have a chopped-off look. Human lashes are slightly thinner at their ends, and the smudging process helps the fake lashes look a little more natural.

● 8.26

● 8.27

[T I P]

When you're working zoomed in close to your subject, it's easy to lose sight of the overall effect your retouching is having. Periodically, zoom out to make sure you haven't gone overboard, or conversely, that your efforts haven't really had any impact at all.

[N O T E]

You can enhance the lash line further by drawing a line of eyeliner onto the lid, following the lash line closely. Use a soft-edged brush, set to a color that's slightly darker than the lashes and paint slowly and carefully. You can use the Blur or Smudge tool to soften the line as needed.

Plucking and Reshaping Eyebrows

Whether it's a man with brows like small shrubs or a woman who's gone too far in her real-life brow plucking, you can do a lot to tame, re-grow, and reshape the eyebrows in your photos' subjects.

- To thicken brows that have been over-plucked, use the Clone Stamp, set to a very small brush Size, to repeat the existing brow hairs, right next to the existing brows (8.28). Follow up with the Smudge tool, set to a low Strength to smooth

8.28

the added portions out and blend them with the original brows, as needed.

- To reduce thick, wiry brows, use the Blur tool to soften them slightly (set the tool to a low Strength, something under 50%). If the brow area is too large, you can use the Clone Stamp to cover hair with skin from the surrounding areas of the face, using skin that's currently next to the eyebrows. This helps the skin look like it "belongs" there (8.29). After cloning, use the Blur tool, again set to a low Strength, to soften the edges of the new skin and the remaining brows.

[T I P]

You can use the Dune Grass brush preset to paint "hair" onto eyebrows, mustaches, even add fur to animals. You can, of course, also paint grass onto surfaces. On the face, however, you can use this preset to create small strands or long ones, soft ones or thick ones, depending on the rest of the brush settings with size, opacity, and the airbrush option turned on.

- To change the arch of brows that are the right thickness but just the wrong shape, use the Liquify filter's Warp tool, set to a small brush size and gently nudge the brows up and out,

8.29

increasing the height and width of the arch as needed (8.30). Be careful not to warp the eyelid or other surrounding features. This is where using a small brush size is key so that your changes only affect the brows.

Be subtle when changing the arch of brows and keep the rest of the face in mind. If the person has close-set eyes, don't bring the brows too close together between the eyes. The arch of the brow should be directly over the pupil of the eye, or slightly to the outside of the pupil if the eyes are close-set. Going overboard with brow reshaping never improves things — you don't want to leave someone looking like they're perpetually surprised or as though they're doing a bad Jack Nicholson impression.

Adding Color to Lips and Cheeks

Nice rosy cheeks give a face a healthy glow. This applies to both men and women, children, adults — anyone who may currently look a little pasty or pale. You can add color through any of the color-adjustment tools discussed in Chapter 3, specifically

adjusting hue and saturation. You needn't restrict this recoloring to the cheeks, either. If someone has a sunburn that you want to tone down, you can do it on the entire face or anywhere on the body. Conversely, if the person is pale all over, you can add some healthy skin tone to more than just the face.

Creating Subtle Changes in Skin Tone

The key to changing skin tone is to select the skin. Otherwise, if you increase the level of a particular color, the change can affect the hair, clothing, and surrounding content as well. Therefore, any recoloring project must begin with you selecting the skin area that you want to change (8.31).

Next, use the Hue/Saturation command to change the skin tone in the selected area. Choose Enhance → Adjust Color → Hue/Saturation. Drag the Hue slider

● 8.31

● 8.30

(8.32) and observe the changes in skin tone. You can make it more pink, more peach, or reduce yellow and sallow tones. When you like the way the selection looks, click OK to commit to the changes in your photo.

Applying Color and Shine to Lips

If your subject wasn't wearing lipstick and would have looked better if she had, you can add the color and shine later, using color enhancement tools to brighten the lips and the Brush tool to add little pools of light, which mimics the look of lip gloss. The results can be quite natural-looking if you're careful, and if you don't go overboard with color or shine (8.33).

To apply lip color, first, select the lips with the Selection Brush tool or the Lasso. Then, use the Color Variations command (Enhance → Adjust Color → Color Variations) and select the Increase Red thumbnail. You can also decrease other colors, such as green or blue to create other shades of "lipstick" (8.34). You can darken the color you end up with by clicking the Darken thumbnail before clicking OK to commit to the changes.

To add shine, activate the paint Brush tool and set it to a small brush with soft edges. Click (don't drag) on the lips, applying light to the high spots on the lips — the fullest points and the points that stick out

● 8.33

● 8.32

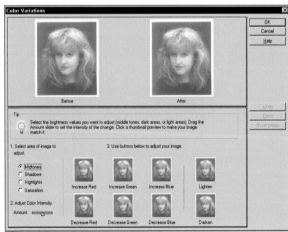

● 8.34

farthest from the face (8.35). You can click in place repeatedly to brighten spots where you feel the gloss would be the most dramatic, and click only once, perhaps on a lower Opacity setting, where you feel the gloss would be subtle.

● 8.35

[T I P]

Don't add too many glossy spots to the lips because it won't look natural. If you find that even one spot looks fake but you really want to accentuate the shape of the lips through the application of light, use the Selection Brush and select one or two of the fullest and/or highest points on the lips. Then use the Color Variations command and click the Lighten thumbnail to add light to the selection. Later, you can blur the edges of the lightened area to blend it with the rest of the lips.

The Big Picture

In this chapter, you read how to alter people's appearance by using paint brushes, blending and cloning tools, and the Photoshop Elements' features that control the appearance of color, light, and shape. In the next chapter, you read how to perform some additional magic, such as applying special effects through the Filters and Effects tabs and the Filter menu, and turning photos into works of art, abstraction, or both.

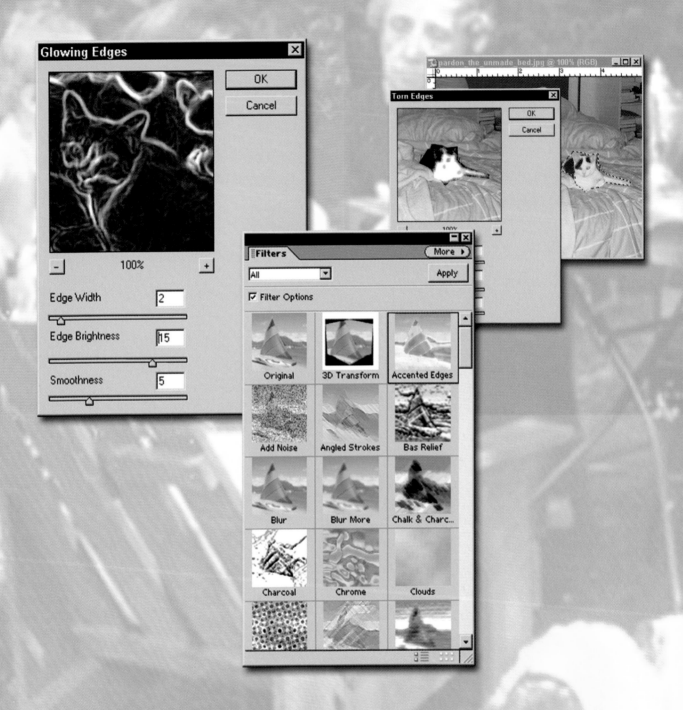

Mastering Special Effects and Filters

United with reason, imagination is the Mother of the Arts and a source of their wonders.

FRANCISCO DE GOYA

By this point in the book, you probably know your way around Adobe Photoshop Elements and know how to use the filters that create an improved reality — the Blur and Sharpen filters, which are the filters used to eliminate noise in the form of dust, speckles, and small stray dots. In this chapter, you discover how to use the filters that free your imagination, enabling you to apply special effects ranging from artistic treatments that turn photos into paintings to distortion and reshaping filters that bend reality and create entirely original images from what were once your simple photographs.

You also find that some of the more imaginative filters can help you make use of photos that are hopelessly dull (yet perhaps contain the images of people who are precious to you) or that have slipped beyond the point where retouching is do-able. While virtually all damage is repairable, even down to restoring photos that have been nearly shredded or burned, sometimes it takes more time than you have, so you decide not to do it. Using filters that make a photo look like a drawing done with pastels, or a filter that turns your photo into a watercolor painting may be the answer. A multitude of sins can be hidden in the filters' effects, giving you a work of art where there once was a damaged photo you thought you could never display.

Applying Special Effects

In the upper-right corner of the Photoshop Elements workspace, you see the docking well that is loaded with tabs for several of the palettes you need as you use the product on a variety of different types

of images. You can use the palette tabs (9.1) to display their content directly from the well, or you can drag them down onto the workspace to turn them into individual, free-floating palettes (9.2). The palettes offer different ways to view their content (as floating boxes or displayed from the docking well), and the choice of which of the palette's available options, settings, and thumbnails are viewed in the palette itself.

The two palette tabs covered in this chapter are the Filters and Effects tabs. The Filters tab (9.3) is a visual display and selection tool for the filters that you can also access through the Filter menu and its sub-menus. The Effects tab (9.4) contains special effects that are very similar to filters. You may, like me, wonder why they were put in a separate tab and treated as different tools. My theory is that because Actions are such a popular part of Photoshop, the designers of Photoshop Elements wanted to offer something similar and therefore placed these special effects on a tab by themselves.

Displaying Image Options

To use these two tabs, you can simply click the tabs (one at a time, of course) and view the thumbnails

● 9.1

● 9.2

● 9.3

that give you a visual representation of the filter or effect's results. A simple color image (of a striped sailboat) is used in each of the thumbnails, and from it, you can get a general idea of what the filter or effect does to your image or the selected area within it. You can also view your choices as a list, by clicking the List View button at the foot of the palette (9.5). When you click this button, the view changes to show a text list of Filter or Effect names and to see the thumbnail for any one of the filters or effects, you must click on its name and view the column to the left. The Original of the image (with no Filter or Effect applied) appears at the top, followed by a thumbnail for the selected Filter or Effect (9.6).

● 9.5

● 9.4

● 9.6

Applying Filters and Effects

Before using any filter or effect, it's a good idea to decide if you want the filter or effect to apply to your entire image, a particular layer, or a selection within a layer. If you want to restrict the results to a particular layer, be sure to click on that layer in the Layers palette, and if you want further restrictions, use a selection tool to select an area within that layer (9.7). If you're using a filter to mask damage you don't have the time or patience to retouch, selecting the damaged area is a key first step unless you want to apply the filter or effect to the entire image so as not to draw further attention to the damaged spots.

After you make your selection of a layer or area within it, you're ready to select a filter or effect and apply it to your image. To select a filter or effect, simply click on it in the Thumbnail or List View and click the Apply button (9.8). If you need to use a dialog box in order to apply the filter or effect, the dialog box will appear (9.9). If no dialog box is required, the effect or filter will apply to the entire image or your selection therein, no questions asked.

● 9.7

● 9.8

You may recall from earlier in this chapter, as well as in other chapters where filters are used restoratively, that you can also access filters via the Filter menu. The menu is broken up into several submenus (9.10), each a grouping of related filters. You apply each individual filter through a dialog box (where adjustments can or must be made by the user) or it applies automatically as soon as you select the filter from the submenu. The results of the filters are the same whether you apply them through the Filter menu or the Filters tab, and other than providing a thumbnail preview of each filter (for those that are not very illustratively named), there is no benefit to working with the Filters tab instead of the Filter menu.

● 9.9

● 9.10

Distorting Image Content

Because you already read about how to use filters that restore your photos, it's high time to look at the ones that go to the other extreme — the Distort filters. With the Distort filters, you can create the illusion of water on top of or running through your images (9.11); you can spin the image content, swirl it, twist it (9.12); or press it under the look of textured glass (9.13).

The Distort filters include

- Diffuse Glow
- Displace
- Glass
- Liquify
- Ocean Ripple
- Pinch
- Polar Coordinates

● 9.11

● 9.12

- Ripple
- Shear
- Spherize
- Twirl
- Wave
- ZigZag

All of the Distort category's filters provide dialog boxes, each allowing you to determine the options for the filter. You can choose between different

textures, shapes, and levels of intensity, all the while viewing a Preview of your image in the dialog box. A preview appears in the image window as well, and if you position the dialog box properly, you can see both previews at once (9.14).

[TIP]

You can combine filters by applying one, then another, and then another, until you achieve the desired look. The order you apply them is dictated only by the results you're looking for, and any dependency between filters. You want to apply a texture before adjusting color, or vice versa, for example.

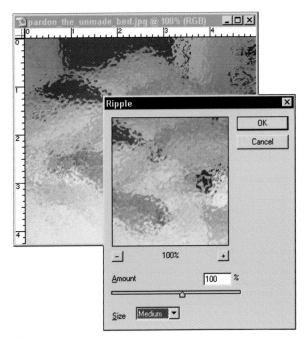

● 9.13

● 9.14

Applying Artistic Filters

The Artistic filters, to which I also add the filters in the Brush Stroke and Sketch submenu categories, turn your photos into paintings and drawings. I like to use them when a photo is really boring as a traditional photo, or when the required retouching is beyond the time or patience I have to devote to the image. I've also taken photos of family members and turned their portraits into paintings, enlarged, and then framed them as gifts. It puts a whole new slant on the photo, and often enhances a person's features — wrinkles become brush strokes, double chins become a soft shadow, and so on.

The Artistic Filters

The Artistic category filters include a variety of artistic media, application methods, and surfaces to which you can apply paint. From Colored Pencil to Watercolor, just about every tool you can use in real life to create a painting or drawing is represented:

- Colored Pencil
- Cutout
- Dry Brush
- Film Grain
- Fresco
- Neon Glow
- Paint Daubs
- Palette Knife
- Plastic Wrap
- Poster Edges
- Rough Pastels
- Smudge Stick
- Sponge
- Underpainting
- Watercolor

Like the Distort filters, all of the Artistic filters require a dialog box for you to establish how to apply the filter. You can choose the width, length, or strength of the brush or pencil strokes, the level of detail, and in some cases, establish the brightness or amount of shadow included (9.15).

As you tinker with the settings in the Artistic filter dialog boxes, you may find that some of the settings can actually render your images unrecognizable. The details are lost to brush strokes or pencil lines, and an entirely new image is created (9.16). This can be a good thing, depending on your intended use of the photo. If you want a subtle effect, keep all your sliders and other options at a low setting (9.17).

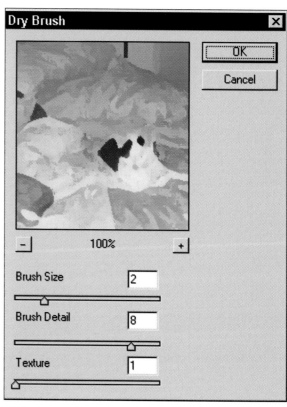

● 9.15

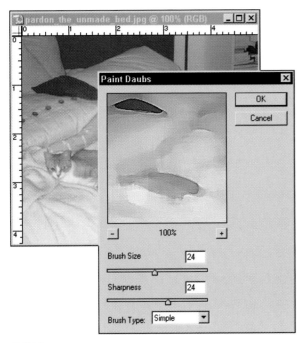

● 9.16

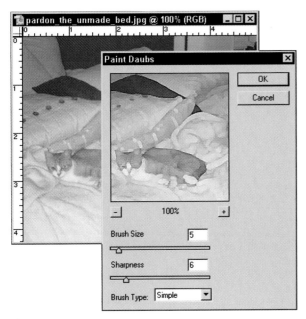

● 9.17

Brush Stroke and Sketch Filters

Most of the Brush Stroke and Sketch filters really could be included in the Artistic submenu, because they're simply variations on artistic media, such as pencils, ink, and different methods of applying paint. The Sketch category is more drawing-oriented, including filters that create the look of drawing with charcoal or using a crayon (9.18). There are also filters that legitimately fall outside of the artistic realm, such as Photocopy and Torn Edges, but these, too, apply a definite artistic look to your photos.

● 9.18

Choosing a Brush Stroke Filter

You can choose how soft or ragged your drawn or painted photo can be by selecting one of the following Brush Stroke filters — the names are fairly self-evident:

- Accented Edges
- Angled Strokes
- Crosshatch
- Dark Strokes
- Ink Outlines
- Spatter
- Sprayed Strokes
- Sumi-e

- Charcoal
- Chrome
- Conte Crayon
- Graphic Pen
- Halftone Pattern
- Note Paper
- Photocopy
- Plaster
- Reticulation
- Stamp
- Torn Edges
- Water Paper

If you have any doubt as to what effect the filter you're considering will apply, you can open the dialog box (all of these filters require one to be used) and view the Preview. A filter such as Sumi-e, which you might not recognize by name, is a good one to check out (9.19). Some of the filters also work better on color images than grayscale, and others, such as Ink Outlines, strip out the color in order to apply the effect (9.20). You can also go to the Filters tab and scroll through the thumbnails, viewing the sample of the filter about which you're curious.

Working with Sketch Filters

The Sketch category comprises filters that achieve the look of a drawing or sketch, thus the name of the submenu. However, a few don't seem to go with the rest. Each of the filters requires the use of a dialog box, however, so selecting the filter and viewing the preview can easily resolve any mystery:

- Bas Relief
- Chalk & Charcoal

● 9.19

You can achieve interesting effects by applying some of these filters to only part of your image. For example, applying Torn Edges to a particular person or object within the image gives the selected content the appearance of being torn out of another photo and pasted into the current one (9.21).

Others are more abstract, such as Photocopy. Unless you're trying to create something that looks photocopied so that you can say it's a photocopy, the results are so destructive to the details and color that you have to have an aesthetic reason for using the filter (9.22).

● 9.21

● 9.20

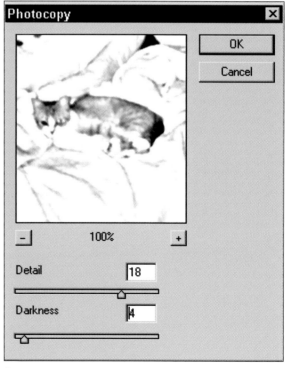

● 9.22

Working with Realistic and Imaginative Textures and Styles

The remaining groups of filters that you're likely to apply to photographs are the Pixelate, Stylize, and Texture filters. These filters apply results that are rather difficult to categorize, such as the looks of stained glass, mosaic tiles, weird glows, and the appearance of wind blowing the photo's content, thus the rather non-descript names for the categories!

With a few exceptions, all of the filters in these three remaining categories have dialog boxes that you can use to customize the filter effect. Those that don't have a dialog box apply immediately to your entire image or to the portion thereof that's selected at the time. You can always use the Undo History palette or choose Edit → Undo, so don't be timid about using these filters:

- Facet and Fragment, both found in the Pixelate category
- Find Edges and Solarize, found in the Stylize category

All of the Texture filters have dialog boxes, so that you can choose how the texture is applied, the sort of texture to use, the level of detail, and so on (9.23).

The Pixelate Filters

The name of this filter category is based on the fact that the filters in it work by focusing on individual pixels or groups thereof. Whereas the Texture and Stylize filters apply more of an overlay or work with the colors in your image, the Pixelate filters break your image into visible pixel-based chunks, often without regard to the color or location of the pixels. Your choices include

- Color Halftone
- Crystallize
- Facet
- Fragment

- Mezzotint
- Mosaic
- Pointillize

The Pointillize filter demonstrates well an example of the pixel-based effect, which converts the image to a pointillist painting, which makes up of lots of dots with the colors not derived directly from the original colors of the pixels in the photo (9.24). You can choose only the size of the points (Cell Size), and the smaller they are, the more detail you retain in the image. If you choose very large cells (9.25), you can render the image unrecognizable.

The Fragment filter, one of the two that don't give you a chance to customize with a dialog box, creates a duplicate of every pixel in the image and offsets it slightly. The result is a fragmented (thus the name) image that looks like two images on top of each other, or a photo taken while the photographer was jumping up and down (9.26). I find the Fragment result to be hard on the eyes, as I can feel my eyes trying to focus on it. I don't suggest using it on an entire

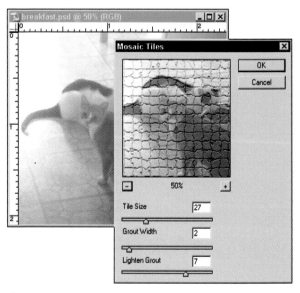

● 9.23

image. It can be effective if used on part of an image, to imply movement in the background, for example.

The Stylize Filters

The Stylize filters are not easily described, thus the rather cryptic name for the category. The effects range from those that soften the image, such as Diffuse (9.27); to those that obliterate it, such as

● 9.26

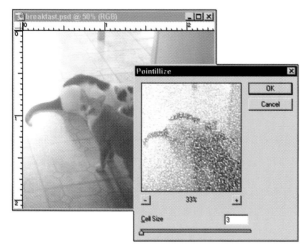

● 9.24

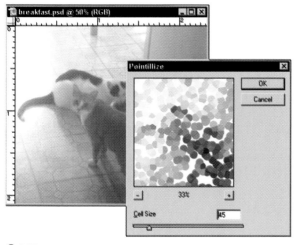

● 9.25

● 9.27

Wind (9.28); to filters that use (but don't change) the photo's color, such as Solarize and Find Edges (9.29); to some that remove the color in between, such as Glowing Edges (9.30).

The complete list of Stylize filters includes

- Diffuse
- Emboss
- Extrude
- Find Edges
- Glowing Edges
- Solarize
- Tiles
- Trace Contour
- Wind

● 9.28

● 9.29

Several of the Stylize filters are hard to imagine using for photos that you've spent any time retouching or restoring. They eliminate so much of the photographic detail that any time spent removing signs of dust and mold, sharpening detail, smoothing out blemishes, and repairing tears would be wasted. On the other hand, filters such as Emboss, which turns the image into what looks like the inside of a plaster mold of the photo, create high and low points (the hills and valleys in the mold) based on the colors, highlights, and shadows in the image (9.31). A tear or big stain, therefore, may make this filter unusable, in that the damage is interpreted as part of the photo and make it difficult to determine what's what.

● 9.30

● 9.31

The Texture Filters

Now the filters in this category give you generally illustrative names (Mosaic Tiles, Patchwork, Stained Glass) and one that's a "you-pick-it" sort of filter, called Texturizer. With Texturizer, you can pick from a list of textures to apply to the image, and choose how the one you select can look (9.32).

The complete list of Texturizer filters includes

- Craquelure
- Grain
- Mosaic Tiles
- Patchwork
- Stained Glass
- Texturizer

One of these filters in particular is best used in combination with a filter from another category, although you want to experiment in general with combining filters. If you use the Stained Glass filter on its own, the result is somewhat disappointing. The image doesn't look like glass panes separated by strips of lead, it looks like a cartoon of that effect (9.33). If you use the Glass or Ripple filters (found in the Distort category) first, however, the stained glass effect will look as though it's been applied to real, old, rippled glass (9.34).

[T I P]

The more you play with the different filters in all of the categories, the more combinations you're likely to think of and find good uses for. Don't be hesitant to try combinations that seem like odd pairings. You'd be surprised how effective the right combinations of two or more filters can be.

● 9.32

● 9.33

Applying Layer Styles

Layer Styles, viewable through the Layer Styles palette in the docking well, include 13 different categories (9.35) of special effects that can be applied to the layers in your photo. If your photo is fresh from the scanner and you haven't added any layers or pasted any content from another photo (which creates a new layer), your image may consist solely of a Background layer and nothing else. If that's the case, the effects of the Layer Styles may be inappropriate because they won't make any difference, or they completely cover up your photo.

The samples shown in the Layer Styles palette are applied to a small, gray box (9.36). This makes it hard to imagine how they'll look when applied to a layer in your photo, so be prepared to apply them first, and Undo if you're disappointed with the result. Unlike the Filters and Effects tabs, which show a fairly illustrative thumbnail, the Layer Styles tab is not nearly so helpful.

● 9.35

● 9.34

● 9.36

Applying Layer Styles

To apply a Layer Style, simply click the palette tab to display the palette, and then use the drop-down list to choose the category of styles you want to choose from. By default, the Bevels group displays because it's first in the list. After you see one that you want to apply, you have two choices:

- Click the thumbnail to apply the style.
- Drag the thumbnail onto your image and drop it on the content to which the style should apply (9.37).

To adjust the way a style looks, you can double-click the style layer in the Layers palette (9.38), and then use the resulting dialog box to adjust the depth of the shadow, width of the glow, color of the outline, angle of the beveled edge, and so on. The dialog boxes are as numerous as the styles you can apply, but all rely on common tools, such as sliders, check boxes, and textboxes into which you can enter numbers, indicating the degree of rotation, width, height, or thickness of the style's components (9.39).

● 9.38

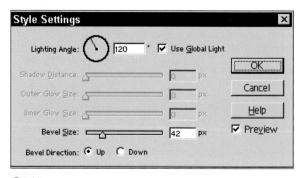

● 9.39

● 9.37

Removing Layer Styles

You can change your mind and turn off a style that you applied by clicking the Clear Style button (9.40), and the last style you applied disappears from the image.

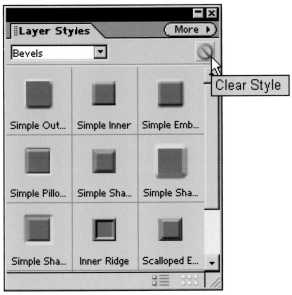

● 9.40

If you already left the palette and want to get rid of a style, you can:

- Choose Edit → Undo.
- Press Ctrl + Z (Command + Z if you're on a Mac).
- Use the Undo History palette and go back one step in the list of actions taken.
- Redisplay the Layer Styles palette and click the Clear Style button (the group of styles containing the one you applied must be displayed in the palette at the time).

The Big Picture

In this chapter, you learned to use the Filter menu and the Filters and Effects tabs to apply special effects to your photos. From turning your photos into paintings and drawings to stretching and twisting your photos' content into new shapes and sizes, you saw all the artistic and abstract effects you can apply and how to customize them for individual goals. In the next chapter, you read about the finishing touches, such as preparing images for printing, posting to the Web, and some interesting ideas for displaying your photos for your own use and as gifts.

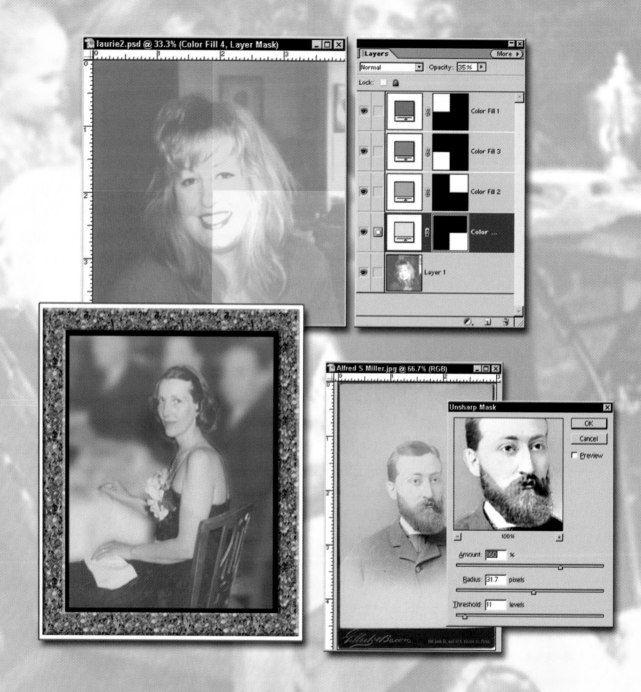

Printing and Displaying Your Restored Images

The beholder's eye, which moves like an animal grazing, follows paths prepared for it in the picture.

<div align="right">PAUL KLEE</div>

You've fixed the scratches, you've excised the unwanted ex brother-in-law and replaced him with a lovely background, you've restored the torn corner, and the photo looks. . . pretty good. If you wanted to frame it for your own use or as a gift, or if you're restoring it for a client or for use on the Web, it shouldn't just be "pretty good," it should be great! You want the person who looks at the picture, be it on paper or online, to get from it what you intended — information, particular emotions, or simply the pleasure of looking at a pretty picture. Your goal in finalizing the restoration of your image is to make sure that nothing distracts or detracts from the photo's impact on the viewer.

In this chapter, you read about some finishing touches that you can apply to make a photo that's structurally fine — no scuffmarks, no dust, no rips and tears anymore — and apply the polish that makes you proud to hang it on a wall, stand it on your desk, or give it as a gift. For images bound for the Web, you also discover how to use Adobe Photoshop Elements' Save For Web command, which turns images into Web-friendly files that Web browser software can display with ease, and that your site's visitors can enjoy.

Putting Finishing Touches on Black-and-White Photos

Black-and-white photos can be very dramatic. The absence of color makes the content of the image stand out on its own. The people, places, inanimate objects, plants, trees, and so on, all have a life of their own based on their shapes, their relationships to each other within the composition of the photo and based on their light and shadows. The lack of color is actually refreshing in some photos, which may make you want to turn some of your color images to Grayscale (Image → Mode → Grayscale) so that you can experience the image without the distraction of color.

Whether your image was always black-and-white or has recently been converted to it, you want to make sure that the image is as crisp and clean as possible, and that your exposure — brightness, contrast — is right for the image. You read how to make those changes in Chapter 4, and you can easily apply to grayscale photos any of the retouching techniques discussed in Chapters 3, 5, 6, and 7. If you want the look of a grayscale image for a color photo, choose Image → Mode → Grayscale and click OK when asked if you want to discard color information. After doing so,

switch back to RGB mode (Image → Mode → RGB) so that the colorization tools are available to you. Your image can remain black-and-white, but you can tinker with the available shades of gray by using the Color Variations dialog box, for example.

[N O T E]

If you don't like your photo in black-and-white and want to add color, you can do that, too. Convert the image to RGB mode and then use the colorization techniques described in this chapter as well as in Chapter 3.

Colorizing a Black-and-White Photo

Adding a bit of color to a black-and-white photo can turn a drab image into a livelier one or make history a little more accurate. For example, if you know your great aunt loved to wear periwinkle, you can make that scarf she's wearing into a lovely shade of just that color. If you know your grandmother's couch was green, it can go from gray to emerald in just a few seconds. You can colorize just parts of the image, or you can go whole hog and colorize the entire image, choosing realistic colors that can make the image look like a color photo, or you can create a duotone or sepia tone image. The choice is yours, and the tools to make it all look realistic are all within the Photoshop Elements toolbox and menus.

Converting Grayscale to RGB

With your grayscale image open, choose Image → Mode → RGB. As soon as you make this choice, a prompt appears (10.1), asking if you want to flatten, or merge, your layers. If you plan to do any work on the layers individually, click the Don't Flatten button.

● 10.1

Now that your image is in RGB mode, all of the color-related commands are available. Instead of a list of dimmed commands in the Enhance menu's various submenus, you see that they're ready and waiting for your use.

Selecting Content to Colorize

With your image in RGB mode and ready for colorization, you need to isolate the parts that you want to color. Even if you plan to colorize the entire image, you probably won't be applying the same color to every part of the image, so you need to select the different regions, similarly to creating the plans for a paint-by-number project (10.2).

The selection tool you use depends on the area you want to select. If the area has straight sides (or mostly straight sides), you may like the Polygonal Lasso.

● 10.2

If your area is completely free-form, use the Lasso, or if there are big differences in shades of gray between your desired area and the surrounding content, use the Magnetic Lasso and let the tool do the work. You can also use the Selection Brush for free-form selections. Whichever tool you use, try to stay as close to the real edges of real objects — shirts, faces, cars, furniture, whatever you're coloring (10.3). If you don't, you'll have your colors overlapping other objects. So Zoom in as close as you can and be careful as you drag to make your selection.

Using Color Variations to Turn Gray to Color

As you make each selection, choose Enhance → Adjust Color → Color Variations to open the Color Variations window (10.4). This is the quickest way to color an image. You can use the individual Hue/ Saturation dialog box or even paint colors on with your Brush tool, but I prefer and recommend the Color Variations tool with no hesitation.

After you're in the Color Variations window, click the Increase and Decrease thumbnails for Red, Green, and Blue. You can also use the Lighten and Darken thumbnails. Watch the After thumbnail at the top of the window, and when you like what you see, click OK. For more detailed colorization, tinker with the Shadows and Highlights levels of each color you increased or decreased. Click the Shadows or Highlights options in area 1 (10.5) of the window

● 10.3

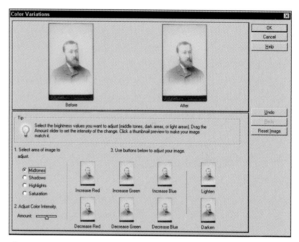

● 10.4

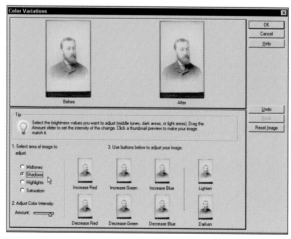

● 10.5

and then use the Increase and Decrease thumbnails to adjust the color levels in just the pixels in shadows or highlight areas of the image.

As you work in the Color Variations window, if you don't like the effect of the thumbnail you just clicked, use the Undo button (in the window) to go back a step. If you hate what you did altogether, click the Reset Image button, which reverts the After thumbnail to match the Before thumbnail.

After you click OK and commit to the results (you can always choose Edit → Undo if you don't like it after seeing it in the image window), you can go on and repeat the process for the next selection within the image. After you color each section of the image — each face, each head of hair, each piece of furniture, wall, carpet, lawn, car, building, sky, whatever — you can use the Unsharp Mask filter (Filter → Sharpen → Unsharp Mask) to bring out the edges of your colored regions. This aids in creating a more realistic look for your image, so that your colors aren't quite so flat (10.6).

[T I P]

If you want to change the amount of color in smaller, or more specific increments than can be achieved with the Increase and Decrease thumbnails, switch to Saturation mode (using the options in area 1 of the Color Variations window), and use the Less Saturation and More Saturation thumbnails to make your adjustments.

Converting a Vintage Black-and-White Photo to Sepia Tone

If you have a black-and-white photo that either is old or just looks old, you can convert it to a vintage-looking sepia tone image rather easily. Simply convert the image to RGB mode (using the steps described in the previous section) and instead of coloring individual regions of the image, create a new, very transparent layer, and color that layer to achieve the look of sepia. Follow these steps to make it happen:

1. **With your image converted to RGB mode, click the Layers tab to display the Layers palette.**

2. **Click the Create New Fill or Adjustment Layer button at the foot of the palette** (10.7). **A menu appears.**

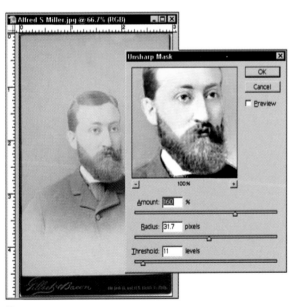

● 10.6

● 10.7

3. Choose Solid Color. A block of color appears, covering your entire image (10.8). Don't panic — you fix this in a second.

4. Drag the Opacity level for the new layer down to 35% (10.9).

5. To set the color to a shade of sepia, double-click the Layer's color block (10.10). This opens the Color Picker.

6. Using the Color Picker (10.11), type CC9933 in the # box. This is a hexadecimal value for a color that's close to a true sepia.

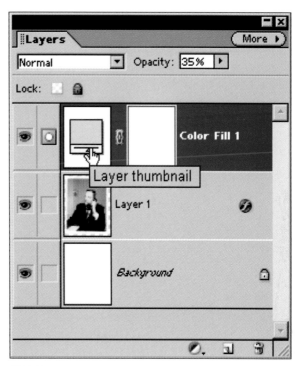

● 10.10

● 10.8

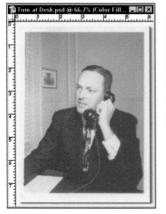 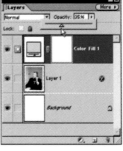

● 10.9

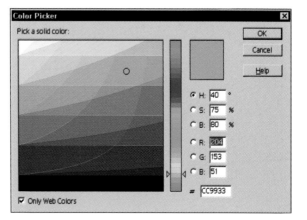

● 10.11

7. **Click OK. The solid color layer, which is now transparent, is also now a sepia color, making your photo look like a vintage sepia tone (10.12).**

[T I P]

Feel free to experiment with other shades of yellowish brown until you find a shade that looks like sepia to you.

Creating Duotone Images

The procedure you used to create a sepia tone image can be used to create a *duotone*, which is simply any image with two (duo) colors, one being black. Your transparent color layer can be any color, and as long as it's on top of a black-and-white image, you can achieve the effect of a duotone (10.13).

For an interesting, sort of Andy Warhol effect, break your photo into four sections and apply a different color overlay to each quadrant. To do this, you need to make four selections, each an exact quarter of the image (10.14), and create a solid color layer for that selection. In the end, you have four blocks of duotone color (10.15).

● 10.13

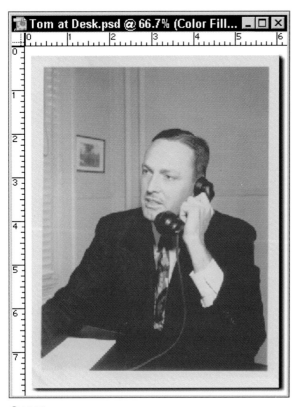

● 10.12

● 10.14

Saving Photos for Use on the Web

If your images are bound for the Web, you have to *optimize* them, which means to make them compatible with the requirements imposed by Web browsers, such as Microsoft Internet Explorer (the browser that comes with Windows and is also available on the Mac) or Netscape Navigator. Web browsers only support a small group of colors and file formats. For the purposes of creating fast-loading images (so your site visitors won't be drumming their fingers on the table as your images appear), the Save For Web window optimizes your photos for you based on settings that you choose.

To open the Save For Web window, choose File → Save For Web. When the window opens, the photo appears twice in the middle of the window. You can see the statistics, such as file size, and in the case of the version on the right, the estimated time it takes to load in a browser window (10.16).

After you're in the window, you can use the Hand, Zoom, and Eye Dropper tools (see them in the upper-left corner) to move your image around within the window (after it's been zoomed in on and it doesn't all fit at once), to zoom in on particular spots and to select colors for a Matte (see this option on the right side of the window — it has a drop list from which you can choose Eye Dropper Color). You can also set the zoom by using the Zoom tool below the images, on the left, which is set to 100% by default.

[N O T E]

Want to see the load-time stats for a different set of circumstances? Click the options triangle above and to the right of the optimized version of the image. You can choose from a variety of modem speeds and Internet connection types, and after you choose, the statistics appearing below the optimized version of the image change accordingly. The default setting is for a 28.8 Kbps (kilobytes per second) modem, but as these are an increasingly rare device (most people are on 56.6 Kbps modems if they're on a dial-up connection), you may want to change it.

Choosing the Right File Format

The file formats that Internet Explorer, Netscape Navigator, and the other browsers your visitors may be using only display three types of graphics:

* JPG (pronounced "jay-peg")
* GIF (pronounced with a hard or soft G, followed by the word "if")
* PNG (pronounced "ping")

● 10.15

● 10.16

Made to Measure

To make selecting rectangular areas easier, especially when you need to select an area that's a specific width and/or height, you can use the Grid (View → Grid), and you can also use the Rulers (View → Rulers). With the rulers displayed, you can set the zero point by dragging from the intersection of the rulers (upper-left corner) and by releasing the mouse when the two lines (one vertical, one horizontal) appear along the ruler where you want the zero to be. You can use this to help you measure your selections. Using the grid is also helpful, in that by choosing Edit → Preferences → Grid, you can set the size of the grid and set the individual blocks to a useful size, such as half or a quarter of an inch, and then use them to select, say, a 3" x 5" rectangle with the Rectangular Marquee tool.

Of these three formats, JPG and GIF are the most popular, and most widely accepted by browser software. PNG is recognized only by browser versions 4.X and later and is not widely used — yet. The format's been around for nearly 10 years, but you see more people using JPG and GIF, simply because it takes a while for newer formats to take hold. When optimizing your images, consider the following points when deciding which one to use for specific images:

- Photos should always be saved in JPG format. JPG supports millions of colors, and GIF supports only 256. JPG allows the fine detail, variety of colors, tones, and shades to be displayed accurately and clearly.
- Line art, such as logos, graphic text, or simple drawings (not photos to which a drawing filter has been applied) are best saved in GIF format.
- PNG is best used for the same kind of images that you save in the GIF format — line art, simple drawings, logos, and the like. Unlike GIF, PNG allows you to make your background transparent in Grayscale and RGB modes.

Given that you're probably reading this with photos in mind, JPG is your bet, even if you added text, a solid color frame, or other simplistic content to the image. The photo's display is the priority, and JPG supports it more fully.

Establishing File Options

For static photos (as opposed to animations, which you can create with Photoshop's companion product, ImageReady), you can work with the Settings and New Size sections of the Save For Web window. In the Settings section, you choose the quality of your image. The higher it is, the slower the file loads, because all that quality increases file size. You generally don't want the image to take more than 10 seconds to load, so keep an eye on the statistics appearing below the optimized version of the image as you tinker with the Settings.

After you make all your choices for the quality and size of the image, you can save it by clicking the OK button. The Save Optimized As dialog box appears, in which you can name and choose a location for your file. Web browsers won't honor spaces, so if you must break words apart in your file name, use the underscore character to indicate a space. Some Web servers don't support capital letters, so the safest bet is to save the file in all lowercase letters. You can use numbers in your file names, as well as dashes.

Printing Your Photos

One of the key decisions in printing your photos is *how* to print them — what kind of printer to use and what kind of paper to print them on. If you have only one printer and no money for another printer, then the decision is made. You'll be printing on the printer you have. If you have the cash for the perfect printer for your particular photo, that's great. With the assumption that you have some choices available to you, however, check this list of printing options, found in Table 10-1.

TABLE 10-1 PRINTER OPTIONS

TYPE OF PRINTER	PRICE RANGE	COMMENTS
Inkjet	$75 - $350	Color inkjet printers can create near photo-quality images, assuming you use good quality photo paper for the output.
Laser	$600 - $3,000	Color laser printers are more expensive than inkjets and black-and-white laser printers. If you're creating camera-ready art for very important, detailed publications, you probably want a color laser.
Dye-Sublimation	$600 - $1,000	Dye-sublimation printers provide an excellent image, especially for color photos. The subtle results are great for professional designers, artists, and photographers.

Should You Use a Laser Printer?

Laser printers work very much like photocopiers. A laser beam is aimed at a photoelectric belt or drum, building up an electrical charge. This happens four times, once each for the four colors used to make all the colors in your image — cyan, magenta, yellow, and black. The electric charge makes the colored toners stick to the belt, where it is then transferred to the drum, along which the paper rolls as it moves through the printer. The toner is transferred to the paper, and then either pressure, heat, or both are used to make the toner stick to the paper.

A Common Choice: The Inkjet

The name "inkjet" gives you an idea of how the inkjet printer works, in that a spray of ink is aimed at the paper. Ink cartridges are vibrated by piezoelectric crystals (the crystals are sandwiched between two electrodes, which make them dance). Different levels of voltage cause the crystals to vibrate differently, adjusting the colors and amount of color sprayed through a nozzle onto the paper.

Working with Dye Sublimation Printers

Here, the name of the printer gives little or no clue as to the way the printer works. Dye Sublimation printers work in a relatively straightforward way.

A strip of plastic film, called a transfer ribbon, is coated with cyan, magenta, and yellow dye. When a print job is sent to the printer, a thermal print head heats up the page-sized (8.5" x 11") panel of plastic transfer ribbon and through variations in temperature, controls the colors and amount of color that are applied to the paper. Because the paper has a special coating on it, the dye sticks.

Selecting the Right Paper for Your Printed Photos

Photo-grade papers are available for every kind of printer you may have, so finding glossy or matte-finish photo paper shouldn't be a problem. The price of photographic paper (for computer printers, not for photographers) is much higher than regular printer paper. A ream of 500 sheets of bright white inkjet paper, for example, may be as little as $4.00, but just 50 sheets of photographic paper can be more than $10.00.

Choosing between glossy and matte-finish paper may be the biggest decision you have to make with regard to printing your photos. Glossy paper is good for newer photos, for color images, and images with very fine detail that you don't want to get lost. Matte-finish paper is good for printing vintage images that would have been printed on porous, matte-finish paper originally. Matte-finish paper does

lose some of the image detail, however, so if crisp, clean details are key, print on glossy paper.

Display Options for Your Photos

You can always put your photos in a photo album or a simple frame, but what if that's not exciting enough? Or what if you can't find the right frame for the photo, or a frame that suits your décor or that of the person to whom you are giving the photo as a gift? Photoshop Elements provides several options for creating display-ready images — either through the creation of a collage, which is a composite of several related images, or by adding a frame to your image, which makes it possible to use a very simple wooden or metal frame without ending up with a dull display.

Creating a Collage

A collage is a collection of items, usually pictures or other printed works of art. You can make a collage of your photos, turning their combination into a single image, utilizing special effects by varying opacity settings, background images, and filters to make the individual image function together as a whole. Moreover, rather than buying one of those usually unattractive frames with a matte that has holes cut in it to house several images, you can take complete artistic control of the finished product and create a collage from photographs you already scanned or captured digitally. By creating the collage in Photoshop Elements, you eliminate the need for a special matte or frame. You can size the overall image to match an appealing frame you already have or use the finished *composite* image as an graphic on your family's Web page. You use the restoration and retouching techniques you already learned in this book's earlier chapters to make the individual images work together.

That's Progress For You

Large images and visitors on a dial-up connection can present a problem, in that the large image may take a while to load, leaving a blank spot until it loads entirely. If you have a large image on your page and are confident that a good percentage of your visitors will be connected to the Internet via modem, you may want to consider using the Progressive option. A Progressive JPG file appears slowly — first as a choppy, blurry version, and slowly composing on-screen until it appears in its full, clear, and crisp glory. If the Progressive option is not on (it's off by default), the image won't appear on-screen at all until it is completely loaded. Bear in mind, however, that for visitors using cable modems, DSL, and other fast connections to the net, the use of the Progressive option may slow their loading of the images, though not very much.

[N O T E]

Stick to a unifying theme for the photos, such as members of a family, people within a group or organization, scenes from a specific vacation, or animals of a certain species so that the collage content makes visual sense to its viewers. You can create a real hodgepodge if you like, but something that ties the items together, at least conceptually, helps people appreciate the collage more.

Combining Content from Several Photos into a Single Image

To begin, create a new, blank image that's the size the finished collage should be. You can tell what size that is by thinking about the frame you intend to use for the finished, printed product, or about the space on your Web page that's allocated to the image. From this point, follow these steps:

1. Open all of the individual images you want to use in whole or in part within the collage.

2. Using any of Photoshop Elements' selection tools, most likely the Marquee or Lasso tools in this case, select the portions of the images that you want to use in the collage (10.17).

3. After making each selection, choose Layer → New → Layer via Copy.

 This creates a duplicate of the selected content on its own layer (10.18). You transfer these layers to the collage document, which leaves the original images (from which you've taken the selections) intact.

4. After all the sections of images you want to use have been copied onto individual layers in the original images, drag these copy layers to the collage document's image window.

 Your mouse pointer changes to a clenched fist, and you see a rectangle, representing the layer in transit (10.19).

● 10.18

● 10.17

● 10.19

5. **After you place all the duplicate layers on the collage document (you can see them accumulate in the collage document's layers palette), (10.20), you can close the original images from which the selections were taken.**

As each is pasted in its own layer, you can easily rearrange the pictures by dragging them with the Move tool. Remember to switch layers, you can use the Layers palette to select the layer you want to work with, or just right-click the content on the layer you want to switch to, and choose the desired layer by name from the context menu (10.21).

[T I P]

Renaming all of your layers is a good idea by giving them names that indicate their content. Renaming makes it easier to spot and select the layer you want in the Layers palette and to make selections from the context menu. To rename a layer, double-click its current name in the Layers palette and type the new name. Press Enter to commit to the new name.

Positioning and Blending the Collage Elements

After positioning all of the items you want in your collage, use the Blur tool to blur the edges of each layer's content. This allows contiguous or overlapping items to blend together nicely (10.22).

[N O T E]

For an interesting effect, place larger images behind smaller ones and use the Opacity setting for the overlapping layers, which reduces the opacity so that the larger image in the background can be seen. The opacity of the image in the background should also be reduced (to at least 70%) so that the overlapping images remain visible and their content clearly identifiable.

Inserting a Background Image

You can place a unifying image in the background, behind all of the collage images, making the collage more interesting than if you just place the images on a solid color background (10.23). To achieve a good balance of images and to make sure the background image is visible over the entire collage, set the opacity of each of the collage images to a level that's low enough to see the background (or a hint of it) while remaining clear and defined themselves. The

● 10.20

requisite Opacity for each layer will be different and depends on the nature of the image itself. Tinker with levels (using the Opacity slider in the Layers palette) until you like what you see (10.24).

Don't merge the pasted layers with the background until and unless you're absolutely sure of their placement. If you're applying special effects, such as filters or specific

● 10.21

● 10.23

● 10.22

● 10.24

retouching tools to certain photos in the collage and not to others, keeping all the layers separate enables you to keep your effects and retouching efforts separate, too. Keeping the layers separate forever makes it possible to rearrange them in the future, potentially adding new images later. To prevent accidental movement of the individual layers in the meantime, select the layers (one at a time) and click the Lock icon in the Layer palette.

Adding a Textured Mat to Frame the Image

Sometimes a photo just needs something extra. Or maybe you can't find a frame and mat at the store that looks right or fits the photo you want to display. What to do? Make your own mat to frame the image with color, texture, or even pictures (10.25).

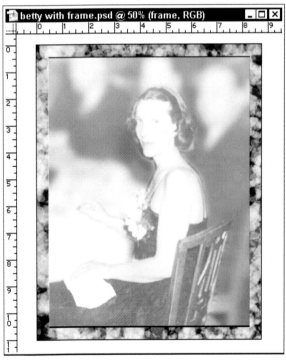

● 10.25

Using Frame Effects

The Effects tab (see the docking well, upper-right corner of the workspace) contains a selection of frame effects (10.26). You can view a sample of their results in the Effects palette, applied to a generic photo of a sailboat. If you want to see only the frame effects, click the drop-down list at the top of the palette and choose Frames from the list (10.27).

To apply one of them to your photo, click the thumbnail for the frame you want to use and click the Apply button. After doing so, a prompt appears, asking if you want to flatten your layers. You don't have a choice if you want to proceed with making

● 10.26

the frame, so click OK. After a few seconds (while the software goes about making the frame you chose), the frame appears around the image (10.28), on its own layer. The size of the image is automatically increased to accommodate the frame, and your photo appears in it. Depending on the frame you choose, you may or may not see a shadow inside the frame, imitating the effect of a 3D frame casting a shadow on the photo inside it.

Creating a Frame from Scratch

If none of the frames in the Effects palettes appeal to you, you can create your own. To do so, follow these steps:

● 10.27

1. **Increase your canvas size (Image → Resize → Canvas Size) in terms of both its width and height** (10.29). The amount of increase depends on the desired thickness of the frame.

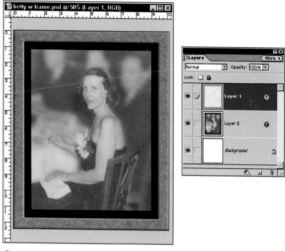

● 10.28

● 10.29

2. Use the Rectangular Marquee, set to Subtract from Selection mode and select the entire image, which encases it in one big rectangular marquee (10.30). You can also press Ctrl + A to select all, which achieves the same result.

3. Draw a smaller rectangle inside the larger one, this one defining where the frame stops (10.31). Because you're in Subtract from Selection mode, the center of the box is no longer part of the selection.

4. Choose Layer → New → Layer. In the resulting dialog box, name the layer "Frame" (10.32).

5. Now you can fill the selection with whatever you want — a solid color, a painted-on texture, another image (only the selection fills with it, which can be an interesting effect), or a pattern or gradient fill.

● 10.31

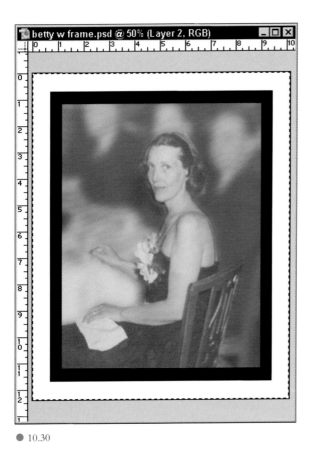

● 10.30

● 10.32

6. **If you want a 3D look for your frame, use the Layer Styles palette to choose a Drop Shadow and Bevel effect (10.33).**

By placing the frame on its own layer, you can hide it if you want to print the photo without the frame, or you can print it with the frame. You can also resize the frame by selecting the frame layer and choosing Image → Transform → Free Transform.

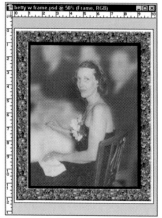

● 10.33

[T I P]

If you want to see a 3D shadow or bevel around the edge of the frame, you need to make your canvas slightly larger than the frame and photo. Do this after you create the frame by using the Image → Resize → Canvas Size command to add just a half or quarter inch around the entire image. This creates room around the frame for the drop shadow and bevel to show on the exterior of the frame, not just around the inside of it.

The Big Picture

In this, the final chapter of this book, you read about applying the kind of finishing touches that turn restored photos into real treasures, such as bringing color to black-and-white photos, creating the look of age with a sepia-tone effect, and saving photos for use on the Web. In addition, you read about printing your photos, including choosing the right printer for your needs. You also discovered how to add a mat to your images that creates a textured or illustrated frame to embrace the photos you painstakingly restored to their original glory.

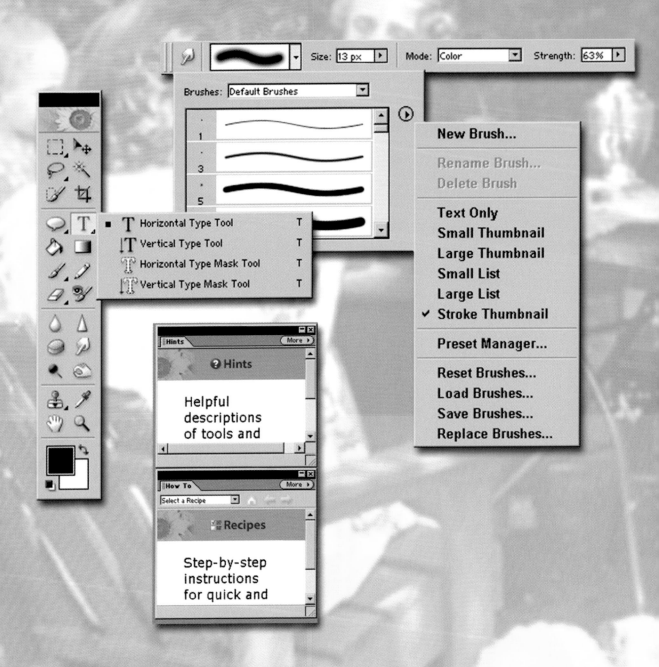

Preserving Your Originals

⏺ Many of your original photographs, whether taken by you or someone else, are precious to you. The fact that you're reading this book and this appendix in particular, proves that you want to keep your images safe from damage, age, and loss. In this appendix, you learn tips for storing different kinds of photos, and how to maintain an electronic "back-up" of your photos so that if the worst happens — your originals are lost or destroyed — you have printable copies on your computer.

Storing Vintage Photos

Vintage photos, which I consider to be any photo taken before cameras were something that "regular people" owned and used on a regular basis, present some challenges:

- Many photos were printed on porous, matte-finish paper, making them susceptible to damage from moisture, dust, dirt, and oil from people's hands. The card stock on which the photos were pasted is also susceptible to drying out and breaking, which accounts for the old photos you see with broken corners and chipped edges. Over time the cardboard dries out, and it simply doesn't stand up to handling very well.
- When exposed to sunlight, vintage photo paper turns brown, and the photos themselves fade.
- Water absorbs easily into the card stock on which photos were printed, and the water marks and rings are impossible to get rid of.
- Very few, if anyone, have the negatives for these photos, so reprints from the original film are not possible.

To remedy the problems related to the paper on which the photos are printed, you must take great care in the methods you employ to store and display vintage photos. First, never store them loose in boxes or drawers. Always store them in such a way as to prevent them banging into each other or scraping against other photos or the box in which they're stored. Some options:

- Store vintage photos in photo albums, made from acid-free paper, with plastic sheeting that goes over the photos but that does not seal the pages. You don't want any moisture to build up under the plastic, but you want the protection from scuffmarks that the plastic provides.

[NOTE]

Why "acid-free"? Because paper with acids in it damages the photos — you see staining and the paper begins to disintegrate. Finding acid-free photo albums and framing materials these days is not hard, so don't worry that you won't be able to find the right storage and display paraphernalia at your local store.

- Store them in envelopes, again using acid-free paper, and keep the envelopes, which should be sized to match the size of the photos in a box.
- Have the photos professionally dry-mounted and framed, using acid-free paper. The glass protects them from physical damage, and the framing makes them easy to display. Do not put the framed photos in the sun, or leave them where the sun may shine for any length of time. Choose a shady corner of the room where very little light hits the photos.
- Store your photos in a cool, dry place. Don't put them in the attic or basement, as the attic is likely to get very hot during the summer and dry heat from your house rises into the attic during the winter. Basements tend to be damp, so unless yours is dry all year round, don't store photos there, either. Good choices are closets and file cabinets, places where the photos won't be

handled excessively, where temperatures remain fairly constant, and where dampness is unlikely to be a problem.

[WARNING]

If your area is prone to flooding, store your photos as high as you can — on top shelves, on upper floors of the house (but not the attic, for reasons mentioned earlier in this appendix), anywhere water won't go if you get a few feet of floodwater in your home during a storm.

[TIP]

Most fireproof filing cabinets prevent paper inside them from charring in the event of even the hottest fire. You can get safes and cabinets that meet different standards, and the prices go up as the fireproof qualities increase. In even the best cabinets and safes, however, the heat may get high enough to melt plastic, so if you store your photos in a fire-proof safe or cabinet, don't put them in plastic bags, sleeves, or envelopes — the plastic can melt and stick to your photos.

Keeping New Images in Mint Condition

Photos taken in the last few decades are much more likely to survive rough handling than their predecessors, which can fade and discolor with time. The paper used by current photo processing labs is also

more durable than the paper used in, say, 1960. The older your photos are, the more careful you need to be in storing and displaying them, and for your photos taken before 1960, it's a good idea to follow the suggestions for storage and display of vintage photos.

For photos taken in the 1970s through today, you don't have to be quite so cautious. You still don't want to handle them with wet or oily hands, as the water and oils in your skin will break down the emulsion on the photos, but you don't have to be as afraid of incidental damage from the photos being stacked in a single envelope or stored in a drawer. You want to reduce the amount of jostling and scraping against each other that the photos endure, however, just to eliminate scuffmarks and any accidental damage from spilled liquids, fire, and rough handling by children.

The same rules for storage in terms of heat, dampness, and risk of loss to flood apply to new photos. While the paper and processing make them hardier than their predecessors, it's still a good idea not to expose photos to any extremes of temperature or humidity.

[T I P]

Some cats find the emulsion on photos to be quite delicious. You'll find them licking the coating off your photos, leaving a sticky mess behind and usually ruining the photo. More important, the chemical coating isn't good for the cat, so if you have cats, don't leave photos lying around unattended. After you finish looking at them, put them back in the envelope.

Creating Electronic Archives

A good backup plan for your most precious originals is to scan them at the highest resolution you can (1200 dots-per-inch, or dpi, for most scanning applications), and store them on CD-ROM. More durable than floppy or zip disks, CDs also hold more information, making it possible to store the huge files that high-resolution scanning will create. You may end up with individual files that exceed 50MB, so being able to store several on one CD is quite convenient. You can read more about the scanning process — setting up your scanner, installing scanning software, scanning photos in color, and so on, in Chapter 2.

[T I P]

If the photos are extremely precious, depict famous people, or document an important event — historically, personally, professionally — and you can't imagine life going on if the photo were lost, scan it, store it on CD, and put that CD in your bank safe deposit box, where it will be safe from fire, theft, flood, and accidental loss or damage.

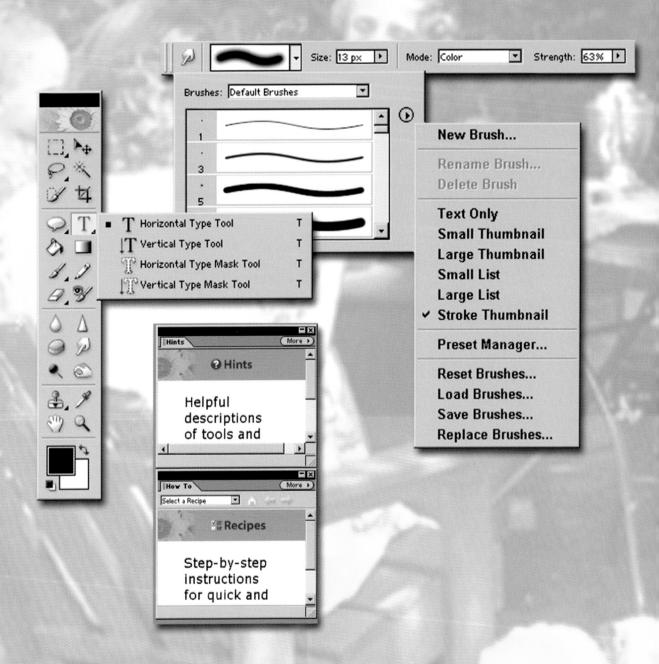

Online Resources

Finding information online about Adobe Photoshop Elements is quite easy — just type **Photoshop Elements** into any search engine, and you get a lot of listings. Many of them are places that sell the software, but among those listings, you find software reviews and tips shared by those who use the software.

Due to the recent release of Photoshop Elements 2.0, there aren't a lot of user groups or online organizations devoted to it. There are, however, many Photoshop-related sites that you can benefit from visiting. Given the great number of common features in the two applications, many of the tips, tricks, and helpful tutorials you find on these sites can be applicable to your use of Photoshop Elements. If you do a search for **Photoshop tips** online, you may find these, and others like them:

www.graphic-design.com/Photoshop

www.eyewire.com/tips/photoshop

www.desktoppublishing.com/photoshoptips.html

www.adobe.com/products/tips/photoshopel.html

The National Association of Photoshop Professionals

This organization is obviously devoted to Photoshop, and not to Photoshop Elements. However, you can find a lot of tips, tricks, and instructional materials and events on its site and through membership in its magazine, *Photoshop User*. To find out more about joining — the fee and what you get for it — check out their Web site at www.photoshopuser.com.

The magazine is free to members, and it's well worth the membership fee. You may not be able to utilize 100 percent of the techniques profiled in the magazine and on the Web site, due to some of the features that are in Photoshop but not in Elements (Actions being the biggest omission in Elements), but you can make use of many of them.

[T I P]

The instructions for some of the tips and tricks include different menu and submenu names. You should be able to find the Photoshop Elements equivalents, however, just by poking around in the menus.

The Photos Used in This Book

The photographs I used throughout this book to demonstrate Photoshop Element's restorative and retouching tools are available through my Web site. You'll find them in JPG format, making the zip file containing the images much faster to download. If I left them as PSD files, you'd need to run the download overnight!

To obtain the photos for your use in practicing the skills I've covered in this book, go to www.planetlaurie.com/elements.

On this page, you find links that you can click to download the photos to your computer. I ask that you don't use any of the images for commercial use, and that you refrain from publishing them in print or on the Web. I'm providing them for your own personal use, as I've found that many readers like to work with the same images that are found in the book, so that they can be looking at the same thing that they see on the page.

I hope you find this helpful, and if you have any questions about the files, about Photoshop Elements, or this book, please send me an e-mail at laurie@planetlaurie.com.

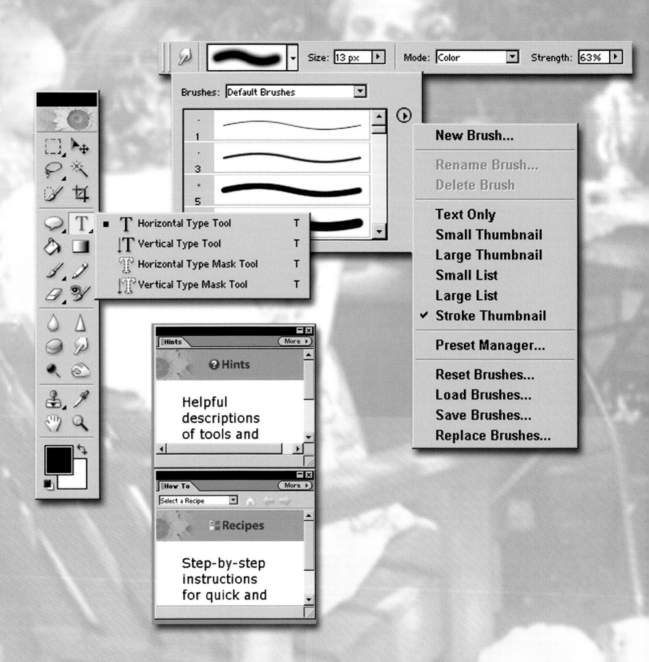

| Size: 13 px | Mode: Color | Strength: 63% |

Brushes: Default Brushes

1

3

5

T Horizontal Type Tool T
|T Vertical Type Tool T
T Horizontal Type Mask Tool T
|T Vertical Type Mask Tool T

New Brush...

Rename Brush...
Delete Brush

Text Only
Small Thumbnail
Large Thumbnail
Small List
Large List
✓ Stroke Thumbnail

Preset Manager...

Reset Brushes...
Load Brushes...
Save Brushes...
Replace Brushes...

Hints More ▶

❓ Hints

Helpful
descriptions
of tools and

How To More ▶

Select a Recipe

Recipes

Step-by-step
instructions
for quick and

Before and After Images

Six images — three in a "before" state, and three "after" versions of those same photos — are analyzed here to help shed light on what can be done to solve a variety of restoration and retouching problems. Luckily for you, most of your images won't have all of the problems shown here — tears, wrinkles, creases, handwriting, yellowed tape, discoloration, fading, and scratches. If you do encounter images with all of these problems at once, at least now you'll know that all is not lost — Adobe Photoshop Elements provides the tools you need to repair even the most severely damaged photographs.

A Damaged and Faded Group Photo

In the Before version of this photo (C.1), there are significant wrinkles from someone crumpling the photo, and two serious tears — one that removed the upper-right corner, and one that nearly ripped the photo in half. There are also deep scratches that run horizontally in the lower half of the photo. The image is also faded, from being displayed across from a sunny window for several years.

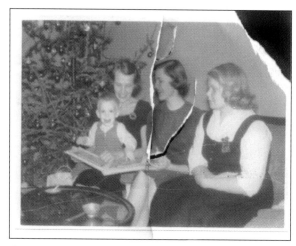

● C.1

In the After version of this image (C.2), the corner has been replaced using the Copy and Paste commands to duplicate the wall from the spot next to the previously missing corner, and the white frame from the opposite corner. The Clone Stamp was used to make the pasted content blend in. The tears that ran down the middle of the image were fixed using the Clone Stamp, set to a variety of brush sizes — large brushes for replacing the areas lost to the worst spots along the tear, and small brushes for fine work, replacing textured fabrics and the knuckles on a hand. The photo was also colorized, using selection tools (the Selection Brush and the Lasso) to select areas — faces, hair, arms, legs, clothing, branches on the tree, the couch — and then the Color Variations dialog box was used to add colors to the Midtones, Highlights, and/or Shadows, depending on the area being colorized at the time. To make sure the shadows weren't lost (under chins, along the couch seat where a person is sitting, between people, and so on), the Burn tool was used to darken. As a final touch, the Unsharp Mask filter was applied to more clearly define the edges of adjacent colorized areas.

[T I P]

Details matter when you're colorizing an image. Here, there is a reflection in the mirrored coffee table's top, showing the bib of the baby's overalls, and part of the Christmas tree. By colorizing these reflections (using slightly darker colors), the "reality" of the colorization is maintained throughout the image.

Writing, Marking, and a Tear

This photo, in its Before state (C.3), was marked for cropping. The owner was so sure that nothing could be done to repair the torn part, that she used a marker to draw a thick line where she felt the image should be cropped. That line, created by an orange magic marker, became more damage to be repaired, as the tear was really no problem to fix. The handwriting along the bottom presented little challenge as well, as it fortunately didn't cross any terribly complex content, such as a face, hands, or a complicated pattern.

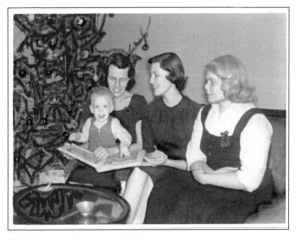

● C.2

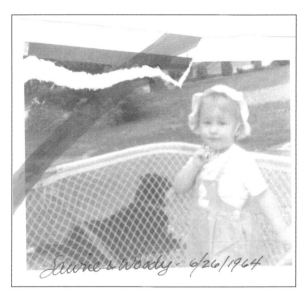

● C.3

After retouching and restoring, this image has no more tear, no more orange line, and no more handwriting. It's also larger, and has a decorative frame around it. The child's overalls have been brightened, and the appliqué duck on the bib of the overalls has been given new life (C.4).

To get rid of the tear, the detached portions of the image were selected (using the Polygonal Lasso) and rotated to bring them into position. They were then moved (using the Move tool and the arrow keys to nudge them) as close to the rest of the image as possible. Then, the Clone Stamp was used to get rid of the tear, replacing the portions of the image lost when the photo was ripped apart.

The orange line and the handwriting were both removed with the Clone Stamp, using brush sizes to match the complexity of the content being replaced — larger brushes to fix the trees and lawn, smaller ones to replace the areas that crossed the child's clothing and the grid of the playpen's sides.

To brighten and intensify the colors throughout the image, the Color Variations dialog box was used, along with the Hue and Saturation dialog box. The duck appliqué was renewed using the Brush tool. The only new colors were the border on the playpen — it went from white to aqua — and the turning of the child's overalls to pink. These changes were achieved by selecting the areas to be colorized, and then using the Color Variations dialog box to add more green and blue (for the border of the playpen) and more red and blue to the overalls.

The frame was added by placing two rectangular selections (a smaller one inside a larger one) on a separate layer, and then filling the selection with a solid black fill and then painting with a flowery brush preset in yellow, purple, and green.

To make the image larger (and more suitable for display), the Image, Resize → Image Size command was used. The proportions were retained, and a size that would fit inside picture frames readily found at any gift shop or stationery store was selected. The flowered "frame" created in Photoshop Elements will function like a paper matte placed around the photo, but it's much more visually interesting than a solid-colored square of cardboard, and is in keeping with the colors and subject matter of the photo.

[TIP]

Rewriting photographic history can be a good thing, or it can be a disappointment, depending on for whom the restored version of the photo is intended. In this case, the photo's owner knew that the appliqué on the overalls was a duck, and remembered it fondly. To have replaced it with a flower or some other perhaps simpler-to-recreate image would have detracted from the delight that the owner felt when seeing the old image brought back to life. Changing the color of the overalls was not a big deal, and choosing pink for the little girl's overalls was an appreciated touch.

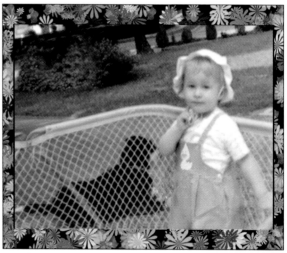

● C.4

The Green Cat in the Bowl

The Before version of this portrait of a cat sitting in a plant pot is green — a problem that was caused by bad film and probably shoddy development technique (C.5). In addition, there are unattractive elements in the photo — a stack of mail on the chair in the background, chips in the plant pot's glazed finish that exposes the terra cotta beneath it, and the cat's really bad case of what's traditionally called "red eye," but in this case, it's more of a case of "yellow eye" thanks to the green tint, the cat's huge pupils, and an overzealous flash.

Once the color was repaired and the red eye removed, the photo was treated to an Artistic effect — the Watercolor filter. The result is a photo that now looks like a painting (C.6), with realistic colors (thanks to the Auto Levels command, found in the Enhance menu), no more demonic-looking eyes (thanks to the Red Eye Brush tool and some manual enhancement with the Brush tool to apply the white highlights), and no stacked mail and no chips in the bowl (thanks to the Clone Stamp tool).

[T I P]

Why get rid of the mail in the seat of the chair? The reasons range from obsessive tidiness on the part of the artist, and a sense that small details can have a big impact if you don't deal with them. In this case, by removing the multi-colored mail, the colors that deviate from the earth tones of the chair, the pot, the table, and the background are restricted to the cat and the slate-colored candle on the table. Had I left the blue stripe of color in the background (the edge of something in the stack of mail), the viewer's eye would have lingered too long on an unimportant detail, distracted from the important features — the cat's eyes, the interesting textures achieved in the silver candlestick, the clay pot, and the cat's fur.

● C.5

● C.6

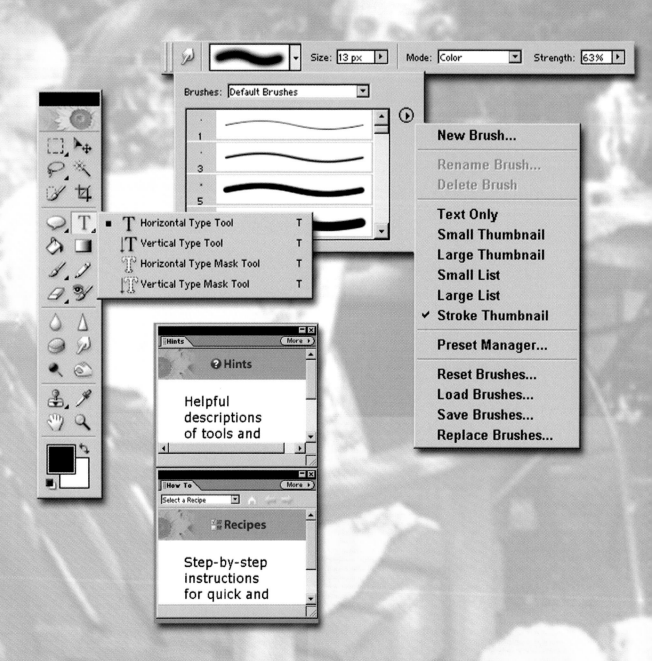

Glossary

Airbrush A Brush tool option that gives the brush strokes a soft edge, much like the effects achieved with a spray can of paint or paint applied with an actual airbrush.

Anchor points As you make a selection with the Lasso tools, each change in direction (with the Polygonal Lasso) or click (with the Magnetic Lasso) adds an anchor point.

Artifacts The spots and imperfections that appear on an image after the user has resized an image manually. The process of file compression (saving a file in a lossy format such as JPG) creates artifacts as well.

Bevel One of the Layer Styles you can apply to content in your image, a beveled edge looks raised and carved, giving the content a 3D look.

BMP This stands for bitmap, a graphic file format that uses a grid of pixels to display the image. In a bitmap image, each pixel is assigned a specific location and color value.

Brightness The amount of white in a color, or the amount of white added to an image to lighten the colors.

Burn The Burn tool darkens the image, and its intensity is controlled by the size of the Brush used, the Exposure (strength) setting, and the Range to which the darkness is applied — Midtones, Highlights, or Shadows.

Canvas The entire image window is known as the Canvas. When you increase the canvas size, you aren't changing the size of the image content (as you are when you change the Image Size) — instead, you're adding to or taking away from the overall size of the image window, allowing more or less room for new or existing content.

Clipboard A Windows and Mac feature that allows you to cut, copy, and paste content between locations within the same file or between files.

CMYK A color model based on the concept that colors are all made up of varying levels of cyan, magenta, yellow, and black. You can view a color's CMYK levels through an application such as Adobe Photoshop, and by adjusting CMYK levels, create new colors.

Color mode The color mode determines the way the image colors are defined and displayed. In Photoshop Elements, you can apply Bitmap, Grayscale, Indexed Color, or RGB, and RGB is the default — all colors therefore being displayed as levels of Red, Green, and/or Blue.

Complementary colors Colors that look good together based on their locations on the color wheel. Complementary colors are opposites on the wheel — the colors directly across from each other work well when used together in any design.

Contrast The amount of difference between two values. With regard to images, contrast normally refers to the amount of light and dark. By adjusting the contrast of an image, you can reduce the brightness of colors (if you're using an overexposed photo, for example) or brighten dark colors if there wasn't enough light in the room when a picture was taken.

Default The default is the standard or automatic setting. For example, by default, the Opacity setting for the Brush and Paint Bucket tools is 100%.

Digital camera A camera that captures images as data, storing the image until it can be downloaded to a computer, where the data can be saved as an image in a variety of graphic file formats and edited through an application such as Photoshop Elements.

Dodge The opposite of the Burn tool, the Dodge tool adds light. You can set the strength (Exposure) of the tool, change the Brush size, and choose which pixels — Midtones, Shadows, or Highlights — are affected.

Drop shadow Applied through the Layer Styles palette, drop shadows give the illusion of depth — as though the content were sitting above the background or above another layer within the image. The direction and depth of the shadow can be changed, depending on the Layer Style you choose.

Duotone An image consisting of two tones — one of which is black — is called a duotone.

EPS Encapsulated PostScript file. EPS is a format that represents both vector (lines and mathematical data, making up an image) and bitmap data. You might save your Photoshop Elements file in this format if you want to use or edit it in a vector-based application such as Adobe Illustrator or CorelDraw.

Filter A set of effects that mimics artistic mediums, various surfaces and coatings, and textures. You can apply them through the Filter menu, or the Filters palette, and most filters provide a dialog box through which you can control how the filter will be applied and the effect it will have on your photo.

GIF Graphic Interchange Format. A graphic file format favored for Web use. The GIF format is best used for line art, simple shapes, and images with large areas of solid color, rather than complex drawings or photographs. GIF files support 256 colors only.

Graphic A picture, such as a scanned or otherwise digitally captured photograph, drawing, piece of clip art, or a collection of computer-generated shapes and/or lines.

Grayscale A color mode that supports 256 levels of gray. If you change a color image to grayscale, all the colors change to a shade of gray. You can colorize a grayscale image, but only after changing the color mode to RGB.

Hue A specific color location on the color wheel or in a color spectrum.

Image Another term for *graphic*. Some people refer to "graphic images," but that's redundant — sort of like saying "text characters."

JPG This graphic file format (also known as JPEG) is an acronym for the people who created it — the Joint Photographic Experts Group. JPG is one of three Web-preferred graphic file formats (the other two are GIF and PNG), and is best for photographs and complex images. JPG files can contain millions of colors, yet generate very small files, which is very good for Web use, as anything you can do to reduce load times for site visitors is valuable.

Layers Like clear plastic overlays that add content to an overhead presentation, layers in a Photoshop Elements image help you keep parts of the image separate so that they can be moved, resized, rotated, recolored, and otherwise edited without affecting the rest of the image. Layers can be hidden and layers can be linked, so that layers containing related content can be treated as one. Files with multiple layers are generally larger than those with a single layer, so you may want to merge your layers — all of them, or only those that are visible, or those that are linked.

Luminosity The luminosity of a color refers to the amount of light (white) in it.

Marquee Geometric-shaped selections are known as Marquee selections. Photoshop Elements offers Rectangular and Elliptical Marquee tools, for selecting box- or circle-shaped selections, respectively.

Mask Like masking off the woodwork when painting the edges of walls in a room, a mask protects part of the image from editing.

Noise Randomly colored and lighted pixels in an image are called noise — think of an old movie with lots of pops and spots and an overall dusty look, and you've got the idea. Photoshop Elements offers Noise filters, which can be used to add or to remove noise, depending on the effect you're looking for.

Palettes In Photoshop Elements, palettes are boxes containing related options — colors, styles, special effects, formats — that you can apply to your images. They can be left in the palette well (in the upper-right corner of the workspace), or dragged onto the workspace to function as free-floating dialog boxes.

Pixel Stands for "picture element," and is the smallest element your monitor can display. Images consist of thousands of pixels, each being a dot of color. When the dots are viewed together (and at a distance), the image is created by the viewer's eye.

PNG Portable Network Graphics. This Web-friendly graphic file format has been approved by the World Wide Web Consortium (W3C) and is gaining popularity among designers. Newer browsers support the format, which is a good thing for designers — the format is great for both photos and line art.

Posterize The Posterize command, found in the Image → Adjustments submenu, enables you to choose the number of brightness values in an image and then sets pixels to the closest matching level.

PPI Pixels per inch. Refers to the resolution of an image. Obviously, the more pixels per inch, the more detail an image will have.

Preset When it comes to the Brush tools in Photoshop Elements — the Brush, Pencil, Eraser, and other tools you use like a paintbrush — the presets are the established brush styles. They range from simple to complex, some mimicking natural textures such as leaves or grass, and others mimic textures, such as rough stone or chalk.

Primary colors The three colors you can't create by mixing other colors: blue, red, and yellow. When you mix primary colors, you get secondary colors.

PSD This is the native file format for Photoshop and Photoshop Elements. It stands for *Photoshop Document.*

Resolution The resolution of an image is often expressed as ppi, or pixels per inch. The more pixels per inch, the larger the file size, and the more information you have to work with when editing the image. Scanning at higher resolutions is a good idea, so that you end up with an image that has lots of pixels to work with in repairing and restoring the photo.

Revert The File → Revert command takes the photo back to the state it was in when it was last saved.

RGB Red, green, blue. This color model is based on the idea that all colors are made up of various levels of these three colors. Web browsers recognize RGB colors.

Sample When used in reference to the Eyedropper tool (and to the eye dropper tools found in a variety of color-adjustment dialog boxes in Photoshop Elements), sampling is the process of selecting a specific pixel or group thereof to serve as a representative. When you sample a color (click on a pixel) with the Eyedropper tool, you're resetting the Foreground Color to the color of the sampled pixel.

Saturation The intensity of a color. A deep, bright, royal blue has a higher saturation, for example, than a more muted shade of slate or denim blue.

Secondary colors The colors you create by mixing two primary colors. Red and blue make purple, blue and yellow make green, and red and yellow make orange. When secondary colors are mixed, tertiary colors are created.

Sepia tone The brownish-yellowish color of certain vintage photos. You can apply it to new images, or to old grayscale images, to achieve a vintage look.

Tertiary colors The colors created by mixing secondary colors.

TIF/TIFF Tagged Image Format. TIF is a bitmap image format that's supported by just about any image-editing or illustration application.

Web-safe Web-safe colors are those that are supported by (and thus displayed accurately by) Web browsing software such as Internet Explorer or Netscape Navigator. There are 216 Web safe colors, and you can access them by clicking the Foreground Color block on the toolbox to open the Color Picker. Turn on the Only Web Colors option to display the Web-safe palette.

Zoom Using the Zoom tool or the zoom tools in the Navigator palette (or the Zoom setting in the lower-left corner of the workspace), you can get closer to or farther away from your image. Zoom in to do fine work, retouching small details. Zoom out to get the "big picture" and to see how different objects within the image work together visually.

Index

3D shadow around frame, creating, 199

A

Accented Edges filter, 172
acid-free paper, vintage photo storage, 202
actions
 Undo History palette, 24
 undoing Auto Contrast effects, 49–50
 undoing Auto Levels effects, 51
 undoing last, 4–5
Add Noise dialog box, 133–134
Add Noise filters, digital image imperfection adjustments, 132–134
Adjust Backlighting dialog box, 68–69
Adjust Fill Flash dialog box, 69
adjustment layers
 Brightness/Contrast, 58
 creating, 56–60
 Gradient Map, 59
 Hue/Saturation, 58
 Invert, 59
 Levels, 58
 opacity settings, 57
 Posterize, 59–60
 selection guidelines, 58–60
 Threshold, 59

airbrush, 215
Alt/Option key, Clone Stamp requirement, 21
alternate tools, viewing/selecting, 4
ambience, lighting property, 72
amount, Unsharp Mask filter settings, 140
anchor points, 215
Angled Strokes filter, 172
arrangement, 89
artifacts, 215
Artistic filters, 170–171
aspect ratio, 95, 150
Auto Contrast (Alt+Shift+Ctrl+L/Option+ Shift+⌘+L) command, 49–50
Auto Levels command, 50–51

B

background colors, Swatches palette uses, 24
Background Eraser tool, photo restoration uses, 21
background images, inserting, 194–195
backgrounds, cloning, 129–130
backlighting
 defined, 68
 exposure corrections, 68–69
Bas Relief filter, 172

Behind mode, effects, 61
bevel
 defined, 215
 around frame, 199
Black Point, photograph adjustments, 50
black-and-white photographs
 color cast corrections, 54–55
 colorizing, 184
 converting color photo to, 81–82
 duotone conversion, 188
 finishing touches, 183–188
 scanning guidelines, 41–42
 sepia tone conversion, 186
blemishes
 removing with Smudge tool, 19
 repair methods, 112–114
 retouching, 143–148
blending modes
 Behind, 61
 Brush tool, 60–65
 Clear, 61–62
 Color, 64
 Color Burn, 62
 Color Dodge, 63
 Darken, 62
 Difference, 64
 Dissolve, 61
 Exclusion, 64
 Hard Light, 63
 Hue, 64

Continued

blending modes *(continued)*
 Lighten, 62
 Linear Burn, 62
 Linear Dodge, 63
 Linear Light, 63–64
 Luminosity, 64
 Multiply, 62
 Normal, 61
 Overlay, 63
 Pin Light, 64
 Saturation, 64
 Screen, 62
 Soft Light, 63
 Vivid Light, 63
blends, image content adjustments,
 93–95
Bloat tool
 raising cheekbones, 152–153
 retouching jaw lines, 154
Blur filter, digital image
 imperfection adjustments,
 137–138
Blur More filter, digital image
 imperfection adjustments,
 137–138
Blur tools
 hair adjustments, 155
 image content adjustments, 92–93
 manual blurs, 139
 photo restoration uses, 17–18
 smoothing out freckles/scars, 146
 softening edges when blending
 repairs, 107–108
 wrinkle removal concerns, 147
blurs, manual, 139
BMP, 215
brightness
 adjustment tools, 48–51
 Quick Fix corrections, 82–83

Brightness/Contrast command, 58
Brightness/Contrast dialog box, 48
Brush Name dialog box, 10
Brush Stroke filters, 171–172
Brush tools
 blending modes, 60–65
 blending out individual marks,
 127–130
 customizing style/size settings,
 9–10
 painting out scratches, 111–112
 thickening eye lashes, 157
Brushed Aluminum, special
 effect, 23
burn, 215
Burn tools
 black-and-white scan
 concerns, 42
 creating shadowy illusions, 107
 light level adjustments, 107
 light/dark area adjustments,
 74–77
 photo restoration uses, 18–19

C

cameras, prime lens, 74
camouflage, spot/stain repair
 method, 116–117
canvas, 215
cats, threat to photos, 203
CDs, photo storage, 203
Chalk & Charcoal filter, 172
Charcoal filter, 172
check boxes, options bar element, 4
cheekbones, raising, 152–153
cheeks, coloring, 159–161
Chrome filter, 172
Clear mode, effects, 61–62

Clipboard, 215
Clone Stamp tool
 cleaning imperfections, 129–130
 cover-ups, 95–96
 filling voids after removing
 undesirable content, 97–98
 fixing rips and tears, 109–111
 hair adjustments, 154–155
 lengthening/shortening hair,
 155–156
 photo restoration uses, 20–21
 plucking/reshaping eyebrows,
 158–159
 repairing small tears, 104
 retouching jaw lines, 153–154
 smoothing out freckles/scars,
 144–145
 spot/stain camouflage, 116–117
 wrinkle removal, 147–148
CMYK, 216
Cold Lava, special effect, 23
collage
 creating, 192–193
 inserting background images,
 194–195
 positioning/blending elements,
 194–196
 selecting theme, 192
Color Burn mode, contrast
 effects, 62
Color Cast command, 54
Color Cast Correction dialog box,
 54, 116
color corrections
 adjustment layers, 56–60
 blending modes, 60–65
 duotone images, 54
 grayscale images, 52
 hue/saturation, 51–54

Quick Fix, 82–83
removing color casts, 54–54
variation adjustments, 55–56
Color Dodge mode, extreme
brightening effect, 63
Color Halftone filter, 174
color images
color cast corrections, 54–55
converting to black-and-white,
81–82
previewing when scanning, 38–39
scanning, 37–45
Color mode
defined, 216
HSL color model, 64
Color Picker, preference
settings, 28
color ramps, 52
Color Variations dialog box, 55–56,
84, 115–116
Color Variations tool, turning gray
to color, 185–186
color wheels, color ramps, 52
Colored Pencil filter, 170
colorizing
repaired photos, 209–212
selecting content, 184–185
colors
amount adjustments, 77–82
color ramps, 52
JPG format versus GIF format, 45
Magic Wand selections, 14
photograph corrections, 51–56
removing/replacing, 81–82
repairing, 212
smearing with Smudge tool, 129
Swatches palette uses, 24
variation adjustments, 55–56

commands
Auto Contrast
(Alt+Shift+Ctrl+L/Option+
Shift+⌘+L), 49–50
Auto Levels, 50–51
Brightness/Contrast, 58
Color Cast, 54
Edit → Copy (Ctrl/⌘+C), 105
Edit → Mode → RGB, 52
Edit → Paste (Ctrl/⌘+V), 105
Edit → Preferences, 27
Edit → Undo (Ctrl/⌘+Z), 4, 51
Enhance → Adjust Color, 84
Enhance → Adjust Color →
Color Cast, 116
Enhance → Adjust Color →
Color Variations, 55, 107, 115,
160, 185
Enhance → Adjust Color →
Hue/Saturation, 80, 159
Enhance → Adjust Color →
Remove Color, 81
Enhance → Adjust Color →
Replace Color, 81
Enhance → Adjust Lighting →
Adjust Backlighting, 68
Enhance → Adjust Lighting →
Fill Flash, 69
File → Import, 38
File → Import → From Scanner, 37
File → Revert, 95
File → Save As, 90
File → Save for Web, 45, 189
Filter → Distort → Liquify, 151
Filter → Noise, 122
Filter → Render → Lens Flare, 74
Filter → Render → Lighting
Effects, 70

Gradient Map, 59
Hue/Saturation, 51–52, 58
Image → Mode → Grayscale, 81
Image → Mode → RGB, 184
Image → Resize → Image
Size, 45
Image → Transform → Free
Transform (Ctrl+T/⌘+T),
94, 118
Invert, 59
Layer → Layer Content
Options, 57
Layer → Merge Linked, 100
Layer → Merge Visible
(Shift+Ctrl+E/Shift+⌘+E),
100, 108
Layer → New → Layer Via Copy,
94, 106, 149
Levels, 50, 58
menu bar selections, 4–5
Posterize, 59–60
Save For Web, 183
Select → Inverse, 78
Threshold, 59
complementary colors, 216
composite images, creating, 192
composition, 89
Conte Crayon filter, 172
contrast
adjustment tools, 48–51
Color Burn mode effects, 62
defined, 216
Craquelure filter, 178
Crosshatch filter, 172
Crystallize filter, 174
cursors, preference settings,
29–30
Cutout filter, 170

D

damaged photo repair, 209–210

dampness, vintage photograph repair, 117–119

Dark Strokes filter, 172

Darken mode, when to use, 62

darkness, photo restoration tools, 18–19

default, 216

Desaturate mode, Sponge tool color adjustments, 78–79

Despeckle filter, digital image imperfection adjustments, 134–136

dialog boxes, color ramps, 52

Difference mode, layer effects, 64

Diffuse filter, 175–176

Diffuse Glow filter, image content distortion, 168

digital cameras
 Add Noise filter, 132–134
 Blur filters, 137–138
 defined, 216
 Despeckle filter, 134–136
 moiré, 130–131, 136–137
 noise/texture imperfections, 130–138
 offset moiré, 136
 Unsharp Mask filter, 139–141

directional lights, when to use, 71–72

Displace filter, image content distortion, 168

Display & Cursors preferences dialog box, 29–30

displaying, vintage photos, 202

Dissolve mode, when to use, 61

Distort filters, 168–169

distortion, image content filters, 168–169

docking well, palette tab display, 163–164

dodge, 76, 216

Dodge tools
 light level adjustments, 107
 light/dark area adjustments, 74–77
 photo restoration uses, 18–19
 whitening teeth, 148

drawings, scanning guidelines, 42

drop shadow, 216

drop-down lists, options bar element, 4

Dry Brush filter, 170

Dune Grass brush, painting hair onto eyebrows, 158

duotone, 216

duotone images
 creating, 188
 hue/saturation adjustments, 54

Dust & Scratches dialog box, 124–126

Dust & Scratches filter, removing imperfections, 122–126

dye sublimation printers, description, 191

E

edges, softening when blending repairs, 107–108

Edit → Copy (Ctrl/⌘+C) command, 105

Edit → Mode → RGB command, 52

Edit → Paste (Ctrl/⌘+V) command, 105

Edit → Preferences command, 27

Edit → Undo (Ctrl+Z/⌘+Z) command, 4, 51

Effects palette, special effects, 23

Effects tab, List View, 165

ellipsis (…) character, menu bar options, 4

Emboss filter, 176–177

Enhance → Adjust Color command, 84

Enhance → Adjust Color → Color Cast command, 116

Enhance → Adjust Color → Color Variations command, 55, 107, 115, 160, 185

Enhance → Adjust Color → Hue/ Saturation command, 80, 159

Enhance → Adjust Color → Remove Color command, 81

Enhance → Adjust Color → Replace Color command, 81

Enhance → Adjust Lighting → Adjust Backlighting command, 68

Enhance → Adjust Lighting → Fill Flash command, 69

EPS, 216

Eraser tool, photo restoration uses, 21

Exclusion mode, layer effects, 64

exposure corrections
 3D texture effects, 73
 backlighting, 68–69
 color amount adjustments, 77–82
 color variations, 84
 creating/repositioning light sources, 70–74
 fill flash, 69

light/dark areas, 74–77

lighting property, 72

Quick Fix, 82–83

Red Eye Brush tool, 85–87

Extrude filter, 176

eye lashes, thickening, 157–158

eyebrows, plucking/reshaping, 158–159

Eyedropper tool

hue/saturation adjustments, 53–54

red eye elimination, 86–87

smoothing out freckles/scars, 145–146

eyes

enlarging, 149–150

make-up application, 157

plucking/reshaping eyebrows, 158–159

thickening lashes, 157–158

F

faces

adding color to lips/cheeks, 159–161

digital cosmetics, 156–161

enlarging eyes, 149–150

hair adjustments, 154–156

jaw line adjustments, 153–154

nose adjustments, 151–152

raising cheekbones, 152–153

re-contouring facial structure, 148–154

skin tone adjustments, 159–160

Facet filter, 174

faded photo repair, 209–210

File → Import command, 38

File → Import → From Scanner command, 37

File → Revert command, 95

File → Save As command, 90

File → Save for Web command, 45, 189

file formats, Web acceptable, 189–190

File menu, most recently-used file preference settings, 29

files, most recently-used preferences, 29

Fill Layers, image content, 99–100

fill tools, customizing style/size settings, 9–10

fills, customizing, 10

Film Grain filter, 170

Filter → Distort → Liquify command, 151

Filter → Noise command, 122

Filter → Render → Lens Flare command, 74

Filter → Render → Lighting Effects command, 70

filters

Accented Edges, 172

Add Noise, 132–134

Angled Strokes, 172

application guidelines, 166–167

application methods, 166–167

Artistic, 170–171

Bas Relief, 172

Blur, 137–138

Blur More, 137–138

Brush Stroke, 171–172

Chalk & Charcoal, 172

Charcoal, 172

Chrome, 172

Color Halftone, 174

Colored Pencil, 170

combining, 169

Conte Crayon, 172

Craquelure, 178

Crosshatch, 172

Crystallize, 174

Cutout, 170

Dark Strokes, 172

defined, 216

Despeckle, 134–136

Diffuse, 175–176

Diffuse Glow, 168

Displace, 168

Dry Brush, 170

Dust & Scratches, 122–126

Emboss, 176–177

Extrude, 176

Facet, 174

Film Grain, 170

Find Edges, 176

Fragment, 174

Fresco, 170

Glass, 168

Glowing Edges, 176–177

Grain, 178

Graphic Pen, 172

Halftone Pattern, 172

Ink Outlines, 172–173

Lens Flare, 73–74

Lighting Effects, 70–73

Liquify, 151–152, 168

Median, 126–127, 136

Mezzotint, 174

Mosaic, 174

Mosaic Tiles, 178

Neon Glow, 170

Continued

filters *(continued)*
 Noise, 131–138
 Note Paper, 172
 Ocean Ripple, 168
 Paint Daubs, 170–171
 Palette Knife, 170
 Patchwork, 178
 Photocopy, 172–173
 Pinch, 168
 Pixelate, 174–175
 Plaster, 172
 Plastic Wrap, 170
 Pointillize, 174
 Polar Coordinates, 168
 Poster Edges, 170
 Reticulation, 172
 Ripple, 169
 Rough Pastels, 170
 selection methods, 166
 Shear, 169
 Sketch, 171–173
 Smart Blur, 137–138
 Smudge Stick, 170
 Solarize, 176
 Spatter, 172
 Spherize, 169
 Sponge, 170
 Sprayed Strokes, 172
 Stained Glass, 178
 Stamp, 172
 Stylize, 175–178
 Sumi-e, 172
 Texture, 178
 Texturizer, 178
 Tiles, 176
 Torn Edges, 172–173

 Trace Contour, 176
 Twirl, 169
 Underpainting, 170
 Unsharp Mask, 139–141
 Water Paper, 172
 Watercolor, 170
 Wave, 169
 Wind, 176
 ZigZag, 169
Filters palette, special effects, 22–23
Filters tab
 image options display, 164–176
 List View, 165
Find Edges filter, 176
Finger Painting
 blemish repair, 113–114
 Smudge tool option, 19
fireproof filing cabinets, photo
 storage, 202
floods, photo storage, 202
fly-out toolbars, workspace
 element, 4
focus, Quick Fix corrections, 83
foreground colors, Swatches palette
 uses, 24
Fragment filter, 174
frame effects, using, 196–198
frames
 creating, 197–198
 selecting, 196–197
freckles, retouching, 144–147
free-floating palettes, moving to the
 workspace, 164
free-form selections, creating,
 13–14
Fresco filter, 170

G
General Preferences dialog box,
 28–29
GIF file format
 defined, 216
 Web images, 189–190
 Web-bound photo
 disadvantages, 45
Glass filter, image content
 distortion, 168
gloss, lighting property, 72
glossy photo paper, 191
Glowing Edges filter, 176–177
gradient fills, customizing, 10
Gradient Map command, 59
Gradient tool, customizing gradient
 presets, 10
Grain filter, 178
Graphic Pen filter, 172
graphics. *See also* images
 black-and-white scanning
 guidelines, 41–42
 defined, 216
 previewing when scanning,
 38–39
 scanning, 37–45
 sunflower, 7
Gray Point, photograph
 adjustments, 50
grays, photograph adjustments, 50
grayscale images
 defined, 216
 hue/saturation unavailable, 52
 scanning guidelines,
 41–42
Grid preferences dialog box, 31

grids
 displaying, 190
 preference settings, 31
 setting, 190

H

hair, retouching, 154–156
Halftone Pattern filter, 172
handles, relocating the options
 bar, 4
handwritten notes, scanning
 guidelines, 42
Hard Light mode, effects, 63
Help menu, information display,
 31–32
Help system
 Help menu, 31–32
 Hints palette, 32
 How To palette, 32
 tool tips, 6–7
highlights
 color variation corrections, 84
 photograph adjustments, 50
Hints palette
 context-sensitive help, 32
 workspace element, 6
How To palette
 user input required, 32
 workspace element, 6
hue
 color corrections, 51–54
 defined, 216
Hue mode, HSL color model, 64
Hue Saturation dialog box,
 colorizing grayscale
 images, 185

Hue/Saturation command,
 51–52, 58
Hue/Saturation dialog box,
 51–54, 80–81

I

Image → Mode → Grayscale
 command, 81
Image → Mode → RGB
 command, 184
Image → Resize → Image Size
 command, 45
Image → Transform → Free
 Transform (Ctrl+T/⌘+T)
 command, 94, 118
image content
 blends, 93–95
 Blur tool adjustments, 92–93
 cover-ups, 95–96
 cropping missing portions, 118
 distorting, 168–169
 Fill Layers, 99–100
 filling in voids, 97–99
 importing from another image, 99
 lighting adjustments, 96
 merging layers, 100–101
 moving selections, 91–92
 pasting over torn corners, 118
 rearranging, 89–95
 rebuilding missing, 104–106
 removing undesirable, 97–99
 resizing, 95
 retouching, 100
 saving original before
 rearranging, 90
 selection methods, 90

images
 3D texture effects, 73
 adding color, 184
 Auto Contrast effects, 49–50
 backlighting corrections, 68–69
 black-and-white scanning
 guidelines, 41–42
 blending modes, 60–65
 blending repairs, 106–109
 brightness/contrast adjustments,
 48–51
 changing into grayscale, 183
 checking download time, 189
 color amount adjustments, 77–82
 color cast corrections, 54–55
 color corrections, 51–56
 color variation adjustments,
 55–56, 84
 color/contrast improvements, 47
 converting color to black-and-
 white, 81–82
 correcting digital, 130–138
 cover-ups, 95–96
 creating one from several,
 192–195
 creating/repositioning light
 sources, 70–74
 cropping missing portions, 118
 damaged/faded group, 209
 display options, 192
 duotone, 54, 188
 exposure corrections, 67–87
 fill flash corrections, 69
 Filters palette special effects,
 22–23
 flattening, 184

Continued

images *(continued)*
 highlight adjustments, 50
 hue/saturation corrections, 51–54
 importing scanned, 38–40
 including paper mat frames when
 scanning, 39
 lens flare effects, 73–74
 light/dark area adjustments, 74–77
 optimizing for Web, 189
 options display, 164–165
 previewing when scanning, 38–39
 printing, 190–192
 Quick Fix corrections, 82–83
 rearranging image content, 89–95
 rebuilding missing image content,
 104–106
 reconstructing torn images,
 103–106
 red eye elimination, 85–87
 removing undesirable content,
 97–99
 restorative tools, 16–22
 saving before rearranging
 content, 90
 saving for Web use, 189
 scanning, 37–45
 scanning old/damaged, 42–44
 scanning Web photos, 44–45
 sepia tones, 42
 store on CDs, 203
 storing new, 202–203
 sunflower, 7
 used in book, 206
 vintage, 117–119
 Web-safe format, 45
imperfections
 blemishes, 112–114, 143–147
 blending repairs, 106–109

Clone Stamp tool cleaning,
 129–130
dampness, 117–119
digital camera noise/textures,
 130–138
dust, 122–130
freckles, 144–147
individual marks (spots), 127–130
manual blurs, 139
merging patch layers, 108–109
mildew, 122–130
minor rips, 109–111
minor tears, 109–111
moiré, 130–131, 136–137
mold, 117–119, 122–130
offset moiré, 136
painting dots on unwanted spots,
 128–129
rebuilding missing image content,
 104–106
scars, 144–147
scratches, 111–112
smearing with Smudge tool, 129
spots, 114–117
stains, 114–117
torn images, 103–106
vintage photographs, 117–119
whitening teeth, 148
wrinkles, 147–148
individual marks (spots), blending
 out, 127–130
Info palette, statistics display, 25–26
Ink Outlines filter, 172–173
inkjet printers, description, 191
installation, scanners, 36–37
intersections, selections, 16
Invert command, 59

J
jaw lines, retouching, 153–154
JPG
 defined, 217
 Web images, 189–190
 Web-bound photo advantages, 45

K
keyboard shortcuts
 described, 8
 displaying, 6–7
keyboards, key preference
 settings, 28
keys, preference settings, 28

L
Lasso tools
 free-form selections, 13–14
 image content selections, 90
 lengthening/shortening hair,
 155–156
 when to use, 11
Layer → Layer Content Options
 command, 57
Layer → Merge Linked
 command, 100
Layer → Merge Visible
 (Shift+Ctrl+E/Shift+⌘+E)
 command, 100, 108
Layer → New → Layer Via Copy
 command, 94, 106, 149
Layer Styles palette
 application methods, 179–180
 removing styles, 181
 special effects, 24, 179–181

layers
 adding transparent, 187
 adjustment, 56–60
 creating/positioning new, 106
 defined, 217
 Effects palette special effects, 23
 Fill Layers, 99–100
 filling voids after removing
 undesirable content, 98–99
 merging, 100–101
 merging patches, 108–109
 renaming, 106, 194
 restacking, 91–92
 selection methods, 49
 sharpening/blurring across, 17
 style effects, 24
 switching, 194
Layers palette
 adjustment layers, 56–60
 creating new layers, 26
 layer selection methods, 49
 moving image content selections,
 91–92
 stacking order, 91–92
 viewing/selecting layers, 12
Lens Flare dialog box, 74
Lens Flare filter, 73–74
Levels command, 50, 58
Levels dialog box, 50
light levels
 blending repairs, 107
 Magic Wand selections, 14
light, photo restoration tools, 18–19
light sources, creating/
 repositioning, 70–74
Lighten mode, eraser-like effect, 62
lighting
 3D texture effects, 73
 backlighting corrections, 68–69

creating/repositioning light
 sources, 70–74
exposure corrections, 67–87
fill flash corrections, 69
image content adjustments, 96
lens flare effects, 73–74
Lighting Effects dialog box, 70–73
Lighting Effects Filter, 70–73
Linear Burn mode, effects, 62
Linear Dodge mode, effects, 63
Linear Light mode, brightness
 adjustments, 63–64
linked layers, merging, 100–101
lips, coloring, 159–161
Liquify filter
 image content distortion, 168
 nose adjustments, 151–152
 raising cheekbones, 152–153
List View, information display, 165
Lizard Skin, special effect, 23
luminosity, 217
Luminosity mode, opacity
 effects, 64

M

Macintosh, scanner installation, 36
Magic Eraser tool, photo
 restoration uses, 21
Magic Wand
 color selections, 14
 light level selections, 14
 selection uses, 14
 when to use, 11
Magnetic Lasso tool
 free-form selections, 13–14
 image content selections, 90

marking, correcting on photos,
 210–211
marquee, 217
Marquee selection tools
 center out selections, 12
 when not to use, 12
 when to use, 11
mask, 217
material, lighting property, 72
matte-finish paper, 191
measurement units, preference
 settings, 30
Median dialog box, 126–127
Median filter
 digital image imperfection
 adjustments, 136
 removing imperfections, 126–127
menu bar
 ellipsis (...) character, 4
 workspace section, 4–5
Mezzotint filter, 174
midtones, color variation
 corrections, 84
mistakes
 Undo History palette, 24
 undoing Auto Contrast effects,
 49–50
 undoing Auto Levels effects, 51
 undoing last action, 4–5
modes, blending, 60–65
moiré
 defined, 130–131
 impact reduction, 136–137
mold, vintage photograph repair,
 117–119
More Options dialog box, 9
Mosaic filter, 174
Mosaic Tiles filter, 178

most recently-used file listing,
 preference settings, 29
mouse
 cursor preference settings, 29–30
 moving selections, 12
Multiply mode, effects, 62

N

National Association of Photoshop
 Professionals, 205
Navigator palette
 Zoom magnifications, 24–25
 zoom selection uses, 11
Neon Glow filter, 170
noise, 217
Noise filters, digital cameras
 imperfection adjustments,
 131–138
Normal mode, result color, 61
nose, adjustments, 151–152
Note Paper filter, 172

O

Ocean Ripple filter, image content
 distortion, 168
OCR. *See* optical character
 recognition
offset moiré, 136
old/damaged photographs,
 scanning guidelines, 42–44
omni lights, when to use, 71–72
online resources, 205–206
opacity, adjustment layers, 57
Opacity settings, adjusting for
 collages, 194–195
optical character recognition
 (OCR), scanned text, 35–36

options bar
 blending modes, 60–65
 brush tool style/size selections, 7
 reshaping selections, 14–16
 selected tool options display, 6
 tool options display, 7
 tool strength settings, 7
 workspace section, 4
originals
 preserving, 201–203
 scan to CDs, 203
overlapping selections, reshaping, 16
Overlay mode, effects, 63

P

Paint Brush tools, smoothing out
 freckles/scars, 145–146
Paint Bucket tool, custom
 patterns, 10
Paint Daubs filter, 170–171
Palette Knife filter, 170
palette tabs, content display, 164
palette well
 attaching/unattaching palettes,
 26–27
 displaying palettes, 5
 Effects palette, 23
 Filters palette, 22–23
 Info palette, 25–26
 Layer Styles palette, 24
 Layers palette, 26
 Navigator palette, 24–25
 reordering palettes, 27
 Swatches palette, 24
 Undo History palette, 24
 workspace section, 5–6
palettes
 attaching/unattaching from
 palette well, 26–27

defined, 217
displaying from palette well, 5
free-floating, 164
hiding/displaying, 26
Layer Styles, 179–181
positioning on the workspace, 5
preference settings, 29
workspace element, 6
paper
 quality effect images, 203
 selecting, 191–192
paper mat frames, including with
 scanned photographs, 39
patch layers, merging when
 blending repairs, 108–109
Patchwork filter, 178
patterns, customizing, 10
Pencil tools, painting out scratches,
 111–112
photo emulsion, danger to cats, 203
photo paper, selecting, 191
Photocopy filter, 172–173
photographs
 3D texture effects, 73
 adding color, 184
 Auto Contrast effects, 49–50
 backlighting corrections, 68–69
 black-and-white scanning
 guidelines, 41–42
 blending modes, 60–65
 blending repairs, 106–109
 brightness/contrast adjustments,
 48–51
 changing into grayscale, 183
 checking download time, 189
 color amount adjustments, 77–82
 color cast corrections, 54–55
 color corrections, 51–56
 color variation adjustments,
 55–56, 84

color/contrast improvements, 47

converting color to black-and-white, 81–82

correcting digital, 130–138

cover-ups, 95–96

creating one from several, 192–195

creating/repositioning light sources, 70–74

cropping missing portions, 118

damaged/faded group, 209

display options, 192

duotone, 54, 188

exposure corrections, 67–87

fill flash corrections, 69

Filters palette special effects, 22–23

flattening, 184

highlight adjustments, 50

hue/saturation corrections, 51–54

importing scanned, 38–40

including paper mat frames when scanning, 39

lens flare effects, 73–74

light/dark area adjustments, 74–77

optimizing for Web, 189

options display, 164–165

previewing when scanning, 38–39

printing, 190–192

Quick Fix corrections, 82–83

rearranging image content, 89–95

rebuilding missing image content, 104–106

reconstructing torn images, 103–106

red eye elimination, 85–87

removing undesirable content, 97–99

restorative tools, 16–22

saving before rearranging content, 90

saving for Web use, 189

scanning, 37–45

scanning old/damaged, 42–44

scanning Web photos, 44–45

sepia tones, 42

store on CDs, 203

storing new, 202–203

sunflower, 7

used in book, 206

vintage, 117–119

Web-safe format, 45

Photoshop Elements

importing printed photos, 38–40

preference settings, 27–31

scanner installation, 36–37

Pin Light mode, effects, 64

Pinch filter, image content distortion, 168

pixel doubling, 30

Pixelate filters, 174–175

pixels

defined, 217

Magic Wand selections, 14

Plaster filter, 172

plastic, melting concerns, 202

Plastic Wrap filter, 170

plug-and-play technology, scanner installation, 36–37

PNG file format

defined, 217

Web images, 189–190

pointers, moving selections, 12

Pointillize filter, 174

Polar Coordinates filter, image content distortion, 168

Polygonal Lasso tool

free-form selections, 13

image content selections, 90

Poster Edges filter, 170

posterize, 217

Posterize command, 59–60

PPI, 217

Preferences menu, Photoshop Element settings, 27–31

preset, 217

primary colors, 217

prime lens, 74

printers, 191

printing, photos, 190–192

Progressive option, Web images, 192

PSD, 218

Pucker tool

raising cheekbones, 152–153

retouching jaw lines, 153–154

Q

Quick Fix dialog box, 82–83

R

radius

Dust & Scratches adjustments, 124–126

Unsharp Mask filter settings, 140

recipes, How To palette help, 32

rectangular area, selecting, 190

Red Eye Brush tool

exposure corrections, 85–87

photo restoration uses, 22

Replace Color dialog box, 81–82

resolution
 defined, 218
 Web-bound photo guidelines,
 44–45
result color, Normal mode, 61
Reticulation filter, 172
retouching
 adding color to lips/cheeks,
 159–161
 blemishes, 143–147
 digital cosmetics, 156–161
 enlarging eyes, 149–150
 hair, 154–156
 jaw lines, 153–154
 nose adjustments, 151–152
 plucking/reshaping eyebrows,
 158–159
 raising cheekbones, 152–153
 re-contouring facial structure,
 148–154
 skin tone adjustments, 159–160
 teeth whitening, 148
 wrinkles, 147–148
revert, 218
RGB mode
 colorizing black-and-white
 photos, 184
 defined, 218
Ripple filter, image content
 distortion, 169
rips, repair methods, 109–111
rotation, Quick Fix corrections, 83
Rough Pastels filter, 170
rulers
 displaying, 190
 preference settings, 30

S

Saturate mode, Sponge tool color
 adjustments, 78–79
saturation
 color corrections, 51–54
 defined, 218
Saturation mode, HSL color
 model, 64
Save For Web command, 183
Save for Web tool, photograph
 scanning guidelines, 44–45
Save Optimized As dialog box, 190
Saving Files preferences dialog
 box, 29
scanners
 black-and-white guidelines, 41–42
 color image guidelines, 40–41
 common software settings, 39
 drawings, 42
 handwritten notes, 42
 importing printed photos, 38–40
 including paper mat frames when
 scanning, 39
 installation, 36–37
 old/damaged photographs, 42–44
 optical character recognition
 (OCR), 35–36
 previewing images when
 scanning, 38–39
 sepia tones, 44
 Web photos, 44–45
 work flow process, 40–41
scars, retouching, 144–147
scratches
 removing, 122–126
 repair methods, 111–112
Screen mode, effects, 62

secondary colors, 218
Select → Inverse command, 78
Selection Brush tool, free-form
 selections, 13–14
selection tools, selection
 guidelines, 11
selections
 augmenting, 15
 brightness/contrast adjustments,
 48–51
 creating from center out, 12
 image content, 90
 image content movement, 91–92
 intersections, 16
 moving on the workspace, 12
 overlapping, 16
 rebuilding missing image content,
 104–106
 stained content, 115–116
 subtracting from, 15–16
 undesirable content, 97
sepia tone
 from black-and-white photos,
 186–187
 defined, 218
 scanning guidelines, 42
shadows
 Burn tool adjustments, 76–77
 color variation corrections, 84
 photograph adjustments, 50
shadowy illusions, blending
 repairs, 107
shapes, free-form selections, 13–14
Sharpen tools
 photo restoration uses, 17–18
 softening edges when blending
 repairs, 107–108

Shear filter, image content distortion, 169

Shift key
 constraining shapes when selecting, 11
 Magic Wand selections, 14

shortcuts bar, workspace section, 5

Sketch filters, 171–173

skin tone, retouching, 159–160

Smart Blur filter, digital image imperfection adjustments, 137–138

smiles, whitening teeth, 148

Smudge Stick filter, 170

Smudge tool (F)
 blemish smudging, 112–114
 blending out individual marks, 127–130
 Finger Painting option, 19
 hair adjustments, 155
 photo restoration uses, 19–20
 smearing colors, 129
 smoothing out freckles/scars, 146
 softening edges when blending repairs, 107–108
 strength settings, 19
 thickening eye lashes, 157

Soft Light mode, effects, 63

Solarize filter, 176

Spatter filter, 172

special effects
 application guidelines, 166–167
 application methods, 166–167
 Artistic filters, 170–171
 Brush Stroke filters, 171–172
 Brushed Aluminum, 23
 Cold Lava, 23
 distorting image content, 168–169

Effects palette, 23
Filters palette, 22–23
Layer Styles, 179–181
Layer Styles palette, 24
Lizard Skin, 23
Pixelate filters, 174–185
selection methods, 166
Sketch filters, 171–173
styles, 174–178
Stylize filters, 175–177
Swatches palette, 24
Texture filters, 178
textures, 174–178

Spherize filter, image content distortion, 169

Sponge filter, 170

Sponge tool
 adding/removing color, 78–79
 flow settings, 79
 washing out stains, 114–115

spotlights, when to use, 71–72

spots
 blending out, 127–130
 repair methods, 114–117

Sprayed Strokes filter, 172

stained content, selecting/recoloring, 115–116

Stained Glass filter, 178

stains, repair methods, 114–117

Stamp filter, 172

styles
 layers, 24
 lighting, 70–71
 special effects, 174–178

Stylize filters, 175–178

Sumi-e filter, 172

sunflower graphic, Adobe online access method, 7

Swatches palette, special effects, 24
symbols, triangle, 7

T

tears, repair methods, 109–111, 210–211

teeth, whitening, 148

tertiary colors, 218

text
 Effects palette special effects, 23
 optical character recognition (OCR), 35–36

Texture filters, 178

textures, special effects, 174–178

Texturizer filter, 178

theme, collages, 192

threshold
 Dust & Scratches adjustments, 124–126
 Unsharp Mask filter settings, 141

Threshold command, 59

thumbnails
 color variation adjustments, 55–56
 image options display, 164–165
 List View information display, 165

TIF/TIFF, 218

Tiles filter, 176

tool tips, displaying, 6–7

toolbars, fly-out, 4

toolbox
 button selections, 6
 keyboard shortcut display, 6–7
 positioning on the workspace, 6
 restorative tools, 16–22
 selection tools, 10–16

Continued

toolbox *(continued)*
 sunflower graphic, 7
 switching between tools, 6–7
 tool options display, 7
 tool presets, 9
 triangle symbol, 7
 viewing/selecting alternate tools, 4
 workspace section, 4
tools
 brush style/size selections, 7
 keyboard shortcut display, 6–7
 options display, 7
 presets, 9
 restorative, 16–22
 selection, 10–16
 strength settings, 7
 switching between, 6–7
 tool tip help, 6–7
 triangle symbol, 7
 viewing/selecting from toolbox, 4
Torn Edges filter, 172–173
torn images, reconstructing, 103–106
Trace Contour filter, 176
Transparency preferences dialog box, 30
triangle symbol, additional tool display, 7
Twirl filter, image content distortion, 169

U

Underpainting filter, 170
Undo History palette
 removing Auto Contrast effects, 49–50
 undoing actions, 5, 24
Units & Rulers preferences dialog box, 30

Unsharp Mask dialog box, 140–141
Unsharp Mask filter, digital image imperfection adjustments, 139–141

V

vintage photographs
 including paper mat frames when scanning, 39
 repair methods, 117–119
 storing, 201–202
Vivid Light mode, effects, 63
voids, filling after removing undesirable content, 97–99

W

Warp tool
 nose adjustments, 151
 raising cheekbones, 152–153
 retouching jaw lines, 154
Water Paper filter, 172
Watercolor filter, 170
Wave filter, image content distortion, 169
Wave tool, raising cheekbones, 152–153
Web images
 file options, 190
 naming files, 190
 Progressive option, 192
Web, saving photos for use, 189
Web sites
 Adobe, 7, 205
 author, 206
 Kodak, 76
Web-safe colors, 218
Web-safe format, scanned image guidelines, 44–45

White Point, photograph adjustments, 50
Wind filter, 176
Windows, scanner installation, 36–37
workspace
 free-floating palettes, 164
 Hints palette, 6
 How To palette, 6
 menu bar, 4–5
 moving palettes on, 26
 moving selections, 12
 options bar, 4
 palette well, 5–6
 palettes, 6
 sections, 3–6
 shortcuts bar, 5
 toolbox, 4
wrinkles, retouching, 147–148
writing, correcting, 210–211

Z

ZigZag filter, image content distortion, 169
zoom, 218
Zoom status box, zoom selection uses, 11
Zoom tool, selection uses, 11

About the Author

Laurie Ulrich has been working with computers — teaching people to use them, writing about them, and using them in her own business — for nearly 20 years. After working in the computer training industry in a management capacity for several years, Laurie decided to stop working for other people and to pursue her own goals and work in the areas of computing that interested her. The result, Limehat & Company, Inc., was formed in the early 1990s and provides computer training, Web design/hosting, and graphic design to growing businesses, non-profit organizations, and home users as well.

In the past decade, Laurie has trained more than 10,000 people to use computers through her classes at Temple University and at various corporate training centers in the Pennsylvania, New Jersey, and New York City areas. She has also authored and co-authored more than 20 books since 1997, covering a wide variety of topics, including Web design, Adobe Photoshop, Photoshop Elements, and Microsoft Office. You can reach Laurie via e-mail at laurie@planetlaurie.com, and she invites you to visit her Web site, www.planetlaurie.com, to find out more about her professional and personal interests.

Colophon

This book was produced electronically in Indianapolis, Indiana. Microsoft Word XP was used for word processing; design and layout were produced using QuarkXPress 4.11 and Adobe Photoshop 5.5 on Power Macintosh computers. The typeface families used are Bembo, Courier, Orator, and Rotis.

Acquisitions Editor
Tom Heine

Project Editor
Katharine Dvorak

Technical Editor
Robert Fuller

Copy Editor
Jerelind Charles

Editorial Manager
Rev Mengle

Vice President and Executive Group Publisher
Richard Swadley

Vice President and Executive Publisher
Bob Ipsen

Vice President and Publisher
Barry Pruett

Project Coordinator
Nancee Reeves

Graphics and Production Specialists
Beth Brooks
Kristin McMullan
Heather Pope
Erin Zeltner

Quality Control Technician
Laura Albert
Andy Hollandbeck

Proofreading and Indexing
Sherry Massey
Sossity R. Smith